Religion, Art,
and Visual Culture

Religion, Art, and Visual Culture

A Cross-Cultural Reader

Edited, and with Introductions by

S. Brent Plate

palgrave

First published in 2002 by
PALGRAVE™
175 Fifth Avenue, New York, N.Y. 10010 and
Houndmills, Basingstoke, Hampshire, England RG21 6XS
Companies and representatives throughout the world.

PALGRAVE™ is the new global publishing imprint of St. Martin's Press
LLC Scholarly and Reference Division and Palgrave Publishers Ltd.
(formerly Macmillan Press Ltd.).

ISBN 0–312–24003–1 hardback
ISBN 0–312–24029–5 paperback

Library of Congress Cataloging-in-Publication Data
Plate, S. Brent.
Religion, art, and visual culture : a cross-cultural reader / edited, and with
introductions by S. Brent Plate
Includes bibliographical references and index.
 ISBN 0–312–24003–1 (cloth) / ISBN 0–312–24029–5 (pbk)
 1. Art and religion. 2. Religion in art.

N72.R4 R45 2002
704.9'48—dc21

 2001053165

A catalogue record for this book is available from the British Library.

Design by Letra Libre, Inc.
First edition: February 2002
10 9 8 7 6 5 4

Contents

SECTION THREE
QALAM: WORD AND IMAGE
IN ISLAMIC CALLIGRAPHY

SECTION FOUR
SHINJIN: THE SEEING BODY-MIND
IN THE JAPANESE ZEN GARDEN

Preface

This volume grows out of the college classroom, and is written and edited to return to the college classroom. My hope, therefore, is that undergraduate readers will find it accessible and possibly even interesting. I also hope that this volume will have contributed something new to the ongoing academic study of religion and visual culture, both as separate studies and as an interdisciplinary joint project.

The selections provided here represent scholarship published in English since 1990 (with only a few earlier works). Some of the scholars whose writings are included have been trained as art historians, some as scholars of religion, and some are practitioners of the arts, both literary and visual. Due to the volume's interdisciplinary nature, some of the authors may be surprised by the company their writing is keeping here. Indeed, I imagine several authors may be surprised to find their work included, as they probably had no idea they were even interested in the topic, "religion, art, and visual culture." But part of my hope is that, with the juxtapositions presented here, we will be able to see both religion and the visual arts in a new light.

Because this book began in the classroom, I should first of all like to thank the students in my "Religion and the Visual Arts" course at the University of Vermont in the Autumn of 1999. Their initial comments and reactions to materials helped me in the early stages of my editing process. I would also like to thank Tim Beal and his "Religion and Visual Culture" course at Case Western Reserve University in the Autumn of 2000 for taking a test run of a draft of the manuscript.

The research for this volume, including travel to India and Germany, would not have been possible without an American Academy of Religion Individual Research Grant, and I wish to express my appreciation of that support. I would also like to thank support provided by the Department of Religion at the University of Vermont, and especially the chair of the

department, Bill Paden, who provided support in several ways as I was writing and editing.

The process of gathering 24 excerpts from other people's writings, as well as 31 images, put me in touch with a number of people around the world whom I would not have met otherwise. Many of these new friends, colleagues, and acquaintances were amazingly generous with their time and expertise and offered me everything from places to stay when traveling, to critical comments on drafts of the manuscript, to free use of their photographs. Several of these people I have never even met face to face, and there have been times when I truly have relied on the kindness of strangers. Among those who contributed to this volume in various ways, I would especially like to thank Lynn Perry Alstadt, Robyn Beeche, Cocoa Blake, Brian Burgess, Harriette Grissom, Tod Linafelt, Jenny McComas, David Morgan, Sarah Palmer, Sumathi Ramaswamy, Kapila Vatsyayan, Roger Wiberg, and the foundations of Tel Mac. For help above and beyond the call of duty I should single out Philip Lutgendorf for critical comments, encouragement, and Indian travel planning; Ira Bhaskar for a tour of the visual culture of Delhi; Luis Vivanco and Peggy O'Neill Vivanco who, even without reading any of the words, helped infuse this book with spirit by their presence; my editor at Palgrave, Gayatri Patnaik, for supporting the project in many ways; and Tim Beal who did everything possible to help make this work from the beginning. Finally, I wish to thank my companion, Edna Melisa Rodríguez Mangual, for her inexhaustible support.

A note on the text

For the sake of readability and consistency, all diacritical marks have been eliminated from the texts, and all variant spellings (such as "Quran," "Qur'an," and "Koran") have been made consistent across the excerpts. Also, all footnotes from the original texts have been eliminated. Bibliographic information for significant references can be found in the "Suggestions for Further Reading" at the end of each section.

List of Illustrations

Permissions

Introduction

THE CULTURAL RELATIVITY OF DUNG

On September 22, 1999, New York City mayor Rudy Giuliani threatened to cut off the city's financial support of the Brooklyn Museum of Art due to what he saw as the "sick" nature of the museum's exhibition, *Sensation*, and in particular one artwork, *The Holy Virgin Mary*. The image in dispute, created by British artist Chris Ofili, portrays the ever-popular subject of Western art, but with black skin, wearing a stylized blue shawl against a field of yellow that is littered with magazine cutouts of female genitalia, while one of the Virgin Mary's breasts is fashioned out of elephant dung. Giuliani protested that such a portrayal of a divine figure was "Catholic bashing," and claimed, "you can't do things that desecrate the most personal and deeply held views of people in society." Critics, journalists, religious leaders (Jewish and Christian), and politicians from both sides of the liberal-conservative divide quickly joined in the fray, adding their own voices to the multiple issues raised by the image. The ensuing controversy offers many insights to "religion, art, and visual culture" and is worth examining further as an overture to this present volume.

Many rushed to the defense of the Brooklyn Museum and Ofili, claiming First Amendment rights. The museum eventually sued Giuliani, and quickly won on First Amendment grounds, insuring that funding to the museum would continue. Liberal-oriented newspapers and websites rapidly filled with essayists and pundits offering their own interpretations of the artwork, arguing that the naked female cutouts evoked the crucial theological issue of the sexuality of the Virgin. In so doing, they believed one of the legitimate functions of art to be provocation, and Ofili's piece induced viewers to review their own theological, as well as human, assumptions. As a *New York Times* editorial claimed in the midst of a defense of Ofili and the Museum: "Art is the name of a perpetual human struggle with the limits of perception." And Ofili, a practicing Catholic whose parents immigrated to Britain from Nigeria, has this to say: "As an altar boy, I was confused by the idea of a holy Virgin Mary giving birth to a young

boy. Now when I go to the National Gallery and see paintings of the Virgin Mary, I see how sexually charged they are. Mine is simply a hip-hop version." Ofili, some of his defendants would claim, tests the limits of theological perception for a contemporary age, offering new ways of seeing old subjects.

The real controversy, for whatever reason, had little to do with nudity and sexuality, and much more to do with the elephant dung. It was the dung that attracted the attention of journalists and the ire of Giuliani. Articles betrayed their writers' points of view within the first paragraph by the words used to describe the picture: proponents of the image described it as "adorned" with dung, while opponents talked of the dung as being "smeared on" or "flung at" the painting. Defenders of the image, including the Brooklyn Museum's director and New York Times commentators, were quick to note how in "African culture," which is Ofili's heritage, elephants are symbols of power, and dung has a spiritually symbolic meaning as it represents fertility (in the sense that it is used as a fertilizer and would, one presumes, have uses in agrarian rituals). This is analogous to the way in which the Madonna's breast also symbolizes nurture, care, and promotes growth. In this way, dung takes on a religious-symbolic connotation. Defenders of Ofili's work aimed to be culturally relative and culturally sensitive.

Opponents of the piece took a "Western" perspective and saw the dung as "dirty," contrasted with Mary's "clean" and "pure" state of being. Attacks on The Holy Virgin Mary even included a physical assault from a man who snuck white paint (a symbolically significant color itself) into the museum and smeared it on the image, calling it "blasphemy." According to the opponents, the juxtaposition of the pure with the impure was what constituted Ofili's unholy action. Such a view—even while opponents were not necessarily cognizant of the fact—reinforces the priestly literature of the Bible, as well as Mary Douglas' anthropological work on the subject, whereby the division of pure and impure stands at the heart of religion and its rituals. As Douglas makes clear in her important study Purity and Danger, "dirt" is a relative term, and different cultures have different divisions separating what is pure from what is dirty or impure. What is dirty, in the end, is what is "out of place" or doesn't belong, according to the customs of a particular group of people. One might see why a Westerner's reaction to a Holy Virgin Mary composed in part by dung would be seen to be mixing substances that are not supposed to be mixed in the name of purity and holiness.

There are several other factors that are bound up in this controversy, including social and political institutions as well as the artist's background. As already implied, the social-political institution of the museum plays a role

in Ofili's work as an artist. Museums are not neutral receptacles in which artists work to fill the empty space. Instead, museum curators work with collectors, financially supportive companies, and others, helping to actively shape artistic values, financial values, and aesthetic judgments about art. Indeed, the collector whose collection constitutes the whole of the *Sensation* exhibition, Charles Saatchi, is a wealthy British businessman who bought up a great many artworks by young British artists, single-handedly generating their status as important new artists. And by labeling the show "Sensation" and producing a spectacular amount of attention (not only in New York, but also in London and Berlin, where the show was on display previously), the value of Saatchi's collection increased exponentially. Further, the show easily became the most popular exhibition in the Brooklyn Museum's 175-year history. The inclusion of Ofili in the midst of the collection has undoubtedly helped the artist's career, and vice versa.

There are also the influences of law and government. Scuffles over artworks are nothing new, and in many controversies one finds government playing a role. In the case of the *Sensation* exhibition it is of course the mayor of New York City who helped spark the fire, and then it was civil liberties lawyers who helped ensure that the Brooklyn Museum would continue to receive government financial support. However, in earlier cases, like that against the Corcoran Gallery's exhibition of Robert Mapplethorpe's photography (opposed due to its homoerotic imagery), the gallery backed down and canceled the exhibition because of political pressure. And due to the controversy in Brooklyn, the National Gallery of Art in Canberra, Australia, canceled their future hosting of the *Sensation* exhibition. Like it or not, art and politics intermingle.

Then there is the question of the artist's identity. In many of his artworks Ofili toys with conceptions of black identity in a predominantly white culture, often attempting to subvert stereotypical conceptions of the black male's associations with music, sport, and violence. And with artists like Marcel Duchamp as a precursor, he also toys with ideas of what *art* is and who gets to name it as such. When Ofili won Britain's notable Turner Prize in 1998, one British citizen protested by dumping a wheelbarrow full of cow manure outside the Tate Gallery in London, claiming, "modern art is a load of bullshit." Ofili himself seems to agree, except that his privilege is to bring the "shit" *inside* the walls of the museum. Indeed, as if preempting the protest, one of his previous works was called *Bag of Shit* and is exactly what the title describes, placed on a pedestal in a museum. Ofili is an artist who exhibits within the walls of museums, and therefore his use of dung/manure/shit becomes an artistic statement. By contrast, the British citizen who protested can look at art in the museum, but his actions must remain outside the institution, where they become a "protest"

rather than "art." And Ofili, while tongue-in-cheek about it all, is onto something that again challenges our conceptions about art as well as religion. "There's something incredibly simple but incredibly basic about it," Ofili said in relation to the dung and *The Holy Virgin Mary,* "It attracts a multiple of meanings and interpretations."

Placing *The Holy Virgin Mary* in the context of Ofili's other work, we get yet another perspective complicating the liberal, culturally sensitive attitude and the conservative "I-don't-know-much-about-art-but-I-know-what's-bad" attitude. While his parents were Nigerian by birth, Ofili was born and raised in England. He claims to have learned a great deal about cultural differences during a six-week trip to Zimbabwe several years ago. But while some commentators seem to imagine he "found his roots" there, he instead insists that Zimbabwe is "a foreign country for me and the idea of looking for your roots and stuff is ridiculous." Hence, how "African" is he? Coupled with the fact that many of his other works take the "Western" view of dung as something dirty—there is little spiritual symbolism to be interpreted out of a "bag of shit"—it becomes difficult to simply accept the views of some of Ofili's defenders. To his credit, Ofili refuses to be objectified by either side of the battle, and *The Holy Virgin Mary* itself raises interesting and abiding issues of purity and danger, the sacred and the profane.

So, who does one agree with? Those who from a culturally relative perspective make claims to the image's "African" roots? Or those seeing it from within U. S. or British cultures, who may know nothing of African life? More broadly, how does one evaluate such an artwork? From what standpoint does one call it "good," "bad," "offensive," or "beautiful"? How are lines drawn between "art" and "non-art," the "pure" and the "dirty," the "sacred" and the "profane"? How do certain descriptive and emotive words used about art change the way it is viewed? How does the medium of the work affect the message, and vice versa? How much of the worth and value of the art is decided by politicians, museum curators, religious leaders, art critics, and art collectors? And what about the historical and theological background of the picture in relation to other images and understandings of the Holy Virgin Mary? Is this, or should this be, offensive to a Christian? What about the ethnic, racial, gendered, and national identity of the artist? Should his identity as a black, British artist of African descent affect the way museum goers in New York City see the image? Again, how does one decide what to think of such an image?

Such questions begin to get us thinking about "religion and visual culture." Rather than simply stopping with an analysis of the image itself, we see that there is a complex of issues related to understanding the *meaning* of this "work of art." Therefore, the meaning of the artwork, seen through

the lens of *visual culture*, must take into account the following components
that comprise the overall "field of vision":

- The *image* itself—what it looks like, its execution, physical materials,
 etc.;
- The relationship between the *medium* and the *message*, or *form* and
 content, of the image;
- The *creator* of the image, including his or her ethnic, gendered, sexual,
 racial, religious identity;
- The nature of the *language* that surrounds the image in terms of ex-
 plaining it, arguing against it, or for it;
- The *responses*, on all sides, to the image—physical responses, verbal re-
 sponses in newspapers and journals, the responses of the museum
 goers, legalistic responses;
- The *historical context* of the image—in this case, among thousands of
 other images of the Virgin Mary;
- The *identity of those who view the image*—considering a Christian
 might understand the image differently than a Buddhist or an agnos-
 tic, and a North American differently than an African;
- The particular *cultural crossings* that are constantly taking place—Ofili
 is in a sense both African and British, and his artistic symbols and in-
 spiration derive from both;
- And the role of *social, political, and cultural institutions* in the creation
 and reception of "art."

Each of these multiple components of the field of vision will surface at
various points in the following volume. Meanwhile, no single element can
be taken as more basic than any of the others.

One of the larger issues raised by the Ofili controversy that has crucial
relevance in introducing this volume is the importance of cross-cultural
meanings and interpretations. In the case of *The Holy Virgin Mary*, we ini-
tially see at least two cultures come into conflict: the "African" and the
"European/Western." Almost without exception throughout Western cul-
tures, dung is dirty, whereas in African cultures dung has a variety of sym-
bolic and practical functions. There is certainly more than one view of this
on such a vast continent, and it would be wrong to suggest that all Africans
consider dung to have symbolic significance. In fact, many scholars and
politicians from the African continent themselves spoke out against Ofili's
use of dung on the picture, while many others noted concrete examples of
the use of dung in fashioning visual objects in Africa. One object made in
part from dung is actually in the Brooklyn Museum of Art's African Art
collection, right downstairs from the where the *Sensation* exhibition was

mounted. Thus, one of the problems with the view of many of Ofili's defenders is that it is impossible to speak of "Africa" as a single culture. Many in the Western liberal intelligentsia wanted to make a claim for the spirituality of Ofili's use of dung by referring to its symbolism in "African culture," unwittingly refusing to acknowledge that "Africa" is comprised of hundreds of cultures. Indeed, Ofili's noteworthy visit to Africa was to Zimbabwe, over two thousand miles from his ancestral home in Nigeria.[1]

The bottom line is that objects obtain different *meanings* in different locations and historical settings. And since this volume is cross-cultural, let us just briefly imagine one other culture's perspective. In the midst of the region of Vraj, India, the land in which Krishna was mythically born and reared, we find yet another religious-cultural relation to dung. Figure 0.1 portrays Lord Krishna himself, fashioned out of dung. In this image from a *govardhan puja* (cowdung wealth ceremony) Krishna is worshipped for both his cosmic, world-ordering powers, as well as for his playful, even mischievous, childhood life as a cow herder. In the pilgrimage city of Vrindavan, as elsewhere in India and around the world, cattle are associated with wealth and prosperity. Thus, milk, butter, ghee, dung, and cows themselves are used in multiple ways in religious festivals and rituals; there is a practical as well as spiritual significance to all of these material objects, as they traverse borders between the sacred and the profane. As we will see in section five, which deals more specifically with Hindu visuality, the vital aspect for a Hindu is the ritual context surrounding the image. And for the worshipper facing Lord Krishna, there is no question as to the sacred status of the substance, dung or not. What is cast away as dirty and impure in one culture may be worshipped in another, provided it is understood within its proper context, its situation within a field of vision. Therefore too, the sacred and the profane cannot be understood in any universal way, but must be examined through what Clifford Geertz would call "local knowledges."

Perhaps most importantly, the *Holy Virgin Mary* controversy shows the continuing power of images in human life, even in a modern, cosmopolitan city like New York. Along these lines, *Religion, Art, and Visual Culture* displays some of the variety of ways the human endeavor of seeing is bound up with religious beliefs and practices in a number of times and places. Seeing itself has its own set of local knowledges. And with that, we can turn to define this term "visual culture" a bit more closely, and then introduce the contents of this volume.

WHAT IS VISUAL CULTURE?

Visual culture is a relatively new focus in academia, with major publications first appearing in print in the early 1990s. It is an interdisciplinary

Fig. 0.1 "Sri Krishna" made from cowdung at a govardhan puja (cowdung wealth ceremony) at Sri Gokulanand Mandir, Vrindavan, India. Photo by Robyn Beeche, courtesy of Sri Caitanya Prema Samsthana, Vrindavan.

field of inquiry drawing on established disciplines like art history, graphic design, cultural anthropology, and sociology, and on newer fields of study like gender studies and ethnic studies, among others. Several publications have attempted general overviews, and their differences in approach reveal the diversity of this interdisciplinary area as a whole.[2] For many current scholars working in visual culture from a humanities perspective (meanwhile borrowing reliably from the social sciences), "visual culture" tends to replace the term "art history." Visual culture scholars seek to contribute to a "history of images, rather than to a history of art,"[3] as they analyze the "rejects of the official disciplines."[4] *Art,* in the modern West, is typically associated with the "fine arts" and with "high culture," and usually associated with the media of painting and sculpture. This is in opposition to areas such as design and "popular culture," and media such as television, public art, and fashion, to name but a few. Part of what is going on with these scholars' use of the term visual culture is an attempt to get away from the elitism denoted in the idea of the "fine" or "high" arts.

Academics and other intellectuals have often been rightly criticized for being out of touch with the tastes and opinions of a majority of the people in a culture. Not everyone "gets" art, for it is a matter of *taste.* Yet those tastes are culturally constructed and invariably associated with socioeconomic status. Museums and wealthy collectors, artists and journalists, all help to develop the taste of art for others. This is not to criticize the production of art, but rather to criticize a view of art that makes claims to its supposed independence, and universal appeal and understanding.[5]

On the contrary, visual culture is an attempt to talk about the visual components that are imbedded in *everyday life.* As such it tends to be oriented around personal and public activities like working, playing, birthing, growing, eating, and dying. Art, typically housed in a museum, is not part of most people's everyday life. So, visual culture pays attention to what many people *do see* in their everyday lives. In the Western world, and increasingly everywhere else, this would include a range of things: advertisements on billboards, films (and the endless tie-in products related to some of them), television commercials, the spectacle of sports, graphic design work, architecture and urban planning, public art, and fashion, among other visual media. In fact, visual culture is interested in so many things that one of its criticisms is that it is interested in everything.

This is part of the reason the term "art" has been kept in the title of this volume, problematic though the term may be. The term is without a doubt a modern, Western notion—many languages around the world have nothing comparable to what Westerners talk about when they talk about art—but then again the same may be said of "visual culture" and "religion." Nonetheless, if the term art has been kept, there is also an interest in a trans-

formation of how it is understood. "Art for art's sake," closed off from the outside world and preserved within the confines of museum and university, is no longer a viable alternative, as many artists themselves now realize. Art critic Suzi Gablik discusses just such a transformation in terms relevant to the present volume when she claims, "vision that is truly engaged with the world is not purely cognitive, or purely aesthetic, but is opened up to the body as a whole and must issue forth social practices that 'take to heart' what is seen."[6] The writings of scholars such as Mieke Bal, Norman Bryson, and Hal Foster have opened our eyes to the complexities of visuality by displaying how seeing is an intricate, culturally-constructed human activity with vital repercussions. Art must be reconnected with the broader culture, including religion, from which it has been severed in the modern age. Thus, a cross-cultural look at the interrelations between visual art and religion (contested terms though they are) through the lens of visual culture may help to revitalize both terms at the same time.

The desire for transformation, for a connection between *how we see* and *how we live,* is part of what drives visual culture studies. It is a desire to link aesthetics and ethics. Implied in this shift is the understanding that we cannot simply orient our analyses around the *objects* that are seen—whether these objects are a Van Gogh painting, a Prada fashion line, a calligraphic Quran, or that new Gap commercial—but must take into account the overall field of vision. Visual culture is not simply interested in the formal dimensions of an image, nor merely in the historical background and setting for the "original" production of the image, but rather in the ongoing environment and life of images. Visual culture is engaged with the production *and* the reception of visual objects, the makers *and* the viewers. And in this mode of analysis, gender, sex, race, nationality, religion, family, and other forces of identification come to play vital roles in the construction of the way we look, and are looked at. These components of identity affect the way images are produced and reproduced, and how such images are viewed, and by whom.

The contemporary desire to detach art from its stable, isolated status and reconnect it to broader political and cultural components is, I believe, a desire for some reinvention or reenchantment of ritual as an important component in human life.[7] And in the realm of ritual we find the hinge between the turn toward visual culture and the practices of religious devotion. This volume's focus on "religious visual culture" means that its field of vision will be framed by the particularities of a variety of religious events and performances, whether those take place at home, in a synagogue, a garden, or a museum. Religion and ritual thus serve as delimiting terms for visual culture, just as they open up new dimensions of visual culture. Only, the *sacred* is just as often found in ordinary (*profane*) times and

places as it is in extraordinary, "sanctified" times and places. The perceived split between the sacred and profane is broken down and reoriented. Ofili's creation has already suggested as much.

Religious Seeing and Seeing Religion

Beyond the broadening of the category of art into the realm of visual culture, one of the underlying interests of *Religion, Art, and Visual Culture* is to contribute to a reimagination of the study of religion. While pedagogies are changing, the still common approach to understanding religion is to examine written texts. Important recent works by Colleen McDannell, Sally Promey, and David Morgan, among others, signal the shift in studies of religion away from verbal/textual *doctrine* toward the visual and material artifacts of religious *practice*. This is not to exclude the verbal/textual, but it does imply a further shift in understanding how words themselves are put into practice rather than understood for their doctrinal dimension. Morgan particularly lays out a key theoretical background for the present volume when he suggests that religious visual culture should not be sidelined in the study of religion. Rather:

> The opportunity at hand is to elucidate the role that visuality plays in the social construction of reality. The desired outcome is that historians and scholars of religion will come to see images and visual practices as primary evidence in the study of religion and not merely as incidental illustrations or cover art for augmenting book sales. The new study of religious visual culture begins with the assumption that visual artifacts should not be segregated from the experience of ceremony, education, commerce or prayer. Visual practices help fabricate the worlds in which people live and therefore present a promising way of deepening our understanding of how religions work.[8]

In a number of books since the mid-1990s, Morgan has demonstrated how attention to visual practices supplements and alters our very views of religion. Elsewhere he argues "that the act of looking itself contributes to religious formation and, indeed, constitutes a powerful practice of belief."[9] Therefore, the wager is that attention to the act of looking will reveal a host of characteristics about religious practices and, as a result, about religions themselves in ways that studies of deities or sacred texts, alone, will not.

The present volume is very much in line with Morgan's critically important work, as it looks at religious visual culture in global, cross-cultural perspectives. This volume is not comprehensive of any single religious tradition's relationship to the visual (if such a thing were even possible), nor is it specifically historical in its methodology. Instead it provides, on the one hand, introductory readings and ideas for how to approach the rela-

tion between visuality and religious practice in five major world religions. On the other hand, it begins to suggest new ways in which religious traditions themselves may be understood as new questions are asked about how religions are instituted, practiced, and comprehended.

The focus on the relationship between visual culture and religious practice produces what we will call "religious seeing."[10] By no means a universal experience, *seeing,* in all its manifest forms, is nonetheless a basic activity of humans. The difference in ways of seeing from culture to culture, religion to religion, gender to gender, ethnicity to ethnicity, are enlightening, yet the commonalities in the variety of ways of seeing are also quite instructive. This volume intends to display both the continuities and discontinuities of human seeing.

Religious seeing is, of course, somewhat more specific than just seeing, as the activity is situated within an environment conducive to belief, devotion, and transformation. Therefore, this volume is designed to help readers recognize how religious seeing is a complex process that takes place within particular cultures and times, and is shaped by various systems of belief. In order to examine more closely some of the processes involved in the activity of religious seeing, this volume proceeds through a series of components that make up the overall field of vision. Beginning with the internal relations between the eye and mind, each section progressively works its way externally to encompass spatial, temporal, social, and ritual dimensions of seeing. There can be no simple definition given to "religious seeing"; instead what is presented through this volume is a set of tools from which to continue asking broader philosophical questions like, What is religion? And, How is "religion" distinct from "culture"? To be sure, there are no answers to these questions found herein; we are merely given a chance to think through the questions from another perspective.

How to Read This Book

Visuality is a complex process. As a way to understood the complexity involved, we begin by breaking down visuality into six components that will enable us to examine religious visual culture:

1. *Perception:* an understanding of the relation between the eye and the mind—how perception functions psychologically and physiologically.
2. *Image/Icon:* descriptions and interpretations of the image being looked at.
3. *Word-Image:* examines the relations between words and images and each of their roles in cultural-religious understandings and communications.

4. *Body-Mind:* stresses how visual perception is located in the body, and emphasizes the relation of mind and body.
5. *Interactive and Performative:* the seeing subject "looks" but is always simultaneously being "looked at"—visuality is interactive and performative, never merely subjective.
6. *Memory:* how we see is dependent on our personal and cultural environment and history, as well as the history of the visual media being looked at.

To flesh out these components of visuality, each section is oriented around one of them, seen in relation to one major world religious tradition and a particular visual arts medium. (The first section on perception is the exception; it serves as an introduction.) Thus, Christianity is seen in relation to painting, with an emphasis on the image/icon. Islam is seen in relation to calligraphy, with an emphasis on the relation of words and images. Buddhism is seen in relation to landscape gardens, with an emphasis on the relation of the mind and body. Hinduism is seen in relation to mass media (film and television), with an emphasis on the ritualized relation between the seer and the seen. Judaism is seen in relation to architecture, with an emphasis on memory in constructions of vision. Each section moves from general relations of aesthetic and religious traditions to concrete examples. A schematic outline of the volume follows:

Religious Tradition	Visual Medium	Visuality Component
Christianity	Painting	Image/Icon
Islam	Calligraphy	Word-Image
Buddhism	Landscape gardens	Body-Mind
Hinduism	Mass media	Performance, Interactive
Judaism	Architecture	Memory

Of course, this is not the only possible arrangement. This chart can be rearranged in a wide variety of ways. For example, Buddhist visual culture could just as well be examined through the medium of architecture, as the visual component of interactive performance could be considered in such an arrangement. Or, Hindu visual culture could be considered through sculpture and the relations of words and images could be expressed. In addition, while this volume focuses on five major world religions, religious visual culture could also be charted in relation to smaller-scale traditions

from Sub-Saharan Africa, the Caribbean, or indigenous traditions of Australia and the Americas. It is, therefore, important to emphasize that the structure of this volume is not taken as final approach to religious visual culture. Instead, the hope is that many others will come along and scramble these categories, invent new categories, and suggest perpetually new ways of seeing religion and comprehending religious seeing.

In the first introductory section, the constructed, relative nature of seeing is emphasized. Excerpting from the work of neuropsychologist Richard Gregory, art historian James Elkins, and poetic musings by Diane Ackerman, the section pays attention to the way humans learn to see, and how this learning process is not always as readily apparent as we might believe. The reader begins to understand that *seeing* (that is, making the biochemical processes of vision *meaningful*) is influenced by a host of personal, cultural, and political dynamics. To see, ultimately, is to *interpret* and make meaning out of experiences, and this is always done from within a specific environment. A final reading by mystical/mythical filmmaker Stan Brakhage begins to show a way in which the role of the visual arts might allow us humans to *see differently*. An implicit proposal is made that seeing within a ritualized setting allows for a transformation of personal identity, and that type of seeing is endemic to religious practice itself.

In the second section, it becomes necessary to articulate something about the image being observed. Humans don't just see, they need to be seeing *something*. Here, painted images are related to the religious tradition of Christianity. Excerpting from Margaret Miles' Christian-oriented work on images, the section makes note of the impact of painting on Christian theology (specifically "Christology") and vice versa. Pulling together three excerpts from recent work on Renaissance and Modern Christian painting, readers will see how images affect religious understanding in particular times and places. An excerpt from Anglican priest John Drury situates paintings within the liturgical, communal setting of his church, allowing art to visually expand Christians' understandings of the Annunciation, Crucifixion, and other biblical stories. Next, Leo Steinberg's controversial yet erudite work *The Sexuality of Christ in Renaissance Art* is excerpted along with David Morgan's writings on Warner Sallman's *Head of Christ,* as two intriguing studies that depict particular relationships between religion and visual culture. Steinberg promotes Renaissance painting as the pinnacle of Christian orthodoxy in the way both the human and divine natures of Christ are displayed together. Morgan's work on twentieth-century mass reproduced art shows that images still have the power to affect human religious response.

A culture's religious comprehension is of course never simply a matter of the images utilized. Rather, visual culture always mixes with verbal culture, which brings us to the topic of the third section. Throughout many

religious traditions, the "Word" has taken precedence over the image, and the battle between words and images has accounted for several shifts and splits in religious traditions. While the battle between word and image has emerged in many times and places, it is especially heightened within the orthodox view of Islam with its strong emphasis on the written word of the Quran. An excerpt from art historian Oleg Grabar introduces the reader to some of the broader issues in the Islamic relation between writing and visual artistry. What we find within Muslim societies is a great emphasis placed on the artistic craft of calligraphy. Excerpts from Annemarie Schimmel and Seyyed Hossein Nasr display the breakdown of the word-image opposition by showing the merging of words and images in calligraphy. With calligraphy—as it was developed through medieval times in the Middle East—the magisterial scripting of the word itself becomes an image for contemplation and religious interaction. Then, as artist and theorist Wijdan Ali argues, calligraphy has provided a sense of tradition for contemporary artists, tying their modern artistic interests to their Islamic past. Ali also demonstrates the dynamic potential available through cross-cultural interactions.

None of the visual interactions mentioned in the first three sections can take place without the human body. The existence of the body in matters of language and vision helps us realize that visual interaction is a material, sensual process. The viewer does not passively sit by waiting for images to pass in front of the eyes; rather, the eyes are attached to a body, and that body moves and exists within temporal and spatial dimensions. To highlight this fact, the fourth section focuses on Japan and on landscape gardens and their relation to Zen Buddhism. The section begins with a general overview of Buddhism and the arts in Japan through an excerpt by Richard Pilgrim, and then moves toward the dynamics of the body-mind relationship as given in the work of Yasuo Yuasa. As the reader learns that mind and body are synthesized in Zen cultivative practices, the impact on visual, aesthetic experience also becomes clear. Thus, turning to the space of the Japanese gardens developed by Zen-inspired gardeners from the twelfth century through the twentieth century, one sees how the cosmic order "out there" is connected to the cosmic order of our very body, as the excerpt from Shigenori Nagatomo and Pamela Winfield particularly points out. It is in the garden, among other places, that we see the correlation of the internal and external cosmos taking place. The final excerpt from Mark Holborn provides embodied views of three well-known gardens around Kyoto, Japan.

If seeing is a material as well as an intellectual and psychological process, than the "seer" will simultaneously "be seen." Therefore, seeing in any ritual setting entails that others who are gathered for devotion will also

look at the looker, and in the Hindu setting the worshippers' gaze will be returned by the gods and goddesses who are being worshipped. Diana Eck's highly popular book *Darshan* is excerpted here, detailing some of the experiences of Hindu religious devotion, and noting how India's is a highly visual culture. To see the visual culture of India, as the following excerpt by Richard Davis further suggests, means one takes part in an interactive performance with the images being worshipped. Religious seeing in a Hindu ritualized context entails a different way of seeing objects than in the Western museum setting where one is supposed to see from a detached, objective standpoint. Hindu seeing is instead deeply related to touching. In the midst of this, visual culture in the twentieth century has seen dramatic changes in visual technology, creating all-new types of images: images that are filmed and televised. Rather than destroying rich devotional traditions, however, these images of the mass media have merged with older devotional practices and have created a new form of worship, as Philip Lutgendorf points out in a study of Indian responses to the televised version of the classic text, the *Ramayana*. John Hawley also relates a similar though different response to a "new" goddess, Santoshi Ma, whose huge popularity is owed to a 1975 movie about her.

Finally, in the sixth section, the *space* of seeing is linked up with the *time* of seeing. What takes place in the visual experience is bound up with a sense of history and memory, connoting that we do not see once and for all, but that seeing is a historical process and is influenced by the visual, verbal, and tactile memories of the past. Memory, in the Jewish tradition, is bound to ritual, acted out in space and time. Rather than being an aniconic tradition, as many have claimed of Judaism, the excerpts here display how visuality is part and parcel of modern European Jewish identity. An excerpt from Richard Cohen introduces the function of visual, material culture in the identity formation of modern European Jews, noting the specific ideologies evoked in the institution of the museum. Once we see how the visual does play a role in modern Judaism, memory is "acted out" as the space and time of seeing are brought together in the architectural space of museums and memorials. James Young's intriguing study of Holocaust memorials provides a way to *visualize memory* from within the context of the atrocities of the twentieth century, while an excerpt from Oren Stier brings us specifically to Yad Vashem in Israel and the United States Holocaust Memorial Museum in Washington D.C. In the midst of Young's and Stier's excerpts we also see a reviewing and rethinking of the role of icons and idols within Judaism. Finally, as a counterpoint to the specificities of the Holocaust memorial, Daniel Libeskind's Jewish Museum of Berlin is "visited," pointing toward an optimistic, yet not-forgetful view of the past and the future. In an excerpt from my own writing, I attempt to

demonstrate how Libeskind literally builds memory into the visual-tactile space of his museum.

Somehow we have returned to the museum in the end, in spite of the idea that visual culture attempts to get us out of the museum. But to study visual culture, and especially *religious* visual culture, means we will have to look for the religious-visual interaction at many levels of lived existence. Part of this volume's aim, then, is to raise a pair of interpenetrating questions for contemporary, Western cultures (where this is being written, edited, and, most likely, read): What kind of "artistic" encounter is possible outside of established artistic institutions—in mosques and gardens, city parks and churches? And what kind of "religious" interactions take place inside the supposedly secular artistic institutions?

Religious visual culture finds the religious in the most secular of places, and the secular in the most religious of times, all the while rethinking hierarchical relationships between the sacred and the profane. In the end, religious visual culture is a story of seeing, a story that begins in the internal relations of the eye and mind, moving outward to encompass relations with words and bodies, and then ultimately to the seeing body-mind's relation to ritual and memory in the larger world. Through this process, connections are made between the material and spiritual, between the past, present, and future of a culture, and between human beings

Notes

1. The Ofili controversy can be seen throughout the *New York Times* from late September through mid-October 1999, and in the December 1999 issues of *Artnews* and *Art in America*. The most astute, cross-cultural synthesis of the debate was Donald J. Cosentino's article "Hip-Hop Assemblage: The Chris Ofili Affair," in *African Arts* (Spring 2000): 40–51.
2. For example, the edited volume by Norman Bryson, Michael Ann Holly, and Keith Moxey, *Visual Culture* (Hanover, NH: Wesleyan University Press, 1994) works out of the field of art history; Chris Jenck's *Visual Culture* (New York: Routledge, 1995) looks at the social dimensions of visuality; and Malcolm Barnard's *Art, Design, and Visual Culture* (New York: St. Martin's Press, 1998) approaches it from the standpoint of "visual communication." In my view the most useful and wide-ranging of the introductory work is found in Nicholas Mirzoeff, *Introduction to Visual Culture* (New York: Routledge, 1999), and his edited *The Visual Culture Reader* (New York: Routledge, 1998). Many other studies take one or more of these views and examine the visual components of particular times and places.

Of note is the work of Mieke Bal, who has been practicing visual culture studies (rather than trying to introduce a singular definition) in many works, especially *Reading "Rembrandt"* (New York: Cambridge University Press, 1991), *Double Exposures* (New York: Routledge, 1996), and *Quoting Caravaggio* (Chicago: University of Chicago Press, 1999).

3. Bryson, Holly, and Moxey, *Visual Culture*, xvi.
4. Mieke Bal, *Double Exposures*, 11.
5. For more on the cultural constructions of "taste," see Pierre Bourdieu, *Distinction: A Social Critique of the Judgement of Taste*, trans. Richard Nice (Cambridge: Harvard University Press, 1984).
6. Gablik, "Making Art as if the World Mattered," in *The Reenchantment of Art* (New York: Thames and Hudson, 1991), 100.
7. For more on this see Ronald Grimes, *Deeply into the Bone: Re-Inventing Rites of Passage* (Berkeley: University of California Press, 2000).
8. David Morgan, "Visual Religion," *Religion* 30 (2000): 51.
9. David Morgan, *Visual Piety* (Berkeley: University of California Press, 1998), 3.
10. Morgan talks of a similar action, but calls it "visual piety

Suggestions for Further Reading

Bal, Mieke. *Reading "Rembrandt": Beyond the Word-Image Opposition.* New York: Cambridge University Press, 1991.
————. *Double Exposures: The Subject of Cultural Analysis.* New York: Routledge, 1996.
————. *Quoting Caravaggio: Contemporary Art, Preposterous History.* Chicago: University of Chicago Press, 1999.
Barnard, Malcolm. *Art, Design, and Visual Culture: An Introduction.* New York: St. Martin's Press, 1998.
Bell, Catherine. *Ritual: Perspectives and Dimensions.* New York: Oxford University Press, 1997.
Bertelsen, Lars Kiel, Rune Gade, and Mette Sandbye, eds. *Symbolic Imprints: Essays on Photography and Visual Culture.* Aarhus, Denmark: Aarhus University Press, 1999.
Bryson, Norman, Michael Ann Holly, and Keith Moxey, eds. *Visual Culture: Images and Interpretation.* Hanover, NH: Wesleyan University Press, 1994.
Carson, Fiona and Claire Pajaczkowska, eds. *Feminist Visual Culture.* New York: Routledge, 2001.
Doty, William. *Mythography: The Study of Myths and Rituals.* 2nd ed. Tuscaloosa: University of Alabama Press, 2000.
Evans, Jessica, and Stuart Hall, eds. *Visual Culture: The Reader.* Thousand Oaks, CA: Sage Publications, 1999.
Foster, Hal, ed. *Vision and Visuality.* Seattle: Bay Press, 1988.
Geertz, Clifford. *Local Knowledge: Further Essays in Interpretive Anthropology.* New York: Basic Books, 1983.

Jencks, Chris. *Visual Culture*. New York: Routledge, 1995.

Leppert, Richard. *Art and the Committed Eye: The Cultural Functions of Imagery*. Boulder, CO: Westview Press, 1996.

McDannell, Colleen. *Material Christianity: Religion and Popular Culture in America*. New Haven: Yale University Press, 1995.

Mirzoeff, Nicholas. *An Introduction to Visual Culture*. New York: Routledge, 1999.

———, ed. *The Visual Culture Reader*. New York: Routledge, 1998.

Morgan, David. *Visual Piety: A History and Theory of Popular Religious Images*. Berkeley: University of California Press, 1998.

Morgan, David and Sally M. Promey, eds. *The Visual Culture of American Religions*. Berkeley: University of California Press, 2001.

Neiva, Eduardo. *Mythologies of Vision: Image, Culture, and Visuality*. New York: Peter Lang, 1999.

Sturken, Marita and Lisa Cartwright. *Practices of Looking: An Introduction to Visual Culture*. New York: Oxford University Press, 2001.

 Section 1

Aisthesis

Perceiving Between the Eye and the Mind

Aes·the·ti·cian *(or es·the·ti·cian)* **1** *One versed in the theory of beauty and artistic expression.* **2** *One skilled in giving facials, massages, depilations, manicures, pedicures and other beauty treatments.*

- -*American Heritage Dictionary*

To perceive is to make a continuous series of educated guesses, on the basis of prior knowledges and expectations, however unconscious.

Teresa de Lauretis, Alice Doesn't

Walking through town, one may come across a small shop with the word "aesthetician" stenciled on the window. A scholar of philosophy or literature may be tempted to peer in, hoping to find stacks of theoretical books on the desk and paintings on the walls. But on closer inspection it is revealed to be a "beauty parlor," a place to change the appearance of one's body in order to fit certain conventions of attractiveness. Taking this bodily alteration to a further level, one may see an advertisement in a newspaper for "aesthetic surgery," a service that modifies one's body in more extreme ways to fit cultural conventions. So, what have the beauty parlor and surgery to do with the arts? Perhaps nothing, perhaps everything.

While an initial explanation may dwell on the idea that the plastic sur-geon and artist are joined in the pursuit of beauty, the real hinge that holds and folds these two is none other than the human body with its five senses. "Aesthetics" stems from the Greek term, *aisthesis,* which simply means "sense perception." Thus, in its strictest form, aesthetics deals with taste, touch, hearing, seeing, and smelling. In other words, "aesthetics is born as a discourse of the body."[1] Yet, in common scholarly usage today, there is a tendency to equate aesthetics with a philosophy of art that asks questions about "style," "beauty," and "taste" (the "taste" achieved by the mind, not the tongue). That is, aesthetics may have been born of the body, but it has evolved into a discourse of the mind. The originator of the modern study of aesthetics in the eighteenth century, Alexander Baumgarten, distin-guished between the two aesthetics—the intellectual interest in beauty and taste is called *aesthetica artificialis,* as opposed to the perceptual, bodily con-notations of *aesthetica naturalis.* So, while the "natural" scope of aesthetics is to examine the basic bodily facts about sense perception, it has "artificially" involved itself in the relation between *art* and *culture* when it focuses on taste and beauty.

Nevertheless, research since the time of Baumgarten has suggested that neither of these types is fully natural nor fully artificial; rather, there is a constant crossing from one to the other. Mind and body, culture and na-ture, the intellectual world and the physical word, are linked to each other in manifold ways. We may think "beauty is in the eye of the beholder," but the idea of beauty always turns out to be a highly constructed notion that bears the marks of the beholder's culture. And we may "believe it because we see it," but a reliance on the senses will not get us as far as we want ei-ther, for perception is a tricky thing, as we will soon see. What is needed instead is a mixing of both of these notions of aesthetics—in shorthand, the "aesthetics of the mind" and the "aesthetics of the body"—to see aes-thetics as the mixing of "the material and the immaterial: between things and thoughts, sensations and ideas."[2]

The intertwining of these aesthetics will weave its way through this volume, and I have begun this first main section with the concept of aes-thetics because it opens many doors that will be passed through in the following sections, including the role of the body and the relation be-tween the body and the mind. Relatedly, aesthetics will also bear its mark on the relation between words and images, the relations between nature and culture, the importance of cultural attitudes of beauty and taste, and the creation and veneration of images. Aesthetics also provides a broad setting for the perceptual relationship that exists between the eye and the mind in the activity of seeing, which is the central focus of this intro-ductory section.

SEEING AND BELIEVING

Is seeing believing? Can we really trust what we see to be an accurate perception of reality? Do all people see the same thing, in the same way? According to contemporary researchers on vision, the answer to these questions is "no." The world "out there" is not identical to the world that is perceived and understood inside our mind: we cannot directly apprehend the outside world through our eyes or any other sense organ. Instead, there is a series of conversion processes and interpretations that must take place before our conscious mind can understand the world around us. In the conversions and interpretations, variations occur, while our "world" is reconstructed in ever-new ways. James Elkins, who has written a number of books in recent years on topics directly relevant to this volume and who is excerpted below, nicely sums up the complexities and contradictions involved with seeing:

> [S]eeing is irrational, inconsistent, and undependable. It is immensely troubled, cousin to blindness and sexuality, and caught up in the threads of the unconscious. . . . Seeing is like hunting and like dreaming, and even like falling in love. It is entangled in the passions—jealousy, violence, possessiveness; and it is soaked in affect—in pleasure and displeasure, and in pain. Ultimately, seeing alters the thing that is seen and transforms the seer. Seeing is metamorphosis, not mechanism.[3]

Precisely because there are these effects, transformations, and variations, there is also space for religion and art, for religion and art both operate in the realm of *representation*. Representation, as the term indicates, entails that an original "presence" is in turn "re-presented" in another realm. A painting, for instance, may be a re-presentation of an originally present landscape existing in the world outside. Likewise, a religious ritual such as a Good Friday service in a Christian church re-presents the originally present crucifixion of Christ. Such activity, we can surmise, is also the activity of the eye and mind: re-presenting in the mind of the beholder what was originally present in the outside world. Religion, art, and vision itself are each structured through representation.

It must be emphasized, however, that re-presentation always involves an alteration of the original. The original presence is not represented on a point-by-point basis and there is no perfect translation process. Artists, of whatever medium, often challenge our accepted perceptions and enable us to see the world anew by representing a particular vision of "reality." Whether the artist is creating a landscape garden in Japan, a calligraphic manuscript in Persia, a museum in Berlin, a film in India, or a painting in North America, the visual art created often takes our perception of reality

and transforms it, offering a fresh perspective on the world. In the follow-ing sections of this volume, many specific examples of the visual arts will be described that show how humans continue to have their worlds remade by the power of the visual arts, much in the same way Chris Ofili chal-lenged viewers' conceptions of purity and impurity in his *Holy Virgin Mary*, as discussed in the introduction.

Relatedly, through the creation and use of myths, symbols, and rituals, religious traditions also affect our perception of reality. As has often been noted, religions create a "worldview," and if we simply turn this term around we note its visual dimension, as religions create our "view of the world." This is not merely metaphorical, since religious myths and rituals alter the actual perception of the world, as religious studies scholar William Paden suggests:

> Religions do not all inhabit the same world, but actually posit, structure, and dwell within a universe that is their own. They can be understood not just as so many attempts to explain some common, objectively available order of things that is "out there," but as traditions that create and occupy their own universe. Acknowledging these differences in place, these intrinsically dif-ferent systems of experiencing and living in the world, is fundamental to the study of religion. . . .
>
> In the broadest sense there are as many worlds as there are species; all living things select and sense "the way things are" through their own or-gans and modes of activity. They constellate the environment in terms of their own needs, sensory system, and values. They see—or smell or feel—what they need to, and everything else may as well not exist. A world, of whatever set of creatures, is defined by this double process of selection and exclusion.[4]

Thus, the study of religion runs alongside the study of visuality, creating worlds through orderings, reorderings, memories, and experiences. Seeing "religiously"—whether in a museum or mosque—alters the way we see in general: one begins to notice things they haven't noticed before; space en-larges or contracts; time moves slower or faster; and new ways of thinking are introduced into one's conceptual worldview. These effects are what continue to link religion to the visual arts, and this relationship is bound up with the operations of seeing.

With that, we enter into the strange world of the eye, tracing its rela-tionship to the mind, and exploring the perceptual interaction between human and world. At first, we need to begin with some understandings of the way vision works, and each of the excerpts given in this section will offer further insights into the amazing activity of seeing. To start, let's begin by differentiating between "vision" and "seeing." Vision, to give a simple

definition, takes place along the biochemical processes of the eyes and nerves as they transmit information about the external world to the brain. At first, light enters the eye, bringing with it the forms, distances, dimensions, colors, contrasts, and movements of the outside world. An image is then imprinted on the retina on the back of the eye and picked up by photoreceptors (cones and rods) that line the retina. There are about 120 million rods that detect contrasts in light and are most prominently in use when a minimal amount of light is available, while there are about 7 million cones that detect color and are in use during the daytime or with strong lighting. The retinal image is translated into chemicals by these two types of photoreceptors, and the chemicals are eventually translated into electrical impulses that communicate through neurons with the brain. Vision, in our cursory definition, is the material process of sensing the world through the eyes and nerves.

Seeing, in contrast, is what makes vision *meaningful*. Somewhere in the series of transfers from light to chemicals to electrical signals between the eye and the mind, a meaningful image of the world is produced. This image (which in the mind is merely a collection of electrical impulses and not a real image at all) is only fully understood by the mind when it is compared to other images and sensory experiences stored in the memory of the brain. In other words, seeing is impossible without memory and previous experiences. While the physiological activities of *vision* occur without previous experience, *seeing* cannot occur. This has led to the theory that the reason we have so few visual memories of our infancy and early childhood is because we had so little experience of the world from which to relate images and create lasting impressions. Most importantly for now, we must realize that it is not enough for us humans to have vision, we must know what it is we are looking at. Even when we do not *know* what it is we are looking at, our minds nonetheless construct meanings out of what we see. Seeing is a meaningful, world-constructing encounter.

One of the key themes that will come up again and again in the readings from this section is the fact that *seeing is a learning process*. Most newborn human babies have sight, but it takes them some time to learn how to see. This learning process will gradually involve things like being able to differentiate objects from each other; for example, learning that the humans in the baby's scope of vision are separate beings and separate from the crib in front and the wall behind—not all objects provide nourishment and love. Then later the baby will learn to attach names to objects: at first, perhaps, attaching the word "ma-ma" to one particular individual near the baby. Later, more abstract notions will be learned. For example, the term "green" (as opposed to, say, "purple") will come to be associated with the grass outside. And even later the growing human will learn how abstract

ideas are associated with specific visual symbols: a cross is associated with Christianity, a crescent moon and star are associated with Islam, and so forth.

THE READINGS

To begin to understand the role of seeing in religious traditions, we begin with a collection of readings that emphasize the constructed nature of seeing. Somewhere in the imprecise transfer of vision from eye to mind, worlds are created.

Beginning with an excerpt from Diane Ackerman, we see how vision is embedded in human life in ways that are sometimes mysterious, sometimes profound, and oftentimes mundane. Ackerman is a contemporary poet who turned her attention to the way the human body perceives the world. The result was a book entitled *A Natural History of the Senses*. The excerpt provided here, naturally enough, is an excerpt from the chapter on "Vision" where she provides physiological descriptions of the process of vision, interweaving these descriptions with poetic musings on how our vision is bound up with our most intimate relationships and identity.

Given the sheer complexities of vision (imagine, millions and millions of photoreceptors and nerve endings all trying to transmit information), it doesn't take much to see how a multitude of various ways of seeing can take place. If, for instance, we each have different hair colors, facial features, and body shapes, then it is not hard to presume we will each also see colors, forms, and movements in differing ways. Thus, Ackerman rethinks the way "visionary" Western artists such as Renoir, van Gogh, Monet, O'Keefe, and, most importantly, Cézanne, saw the world differently due to the physiological differences in their eyes. Because of "abnormalities" in their eyes (if, indeed, we can consider one particular vision to be "normal"), these artists depicted the world in ways that have seemed strange to many others, yet also in ways that have made us look again at the world around us. For whatever reasons, biological or imaginative, artists provide a renewed view of the world and allow humans to generate new meanings.

Richard Gregory is a neuropsychologist who originally wrote the introductory book, *Eye and Brain,* in 1966. Due to its popularity it has been reissued at several points and was most recently revised for its fifth edition, published in 1997 and excerpted here. By introducing the way vision functions from both psychological and physiological perspectives, Gregory outlines what he calls "the intelligent eye." The concept of the intelligent eye suggests that seeing is ultimately an activity of the mind. The mind tests various hypotheses in search of meaningful ways of understanding

what is seen. Gregory suggests: "Perception is not determined simply by the stimulus patterns; rather it is a dynamic searching for the best interpretation of the available data. . . . the senses do not give us a picture of the world directly; rather they provide evidence for checking hypotheses about what lies before us." Seeing is an interpretive action that relies on memories and experiences of the observer as the world "out there" is represented in the mind.

What is also discovered on this view is that seeing varies from culture to culture, depending on environmental factors as well as belief systems. Gregory's excerpt ends on a short note concerning the cultural relativity of seeing, suggesting many important considerations for historical, comparative studies of religion. This brief segment by Gregory is merely anecdotal here, yet it should at least be suggestive for others to pursue these matters further.

In the next excerpt James Elkins brings us further into the experience of seeing, setting up not only the relation between the observer and the object, but the whole context in which the visual interaction takes place. We travel to museums in far-off lands and are confronted with famous images (such as the *Mona Lisa*), about which we have a host of ideas already stored in our imagination. After all, most of us have seen the *Mona Lisa* on T-shirts, coffee mugs, and even reappropriated in advertisements. In other words, we see with preconceived ideas, and these preconceptions color our vision. Even if museums have built their walls separating "art" from the rest of the world, viewers do not see art in isolation, for they bring the world (*their* world) with them to the museum. Similarly, images themselves take on different meanings when placed in different contexts, an idea that finds its way into all the sections of this volume.

One of the further implications of seeing, as Elkins makes clear, is that the object looked at affects the observer. The object may have different meanings in different settings, but the observer, too, is under constant transformation. Images, even if inert conglomerations of oil and canvas, exert power over the observers. This notion led Elkins to title his book *The Object Stares Back,* implying that seeing is always a two-way process, and that the observer is changed in the interaction. In this two-way interaction between observer and object, the sacred and profane are also oftentimes crossed, as are the differences between "high" art and "low" art.

To conclude this section, the final excerpt by Stan Brakhage takes the notion that seeing is learned and applies it to the vocation of the artist as well as the "saint." If seeing is relative to physiological, psychological, and environmental factors, then it is also possible to create new visions that stimulate humans to *see differently.* Brakhage is an avant-garde filmmaker from the United States who experiments with filmic images, challenging

his viewers to see shapes, colors, light, and motion in new ways. He has experimented with film much in the way that Impressionists and Post-Impressionists experimented with paint and canvas; he breaks images down into visual elements of light, contrast, and color, and makes the viewer aware of the media of art as well as the intermediaries of perception. There is a possibly apocryphal story about Brakhage that tells of a revelation he had while still a student at Dartmouth College in the late 1950s: at the moment he decided he wanted to make films, he threw away his eyeglasses, refusing to have his "natural" vision molded into a standard, "20–20" way of seeing. His films similarly reject a standardized form of filmmaking and viewing.

The excerpt below follows in this vein by inspiring filmmakers and filmviewers to an "adventure of perception," where we might "imagine a world before the 'beginning was the word.'" The excerpt is something of a mystical manifesto (with intentionally difficult-to-follow sentences), for filmmakers to endlessly experiment with the equipment they have, using it to create new myths and symbols for a new age. While human interests may remain the same—"birth, sex, death, and the search for God"—there are ever-new ways to deal with these subjects. Meanwhile, for Brakhage the cinematic experience simultaneously becomes a religious experience. He challenges the makers and viewers of films to a heightened awareness of the lights, forms, textures, and movements of film, and simultaneously to a greater visual perception of the world surrounding us.

Notes

1. Terry Eagleton, *The Ideology of the Aesthetic* (Oxford: Basil Blackwell, 1990), 13. The initial development of the field of aesthetics, Eagleton further states in an excellent phrase, "is thus the first stirrings of a primitive materialism—of the body's long inarticulate rebellion against the tyranny of the theoretical" (ibid).
2. Ibid. This was also something of Merleau-Ponty's aesthetic project, developing what he labeled the "aesthesiological body," in which ideas and sensations stream forth together in the body. See "The Chiasm," in *The Visible and the Invisible,* trans. Alphonso Lingis (Evanston, IL: Northwestern University Press, 1967). For an interesting recent move also in this direction, see Richard Shusterman's *Performing Live: Aesthetic Alternatives for the Ends of Art* (Ithaca, NY: Cornell University Press, 2000).
3. James Elkins, *The Object Stares Back: On the Nature of Seeing* (New York: Simon & Schuster, 1996), 11–12.
4. William Paden, *Religious Worlds* (Boston: Beacon Press, 1988), 51, 52.

Diane Ackerman, from "Vision," in *A Natural History of the Senses*

THE BEHOLDER'S EYE

Look in the mirror. The face that pins you with its double gaze reveals a chastening secret: you are looking into a predator's eyes. Most predators have eyes set right on the front of their heads, so they can use binocular vision to sight and track their prey. Our eyes have separate mechanisms that gather the light, pick out an important or novel image, focus it precisely, pinpoint it in space, and follow it; they work like top-flight stereoscopic binoculars. Prey, on the other hand, have eyes at the sides of their heads, because what they really need is peripheral vision, so they can tell when something is sneaking up behind them. Something like us. If it's "a jungle out there" in the wilds of the city, it may be partly because the streets are jammed with devout predators. Our instincts stay sharp, and, when necessary, we just decree one another prey and have done with it. Whole countries sometimes. Once we domesticated fire as if it were some beautiful temperamental animal; harnessing both its energy and its light, it became possible for us to cook food to make it easier to chew and digest, and, as we found out eventually, to kill germs. But we can eat cold food perfectly well, too, and did for thousands of years. What does it say about us that, even in refined dining rooms, our taste is for meat served at the temperature of a freshly killed antelope or warthog?

Though most of us don't hunt, our eyes are still the great monopolists of our senses. To taste or touch your enemy or your food, you have to be unnervingly close to it. To smell or hear it, you can risk being farther off. But vision can rush through the fields and up the mountains, travel across time, country, and parsecs of outer space, and collect bushel baskets of information as it goes. Animals that hear high frequencies better than we do—bats and dolphins, for instance—seem to see richly with their ears,

hearing geographically, but for us the world becomes most densely informative, most luscious, when we take it in through our eyes. It may even be that abstract thinking evolved from our eyes' elaborate struggle to make sense of what they saw. Seventy percent of the body's sense receptors cluster in the eyes, and it is mainly through seeing the world that we appraise and understand it. Lovers close their eyes when they kiss because, if they didn't, there would be too many visual distractions to notice and analyze—the sudden close-up of the loved one's eyelashes and hair, the wallpaper, the clock race, the dust motes suspended in a shaft of sunlight. Lovers want to do serious touching, and not be disturbed. So they close their eyes as if asking two cherished relatives to leave the room.

Our language is steeped in visual imagery. In fact, whenever we compare one thing to another, as we constantly do (consider the country expression: "It was raining harder than a cow pissing sideways on a rock"), we are relying on our sense of vision to capture the action or the mood. Seeing is proof positive, we stubbornly insist ("I saw it with my own eyes . . ."). Of course, in these days of relativity, feats of magic, and tricks of perception, we know better than to trust everything we see (" . . . a flying saucer landed on the freeway . . ."). See with our naked eyes, that is. As Dylan Thomas reminds us, there are many "fibs of vision." If we extend our eyes by attaching artificial lenses and other accessories to our real ones (glasses, telescopes, cameras, binoculars, scanning electron microscopes, CAT scans, X-rays, magnetic resonance imaging, ultrasound, radioisotope tracers, lasers, DNA sequencers, and so on), we trust the result a little more.
[. . .]

THE PAINTER'S EYE

In his later years, Cézanne suffered a famous paroxysm of doubt about his genius. Could his art have been only an eccentricity of his vision, not imagination and talent guarded by a vigilant esthetic? In his excellent essay on Cézanne in *Sense and Nonsense,* Maurice Merleau-Ponty says: "As he grew old, he wondered whether the novelty of his painting might not come from trouble with his eyes, whether his whole life had not been based upon an accident of the body." Cézanne anxiously considered each brush stroke, striving for the fullest sense of the world, as Merleau-Ponty describes so well:

> We *see* the depth, the smoothness, the softness, the hardness of objects; Cézanne even claimed that we see their odor. If the painter is to express the world, the arrangement of his colors must carry with it this invisible whole, or else his picture will only hint at things and will not give them in the im-

perious unity, the presence, the insurpassable plenitude which is for us the definition of the real. That is why each brush stroke must satisfy an infinite number of conditions. Cézanne sometimes pondered for hours at a time before putting down a certain stroke, for, as Bernard said, each stroke must "contain the air, the light, the object, the composition, the character, the outline, and the style." Expressing what *exists* is an endless task.

Opening up wide to the fullness of life, Cézanne felt himself to be the conduit where nature and humanity met—"The landscape thinks itself in me . . . I am its consciousness"—and would work on all the different sections of a painting at the same time, as if in that way he could capture the many angles, half-truths, and reflections a scene held, and fuse them into one conglomerate version [see fig. 1.1]. "He considered himself powerless," Merleau-Ponty writes, "because he was not omnipotent, because he was not God and wanted nevertheless to portray the world, to change it completely into a spectacle, to make *visible* how the world *touches* us." When one thinks of the masses of color and shape in his paintings, perhaps it won't come as a surprise to learn that Cézanne was myopic, although he refused glasses, reputedly crying "Take those vulgar things away!" He also suffered from diabetes, which may have resulted in some retinal damage, and in time he developed cataracts (a clouding of the clear lens). Huysmans once captiously described him as "An artist with a diseased retina, who, exasperated by a defective vision, discovered the basis of a new art." Born into a different universe than most people, Cézanne painted the world his slightly askew eyes saw, but the random chance of that possibility gnawed at him. The sculptor Giacometti, on the other hand, whose long, stretched-out figures look as consciously distorted as one could wish, once confessed amiably: "All the critics spoke about the metaphysical content or the poetic message of my work. But for me it is nothing of the sort. It is a purely optical exercise. I try to represent a head as I see it."

Quite a lot has been learned in recent years about the vision problems of certain artists, whose eyeglasses and medical records have survived. Van Gogh's "Irises" sold at Christies in 1988 for forty-nine million dollars, which would surely have amused him, since he sold only one painting during his lifetime. Though he was known for cutting off his ear, van Gogh also hit himself with a club, went to many church services each Sunday, slept on a board, had bizarre religious hallucinations, drank kerosene, and ate paint. Some researchers now feel that a few of van Gogh's stylistic quirks (coronas around streetlamps, for instance) may not have been intentional distortions at all but the result of illness, or, indeed, of poisoning from the paint thinners and resins he used, which could have damaged his eyes so that he saw halo effects around light sources. According to Patrick

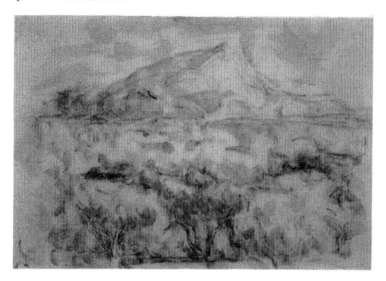

Fig. 1.1 Paul Cézanne, Mount Sainte-Victoire. 1905–1906. Watercolor on paper, 36.2 x 54.9 cm. For the last two decades of his life, Cézanne repeatedly painted this mountain near his home in Aix-en-Provence, re-presenting it from different perspectives and under different light conditions. Courtesy of the Tate Gallery, London/Art Resource, New York.

Trevor-Roper, whose *The World Through Blunted Sight* investigates the vision problems of painters and poets, some of the possible diagnoses for van Gogh's depression "have included cerebral tumour, syphilis, magnesium deficiency, temporal lobe epilepsy, poisoning by digitalis (given as a treatment for epilepsy, which could have provoked the yellow vision), and glaucoma (some self-portraits show a dilated right pupil, and he depicted colored haloes around lights)." Most recently, a scientist speaking before a meeting of neurologists in Boston added Geschwind's syndrome, a personality disorder that sometimes accompanies epilepsy. Van Gogh's own doctor said of him: "Genius and lunacy are well known next-door neighbors." Many of those ailments could have affected his vision. But, equally important, the most brilliant pigments used to include toxic heavy metals like copper, cadmium, and mercury. Fumes and poisons could easily get into food, since painters frequently worked and lived in the same rooms. When the eighteenth-century animal painter George Stubbs went on his honeymoon, he stayed in a two-room cottage, in one room of which he hung up the decaying carcass of a horse, which in free moments he studiously dissected. Renoir was a heavy smoker, and he probably didn't

bother to wash his hands before he rolled a cigarette; paint from his fingers undoubtedly rubbed onto the paper. Two Danish internists, studying the relationship between arthritis and heavy metals, have compared the color choices in paintings by Renoir, Peter Paul Rubens, and Raoul Dufy (all rheumatoid arthritis sufferers), with those of their contemporaries. When Renoir chose his bright reds, oranges, and blues, he was also choosing big doses of aluminum, mercury, and cobalt. In fact, up to 60 percent of the colors Renoir preferred contained dangerous metals, twice the amount used by such contemporaries of his as Claude Monet or Edgar Degas, who often painted with darker pigments made from safer iron compounds.

According to Trevor-Roper, there is a myopic personality that artists, mathematicians, and bookish people tend to share. They have "an interior life different from others," a different personality, because only the close-up world is visually available to them. The imagery in their work tends to pivot around things that "can be viewed at very close range," and they're more introverted. Of Degas's myopia, for example, he says:

> As time passed he was often reduced to painting in pastel rather than oil as being an easier medium for his failing sight. Later, he discovered that by using photographs of the models or horses he sought to depict, he was able to bring these comfortably within his limited focal range. And finally he fell back increasingly on sculpture where at least he could be sure that his sense of touch would always remain true, saying, "I must learn a blind man's trade now," although he had always in fact had an interest in modeling.

Trevor-Roper points out that the mechanism which causes shortsightedness (an elongated eye) affects perception of color as well (reds will appear more starkly defined); cataracts, especially, may affect color, blurring and reddening simultaneously. Consider Turner, whose later paintings Mark Twain once described as "like a ginger cat having a fit in a bowl of tomatoes." Or Renoir's "increasing fascination for reds." Or Monet, who developed such severe cataracts that he had to label his tubes of paint and arrange colors carefully on his palette. After a cataract operation, Monet is reported by friends to have been surprised by all the blueness in the world, and to have been appalled by the strange colors in his recent work, which he anxiously retouched.

One theory about artistic creation is that extraordinary artists come into this world with a different way of seeing. That doesn't explain genius, of course, which has so much to do with risk, anger, a blazing emotional furnace, a sense of esthetic decorum, a savage wistfulness, lidless curiosity, and many other qualities, including a willingness to be fully available to life, to pause over both its general patterns and its ravishing details. As the

robustly sensuous painter Georgia O'Keeffe once said: "In a way, nobody sees a flower really, it is so small, we haven't time—and to see takes time, like to have a friend takes time." What kind of novel vision do artists bring into the world with them, long before they develop an inner vision? That question disturbed Cézanne, as it has other artists—as if it made any difference to how and what he would end up painting. When all is said and done, it's as Merleau-Ponty says: "*This work to be done called for this life.*"

Richard L. Gregory, from *Eye and Brain: The Psychology of Seeing*

The eye is a simple optical instrument. With internal images projected from objects in the outside world, it is Plato's cave with a lens. The brain is the engine of understanding. There is nothing closer to our intimate experiences, yet the brain is less understood and more mysterious than a distant star.

We have only to open our eyes, and spread before us lies a banquet of colors and shapes, shadows, and textures: a pageant of rewarding and threatening objects, miraculously captured by sight. All this, from two tiny distorted upside-down patterns of light in the eyes. Seeing is so familiar, apparently so easy, it takes a leap of imagination to appreciate that the eyes set extremely difficult problems for the brain to solve for seeing to be possible. How does it work? How are ghostly images transformed into appearance of solid objects, lying in an outer world of space and time?

From the beginnings of recorded questioning there have been several approaches to how we see. These are very different from current views. An essential problem was how distant objects reached eye and brain, while remaining out there in space. Two and one-half millennia ago, Greek philosophers thought that light shoots out of the eyes, to touch objects as probing fingers. A different notion at that time was that objects have expanding "shells" like ripples from a stone dropped on a pool, but maintaining the object's shape to great distances. Called "sense data" until quite recently by philosophers, they were supposed to be intermediaries—neither matter nor mind—between objects and perceptions. Both of these ideas were serious candidates before it was realized that in the eyes there are images of light, optically projected from the outside world onto the screens of the retinas. Optical images were unknown before the tenth century, and not until the start of the seventeenth were images discovered in eyes. At last it became clear that light does not enter or leave the brain, locked privily in its box of bone. All the brain receives

are minute electrochemical pulses of various frequencies, as signals from the senses. The signals must be read by rules and knowledge to make sense. Yet what we see, and what we *know*, or believe, can be very different. As science advances, differences between perceived appearances and accepted realities become ever greater.

[. . .]

THE INTELLIGENT EYE

This philosophy, or paradigm, is largely derived from Helmholtz. It is that visual and other perception is intelligent decision-taking, from limited sensory evidence. The essential point is that sensory signals are not adequate for direct or certain perceptions; so intelligent guessing is needed for seeing objects. The view taken here is that perceptions are predictive, never entirely certain, *hypotheses* of what may be out there.

It was, perhaps, the active intelligence of perception that was the evolutionary start of conceptual problem-solving intelligence. When, a generation before Freud, Helmholtz called perceptions unconscious inferences he was much criticized—for how could blame or praise be applied to unconscious perceptions and actions? We are still puzzled by these issues.

There are many traps along the way of exploring Eye and Brain. It is important to avoid the temptation of thinking that eyes produce pictures in the brain which are perceptions of objects. The pictures-in-the-brain notion suggests an internal eye to see them. But this would need a further eye to see *its* picture—another picture, another eye—and so on forever, without getting anywhere. Early this century, the Gestalt psychologists held that perceptions were pictures inside the brain: supposed electrical brain fields copying forms of objects. So a circular object would produce a circular brain field. Presumably a house would have a house-shaped electrical brain-picture, though this is far less plausible. A green object having a green brain-trace is ridiculous. This notion, known as isomorphism, led to supposing that properties of brain fields produce visual distortions (like bubbles tending to be spherical), visual phenomena being explained by their supposed mechanical or electrical properties. There is no evidence for isomorphic brain traces.

We now think of the brain as *representing,* rather as the symbols of language represent characteristics of things, although the shapes and sounds of language are quite different from whatever is being represented. Language requires *rules* of grammar (syntax), and *meanings* of symbols (semantics). Both seem necessary for processes of vision; though its syntax and semantics are implicit, to be discovered by experiment.

Some puzzles of vision disappear with a little thought. It is no special problem that the eyes' images are upside down and optically right-left reversed—for they are not seen, as pictures, by an inner eye. As the image is not an object of perception, it does not matter that it is inverted. The brain's task is not to see retinal images, but to relate signals from the eyes to objects of the external world, as essentially known by touch. Exploratory touch is very important for vision, it matters that touch-vision relations remain unchanged. When changed experimentally (with optically reversing prisms, or lenses or mirrors) then a problem is set up, and special learning is required. No special learning is needed for a baby to see the world the right way up.

[. . .]

If the brain were not continually trying out organizations of data, or searching for objects, such as faces, the cartoonist would have a hard time. In fact all he or she has to do is to present a few well-chosen lines and we see a face, complete with an expression. This essential process of vision can, however, go over the top to make us see faces in the fire, galleons in the clouds, or the Man in the Moon. Vision is certainly not infallible. This is largely because knowledge and assumptions add so much that vision is not directly related to the eyes' images or limited by them—so quite often it produces fictions. This can be useful, as images are inherently inadequate, but visual fictions, and other illusions, worry philosophers seeking certainty from sight.

How did such complex processes for representing things start? What is their evolutionary benefit? For simple organisms, the eyes' signals do initiate behavior quite directly. Thus tropisms toward or away from light may serve to find protection or food in typical conditions, without the creature being capable of making decisions between alternative courses of action. We might say that primitive organisms are almost entirely controlled—tyrannized—by tropisms and reflexes. Many reflexes still protect us (such as blinking to a puff of air on the eye, or to a sudden loud sound) and reflexes are essential for the maintenance of body functions such as breathing and digestion. But gradually, through evolution, direct control from outside objects has been largely replaced by more and more indirect representations of objects and situations. This has the huge advantage that behavior can be appropriate to properties of objects that are not and often cannot be signaled by the senses. Thus we pick up a glass to drink not simply from stimuli, but from knowledge of glasses, and what they may contain. By contrast, a frog surrounded by dead flies will starve to death, for though they are edible it does not see them, as they do not move.

These brain representations are far more than pictures. They include information of what various kinds of objects may do, or be used for. For

behavior to be appropriate in a wide variety of situations requires a great deal of knowledge of the world. Knowledge must be selected and accessed within a fraction of a second to be useful for perception, or the moment for action (or survival) will pass. So the intelligence of vision works much faster than other problem solving. This may be why perceptions are quite surprisingly separate from generally more abstract conceptions, and may disagree. Thus, one experiences an illusion, though one knows it is an illusion and even what causes it. Illusions tell us a great deal—sometimes, as I shall show, more than we would wish to know!

Here, I have introduced the kind of approach to vision which is developed in this book. This may be called an *indirect* and *active* account. Not all authorities will agree with it. The alternative—that perceptions are directly from the external world—was argued most strongly by the American psychologist James J. Gibson (1904–1979), at Cornell University. His experimental work, especially on moving and stationary gradients for depth perception, is justly celebrated. Gibson considered that seen depth and form are determined by patterns such as these, from what he calls the "ambient optical array" of light. Gibson's theory is a kind of realism, in which perceptions are supposed to be "picked up" from the world, rather than created as representations. Realism has always been attractive to philosophers, as it promises reliable perception, and so unquestionable bases for empirical knowledge. Given retinal images, and the complexities of the physiology of vision, as well as the richness of illusion, it is hard to see how this can be literally true. Gibson's essentially *passive* account is very different from the notion in this book, that perceptions are constructed hypotheses.

Phenomena of illusion are played down as embarrassments by *direct* theorists such as Gibson, but are grist to the mill, and evidence for, knowledge-based processes of perception. But if past experience, assumptions, and active processing are important, there can hardly be raw data for vision. Rather, we might say that perceptual data are cooked, by processes we shall look at here in considerable detail.

PERCEPTIONS AS HYPOTHESES

[. . .]

A central notion here is that perceptions are *hypotheses*. This is suggested by the fact that retinal images are open to an infinity of interpretations, and from the observed phenomena of ambiguity [fig. 1.2]. The notion is that perceptions are like the predictive hypotheses of science. Hypotheses of perception and of science are risky, as they are predictive and they go beyond sensed evidence to hidden properties and to the future. For percep-

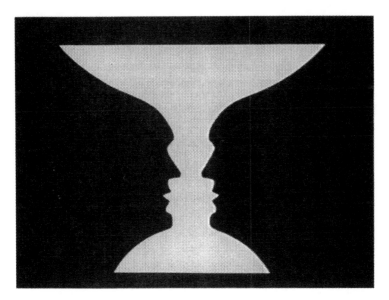

Fig. 1.2 "Face-Vase" optical illusion. Such "ambiguous figures" suggest the interpretive, hypothesizing work necessary to make meaning out of an image. Here, the mind goes back and forth between seeing two black faces (with white as the background) and seeing a white vase (now with black as the background).

tion, as for science, both kinds of prediction are vitally important because the eye's images are almost useless for behavior until they are read in terms of significant properties of objects, and because survival depends on behavior being appropriate to the immediate future, with no delay, although eye and brain take time to respond to the present. We behave to the present by anticipation of what is likely to happen, rather than from immediate stimuli.

Seeing a table, what the eye actually receives is a grainy pattern which is read as wood—though it might be a plastic imitation, or perhaps a picture. Once the *wood* hypothesis is selected, behavior is set up appropriately. People who live with plastic tables pretending to be wood do terrible damage to mahogany! Science and perception work by knowledge and rules, and by analogies. [. . .]

The visual brain has the same kind of problem for accepting or rejecting evidence from patterns of photons in the eyes. Seeing objects involves general rules, and knowledge of objects from previous experience, derived largely from active hands-on exploration.

A central theme of this book is that perceptions are much like hypotheses of science. Hypotheses of science do not only have ambiguities; they can also have or produce distortions, paradoxes, or fictions. It is interesting that all of these can appear as phenomena of perception. For under various conditions which can be set up and investigated, as well as in normal life, we can see distortions, paradoxes and fictions. With ambiguities, these turn out to be key phenomena for investigating and understanding perception.

The big difference between hypotheses of science and perceptual hypotheses is that only perceptions have consciousness.

What is so special about human vision? We learn a lot from observing other animals; but only humans can draw or paint representations, and only humans have a structured language. It turns out that both pictures and language depend on imaginative use of ambiguities.

Our early human ancestors were able to represent and see mammoths and bison in sketchy lines and blodges on cave walls. It was presentations of alternative realities, and playing with fantasies through ambiguities, that released mankind from the tyranny of reflexes and tropisms of our distant ancestors. So humans took off from nature, into evocative art and questioning science, making civilization possible.

[. . .]

CULTURAL DIFFERENCES

Do people brought up in different environments come to see differently? The Western world has visual environments with many straight parallel lines, such as roads, and right-angular corners of buildings and furniture and so on. These are strong, generally reliable perspective cues to distance. We may ask whether people living in other environments where there are few right angles and few long parallel lines have somewhat different perception. Fortunately several studies have been made of people living in such environments.

Those who stand out as living in a non-perspective world were the Zulus. Their world has been described as a "circular culture"—traditionally their huts were round, they did not plough their land in straight furrows, but in curves, and few of their possessions had corners or straight lines. [. . .]

Studies of people living in dense forest have also been made. Such people are interesting in that they do not see many distant objects, because they live in quite small clearances in the forest. When they are taken out of their forest, and shown distant objects for the first time, they see these not as far away but as small. (They have even reported that cattle look like

insects.) People living in Western cultures experience similar distortion when looking down from a height. From a tall building, objects look much too small. Steeplejacks, and men who work on the scaffolding and girder structure of skyscrapers, are reported to see objects below them without this distortion. Again, active movement and handling of objects seem to be very important for calibrating the visual system.

James Elkins, from *The Object Stares Back: On the Nature of Seeing*

What is seeing, then? Even though I can't just look, can't I simply see? Isn't there such a thing as mere biological sensation, so that my eyes might be technically considered just as passive recipients of phenomena, like my tongue or my ears? In a scientific sense, aren't my eyes just tools, like a blind man's cane or a carpenter's tape measure? But as soon as I start asking questions this way, comparing one sense to another as an eighteenth-century philosopher would have, the answers get thrown back in my face. My ears are anything but passive recipients of noise. Out of the buzzing continuum of sounds I listen for certain things: I am acutely sensitive to voices, to rhythmic tappings that might be footsteps, to whistles, howls, shrieks, creaks, and whines. I am capable of entirely ignoring whole ranges of sound: in an airport I scarcely hear the jets, and when I'm cleaning house I don't even think of the deafening vacuum cleaner. The photoreceptors in my eyes have evolved so that they are acutely sensitive to single bursts of energy twinkles of light from a department store display, or a momentary glimpse of a moving face—but the cells in my ears have evolved so that they can sift prolonged, faint signals from the world's constant random background noise. That's the scientific way of putting it, and it implies my ears are specialized: they don't just pick up everything, but they actively search. The same could be said about my tongue, or my fingertips, or the blind man's cane.

Once I wanted to write a book with the title *The Observer Looks at the Object*. It would have been an academic exercise, designed to destroy its own title, to tear it apart and show how little sense it makes. The idea was to begin with the least objectionable, most elementary sentence describing the rudimentary facts of vision: after all, there has to be an observer, something to be observed, and an action such as looking. From what I've been writing so far, it already seems that the sentence says too little, as if it meant, "The observer *just* looks at the object," or as if it were only half a

sentence and would need to give its reason: "The observer looks at the object *in order to* do something or get something."

Originally what I liked about the idea of dismantling the sentence was that it would seem the work was finished as soon as the word "looks" no longer sounded right. But I think there's much more wrong here. The whole sentence is suspect: there is no such thing as just looking, and there is also no such thing as an object that is simply looked at by something else called an observer. Looking is much too complex to be reduced to a formula that has a looking subject and a seen object. If I observe attentively enough, I find that my observations are tangled with the object, that the object is part of the world and therefore part of me, that looking is something I do but also something that happens to me—so that the neat architecture of the sentence becomes a morass.

Paintings are an interesting example, since we often think of them as isolated objects: there is the *Mona Lisa,* protected by its glass shields, cordoned off from people and placed apart from the other paintings in its room in the Louvre. There is the "sofa painting" hanging by itself on the white wall. There is the picture that is up above my desk as I type this. (It's a ferocious battle scene of swimming centaurs and demure mermaids clubbing one another with bones and sticks.) Paintings seem to be exempt from the world, as if their frames were parentheses letting the text of the world flow on around them, or little fences keeping the picture from straying into the world.

But objects do not exist one by one in isolation, so that an observer could look at *just one* object. My picture of enraged centaurs looked quite different when it was in the bedroom, hanging over the bed—then it seemed to be more of a romantic fable and less of a story about hard work and fighting. I noticed that the centaurs seemed to protect the nereids and that it was really a love battle. Now, when it's over my desk, I tend to look at the clubs and sticks. The *Mona Lisa* would turn into a diva if she were hung in the Paris opera, and if she were hung in the Paris Métro she would look like a homeless person, wrapped in rags. The room in the Louvre that houses the *Mona Lisa* is transformed by her presence. The painting and its case are like a reliquary or an altar, and they make the room function like a little church. People line up to see it like worshipers waiting for the Eucharist. The other paintings look somehow less sacred, which is odd, considering that the *Mona Lisa* is not a religious work and the room contains several wonderful religious images.

For the same reasons, a movie in a suburban theater is different from the same movie in an inner-city theater. I saw John Carpenter's *The Thing* in a huge old theater in downtown Chicago that has since been destroyed. It was a deep, cavernous space, decorated in faux-Baroque shields, twisting

columns, parapets, and plaster statues. There was garbage under the seats, and people were talking and lobbing popcorn across the aisles. The sound was turned way up so that it could be heard over the noise. The people who were watching would yell at the screen, as if they were helping the hero:

"Look out!"

"Oh, my God, you idiot!"

"Don't look in there!"

Later I saw the same movie in an affluent suburban shopping mall. It was the kind of theater in which the cheapest available purple polyester curtains covered cinder-block walls painted in blue enamel. The audience was stony and silent, as if they were trying hard to scare themselves. Afterward they left grumbling and snickering. In effect, I have seen two movies: one that is mingled in my mind with a fusty ancient theater, with noises and smells and interruptions, and another that I remember along with a slightly cold, cryptlike space that smelled like a new car. There is no such thing as the movie *The Thing* in my mind apart from those two experiences.

This painting [fig. 1.3], which has the traditional title *Icon with the Fiery Eye,* is in a church in Moscow; but it also exists in many different sizes and shapes on postcards and in books, including this one. Each one is a different face. Even the reproduction will change, depending on where you are right now as you're reading this. It will look different if you're on a sofa, or eating, or reading in bed. (I was once told not to look at religious images in the bathtub. Presumably that was because I could see holy bodies and my own body at the same time, but I was never quite sure why that was bad.) Each time you glance at this picture it will mean something slightly different. At first it might be just a picture of Jesus, and then on second look it might seem oddly frowzy or troubled (at least that's the way it looked to me at one point, since it is not the symmetric face found in many icons). Then you might notice the cracks and flaws, and it may suddenly seem ancient. On later inspections you might take note of the single curl on the forehead, and the face might become a little more human. If you're reading these sentences in between glances at the picture, you're also mingling memories of the text with changing images of the *Icon with the Fiery Eye.* After a few moments, you might decide to give it a really thorough look and let its strange, surprised expression bear down on you in full force. After a long look at something, I usually shift my position a little or scratch my head. And each move I make moves the image in my mind. If you get a slight crick in your neck and press your hand over it, the icon might take on a subtle undertone of discomfort. If you're lying in a bubble bath, that furrowed brow might look a little more relaxed and a

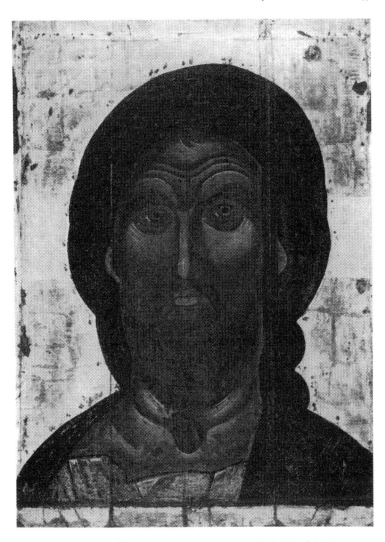

Fig. 1.3 Icon with the Fiery Eye, *Fourteenth century. Cathedral of the Dormition, Moscow.*

bit less puzzled. In the end, when you've seen it enough and it's time to move on, the image will be quite complex—a kaleidoscope of thoughts and images that coalesce from all the individual moments that you spent thinking and looking. Many people in my profession are attracted to a beautiful, bloody picture by the Renaissance painter Titian that hangs in a small town in Slovakia. I have never seen that painting, and I probably never will; but I have learned to love it by looking at reproductions in books. My idea of the picture is composed of all those reproductions, in black-and-white, in color, and in slides, together with all the remembered and half-remembered things I've read and heard.

[. . .]

How can the observer look at the object if it is multiplying and changing under his very eyes? The supposedly static object is a moving target, like the exit door in a hall of mirrors. In a good hall of mirrors, the exit cannot be seen at all, and it seems there is no way out and then a moment later, with a slight change in position, there are nothing but exit doors wherever you look. Some of them are only half-visible, and you can't get a clear look at them. Others send out curving streamers, copying themselves into infinity. The elusive exit door is the analogue to the fixed object. Any object dissolves and shatters itself if it's seen too long or sought for too carefully. Perhaps "the observer looks at the object" should be "the observer looks *for* the object" or "the observer looks *among the objects.*"

And all this so far supposes there is an observer. We need to think this, even when we have given up the idea that looking is straightforward or that objects are stable. I need to think that I am the one doing the looking and sifting one version of an object from the next. But what if I were changing along with the objects? What if the sentence were "The *observers*"—the multiple moments of myself—"look among the objects"?

I am not a member of the Eastern Orthodox Church—I'm not among the intended viewers of this icon—but since I'm an art historian I am used to looking at images like this. If I were Hindu or Parsee or Navajo, the face would lose the aura that any Westerner senses in Judeo-Christian images. Even if you are Eastern Orthodox, born and raised in Russia (where this icon was made seven centuries ago), the icon will look quite different if you've just been to the Eucharist, or if you're about to stop reading and go to the Eucharist, or if you've just skipped the Eucharist and you're feeling guilty.

In European churches it happens that local worshipers walk right by "important" paintings and sculptures and kneel in front of "unimportant" images instead. In a church in Italy, I saw a crowd of townspeople gathered in front of an altar that had a cheap, Holiday Inn-style painting and a plastic baby-doll Jesus draped with Christmas lights. Less than twenty feet

away was one of the masterpieces of Western art, supposedly full of noble and uplifting religious feeling. In both chapels the Christ Child glowed with the light of the new Sun: in the "important" painting, his body was mysteriously luminescent, and it cast a daunting cold light on Mary and Joseph. The plastic doll in the other chapel had a bulb inside it that made it look like a tacky novelty light. On the afternoon I was there, the worshipers ignored the painting as completely as the tourists ignored the plastic doll. How can I begin to understand the people who would rather worship a novelty light? What do they see? And for my part, could I ever worship the painting? And what do I fail to see when I lecture about the masterpiece as an example of the art of painting? These are the kinds of questions that art history professors have a great deal of difficulty in answering. In the art historical textbooks that discuss this church, there is no mention of the plastic Jesus, and I doubt there are any books on it except perhaps some tongue-in-cheek study of postmodern culture. People who worship the plastic Jesus do just that, and often only that and they do not write books or give lectures. And we are no less guilty of failing to speak about our own ways of seeing: our own irreligion, our assumptions about what is of interest.

[. . .]

No two people will see the same object: that's a truism that is proved each time two artists try to draw the same object and end up with two irreconcilable versions of it. What makes it more than a common truth is that it applies just as well *within* a single person. I am divided, and at times my modes of seeing are so distinct from one another that they could belong to different people. At other moments they coalesce, but I am normally aware that differing viewpoints collide in the ways I see. Within limits, I do not *want* to see things from a single point of view: I hope to be flexible, to think in as liquid a way as I can, and even to risk incoherence. And above all, I want to continue to change—I do not wish to remain the same jaded eye that I was a moment ago. Art is among the experiences I rely on to alter what I am.

Stan Brakhage, from "Metaphors on Vision"

Imagine an eye unruled by man-made laws of perspective, an eye unprej-
udiced by compositional logic, an eye which does not respond to the name
of everything but which must know each object encountered in life
through an adventure of perception. How many colors are there in a field
of grass to the crawling baby unaware of "Green?" How many rainbows
can light create for the untutored eye? How aware of variations in heat
waves can that eye be? Imagine a world alive with incomprehensible ob-
jects and shimmering with an endless variety of movement and innumer-
able gradations of color. Imagine a world before the "beginning was the
word."

To see is to retain—to behold. Elimination of all fear is in sight—which
must be aimed for. Once vision may have been given—that which seems
inherent in the infant's eye, an eye which reflects the loss of innocence
more eloquently than any other human feature, an eye which soon learns
to classify sights, an eye which mirrors the movement of the individual to-
ward death by its increasing inability to see.

But one can never go back, not even in imagination. After the loss of
innocence, only the ultimate of knowledge can balance the wobbling
pivot. Yet I suggest that there is a pursuit of knowledge foreign to language
and founded upon visual communication, demanding a development of
the optical mind, and dependent upon perception in the original and
deepest sense of the word.

Suppose the Vision of the saint and the artist to be an increased ability
to see—vision. Allow so-called hallucination to enter the realm of percep-
tion, allowing that mankind always finds derogatory terminology for that
which doesn't appear to be readily usable, accept dream visions, day-
dreams or night-dreams, as you would so-called real scenes, even allowing
that the abstractions which move so dynamically when closed eyelids are
pressed are actually perceived. Become aware of the fact that you are not
only influenced by the visual phenomenon which you are focused upon
and attempt to sound the depths of all visual influence. There is no need

for the mind's eye to be deadened after infancy, yet in these times the development of visual understanding is almost universally forsaken.

This is an age which has no symbol for death other than the skull and bones of one stage of decomposition . . . and it is an age which lives in fear of total annihilation. It is a time haunted by sexual sterility yet almost universally incapable of perceiving the phallic nature of every destructive manifestation of itself. It is an age which artificially seeks to project itself materialistically into abstract space and to fulfill itself mechanically because it has blinded itself to almost all external reality within eyesight and to the organic awareness of even the physical movement properties of its own perceptibility. The earliest cave paintings discovered demonstrate that primitive man had a greater understanding than we do that the object of fear must be objectified. The entire history of erotic magic is one of possession of fear thru the beholding of it. The ultimate searching visualization has been directed toward God out of the deepest possible human understanding that there can be no ultimate love where there is fear. Yet in this contemporary time how many of us even struggle to deeply perceive our own children?

The artist has carried the tradition of vision and visualization down through the ages. In the present time a very few have continued the process of visual perception in its deepest sense and transformed their inspirations into cinematic experiences. They create a new language made possible by the moving picture image. They create where fear before them has created the greatest necessity. They are essentially preoccupied by and deal imagistically with—birth, sex, death, and the search for God.

CAMERA EYE

Oh transparent hallucination, superimposition of image on image, mirage of movement, heroine of a thousand and one nights (Scheherazade must surely be the muse of this art), you obstruct the light, muddie the pure white beaded screen (it perspires) with your shuffling patterns. Only the spectators (the unbelievers who attend the carpeted temples where coffee and paintings are served) think your spirit is in the illuminated occasion (mistaking your sweaty, flaring, rectangular body for more than it is). The devout, who break popcorn together in your humblest double-feature services, know that you are still being born, search for your spirit in their dreams, and dare only dream when in contact with your electrical reflection. Unknowingly, as innocent, they await the priests of this new religion, those who can stir cinematic entrails divinely. They await the prophets who can cast (with the precision of Confucian sticks) the characters of this new order across filmic mud. Being innocent, they do not consciously

know that this church too is corrupt; but they react with counter halluci-
nations, believing in the stars, and cast themselves among these Los Angelia
orders. Of themselves, they will never recognize what they are awaiting.
Their footsteps, the dumb drum which destroys cinema. They are having
the dream piped into their homes, the destruction of the romance thru
marriage, etc.

So the money vendors have been at it again. To the catacombs then,
or rather plant this seed deeper in the undergrounds beyond false nour-
ishing of sewage waters. Let it draw nourishment from hidden uprising
springs channeled by gods. Let there be no cavernous congregation but
only the network of individual channels, that narrowed vision which splits
beams beyond rainbow and into the unknown dimensions. (To those who
think this is waxing poetic, squint, give the visual objects at hand their
freedom, and allow the distant to come to you; and when mountains are
moving, you will find no fat in this prose.) Forget ideology, for film un-
born as it is has no language and speaks like an aborigine—monotonous
rhetoric. Abandon aesthetics—the moving picture image without reli-
gious foundations, let alone the cathedral, the art form, starts its search for
God with only the danger of accepting an architectural inheritance from
the categorized "seven," other arts its sins, and closing its circle, stylistic
circle, therefore zero. Negate technique, for film, like America, has not
been discovered yet, and mechanization, in the deepest possible sense of
the word, traps both beyond measuring even chances—chances are these
twined searches may someday orbit about the same central negation. Let
film be. It is something . . . becoming. (The above being for creator and
spectator alike in searching, an ideal of anarchic religion where all are
priests both giving and receiving, or rather witch doctors, or better
witches, or . . . O, for the unnamable).

And here, somewhere, we have an eye (I'll speak for myself) capable of
any imagining (the only reality). And there (right there) we have the cam-
era eye (the limitation the original liar); yet lyre sings to the mind so im-
mediately (the exalted selectivity one wants to forget) that its strings can
so easily make puppetry of human motivation (for form as finality) de-
pendent upon attunation, what it's turned to (ultimately death) or turned
from (birth) or the way to get out of it (transformation). I'm not just
speaking of that bird on fire (not thinking of circles) or of Spengler (spi-
rals neither) or of any known progression (nor straight lines) logical for-
mation (charted levels) or ideological formation (mapped for scenic points
of interest); but I am speaking for possibilities (myself), infinite possibilities
(preferring chaos).

And here, somewhere, we have an eye capable of any imagining. And
then we have the camera eye, its lenses grounded to achieve nineteenth

century Western compositional perspective (as best exemplified by the nineteenth-century architectural conglomeration of details of the "classic" ruin) in bending the light and limiting the frame of the image just so, its standard camera and projector speed for recording movement geared to the feeling of the ideal slow Viennese waltz, and even its tripod head, being the neck it swings on, balled with bearings to permit it that Les Sylphides motion (ideal to the contemplative romantic) and virtually restricted to horizontal and vertical movements (pillars and horizon lines) a diagonal requiring a major adjustment, its lenses coated or provided with filters, its light meters balanced, and its color film manufactured, to produce that picture post card effect (salon painting) exemplified by those oh so blue skies and peachy skins.

By deliberately spitting on the lens or wrecking its focal intention, one can achieve the early stages of impressionism. One can make this prima donna heavy in performance of image movement by speeding up the motor, or one can break up movement, in a way that approaches a more direct inspiration of contemporary human eye perceptibility of movement, by slowing the motion while recording the image. One may hand hold the camera and inherit worlds of space. One may over- or under-expose the film. One may use the filters of the world, fog, downpours, unbalanced lights, neons with neurotic color temperatures, glass which was never designed for a camera, or even glass which was but which can be used against specifications, or one may photograph an hour after sunrise or an hour before sunset, those marvelous taboo hours when the film labs will guarantee nothing, or one may go into the night with a specified daylight film or vice versa. One may become the supreme trickster, with hatfuls of all the rabbits listed above breeding madly. One may, out of incredible courage, become Méliès, that marvelous man who gave even the "art of the film" its beginning in magic. Yet Méliès was not witch, witch doctor, priest, or even sorcerer. He was a nineteenth-century stage magician. His films *are* rabbits.

What about the hat? the camera? or if you will, the stage, the page, the ink, the hieroglyphic itself, the pigment shaping that original drawing, the musical and/or all other instruments for copula-and-then-procreation? Kurt Sachs talks sex (which fits the hat neatly) in originating musical instruments, and Freud's revitalization of symbol charges all contemporary content in art. Yet possession thru visualization speaks for fear-of-death as motivating force—the tomb art of the Egyptian, etc. And then there's "In the beginning," "Once upon a time," or the very concept of a work of art being a "Creation." Religious motivation only reaches us thru the anthropologist these days—viz., Frazer on a golden bough. And so it goes—ring around the rosary, beating about the bush, describing. One thread runs

clean thru the entire fabric of expression—the trick-and-effect. And between those two words, somewhere, magic . . . the brush of angel wings, even rabbits leaping heavenwards and, given some direction, language corresponding. Dante looks upon the face of God and Rilke is heard among the angelic orders. Still the Night Watch was tricked by Rembrandt and Pollack was out to produce an effect. The original word was a trick, and so were all the rules of the game that followed in its wake. Whether the instrument be musical or otherwise, it's still a hat with more rabbits yet inside the head wearing it—i.e., thought's trick, etc. Even The Brains for whom thought's the world, and the word and visi-or-audibility of it, eventually end with a ferris wheel of a solar system in the middle of the amusement park of the universe. They know it without experiencing it, screw it lovelessly, find "trick" or "effect" derogatory terminology, too close for comfort, are utterly unable to comprehend "magic." We are either experiencing (copulating) or conceiving (procreating) or very rarely both are balancing in that moment of living, loving, and creating, giving and receiving, which is so close to the imagined divine as to be more unmentionable than "magic."

[. . .]

What reflects from the screen is shadow play. Look, there's no real rabbit. Those ears are index fingers and the nose a knuckle interfering with the light. If the eye were more perceptive it would see the sleight of 24 individual pictures and an equal number of utter blacknesses every second of the show. What incredible films might ultimately be made for such an eye. But the machine has already been fashioned to outwit even that perceptibility, a projector which flashes advertisement at subliminal speed to up the sale of popcorn. Oh, slow-eyed spectator, this machine is grinding you out of existence. Its electrical storms are manufactured by pure white frames interrupting the flow of the photographed images, its real tensions are a dynamic interplay of two-dimensional shapes and lines, the horizon line and background shapes battering the form of the horseback rider as the camera moves with it, the curves of the tunnel exploding away from the pursued, camera following, and tunnel perspective converging on the pursuer, camera preceding, the dream of the close-up kiss being due to the linear purity of facial features after cluttersome background, the entire film's soothing syrup being the depressant of imagistic repetition, a feeling akin to counting sheep to sleep. Believe in it blindly, and it will fool you—mind wise, instead of sequins on cheesecloth or max-manu-factured make-up, you'll see stars. Believe in it eye-wise, and the very comet of its overhead throw from projector to screen will intrigue you so deeply that its fingering play will move integrally with what's reflected, a comet-tail integrity which would lead back finally to the film's creator. I am meaning, simply,

that the rhythms of change in the beam of illumination which now goes entirely over the heads of the audience would, in the work of art, contain in itself some quality of a spiritual experience. As is, and at best, that hand spreading its touch toward the screen taps a neurotic chaos comparable to the doodles it produces for reflection. The "absolute realism" of the motion picture image is a twentieth-century, essentially Western, illusion.

Suggestions for Further Reading

Ackerman, Diane. *A Natural History of the Senses*. New York: Random House, 1990.

Arnheim, Rudolph. *Visual Thinking*. London: Faber and Faber, 1969.

———. *Art and Visual Perception: A Psychology of the Creative Eye*. New Version. Berkeley: University of California Press, 1974.

Aumont, Jacques. *The Image*. Translated by Claire Pajackowska. London: British Film Institute, 1997.

Blakemore, Colin, ed. *Vision: Coding and Efficiency*. New York: Cambridge University Press, 1990.

Brakhage, Stan. "Metaphors of Vision." *Film Culture* 30 (1963).

Brown, Frank Burch. *Religious Aesthetics: A Theological Study of Making and Meaning*. Princeton: Princeton University Press, 1989.

———. *Good Taste, Bad Taste, and Christian Taste: Aesthetics in Religious Life*. New York: Oxford University Press, 2000.

Dixon, John W. *Images of Truth: Religion and the Art of Seeing*. Atlanta: Scholars Press, 1996.

Elkins, James. *How To Use Your Eyes*. New York: Routledge, 2000.

———. *The Object Stares Back: On the Nature of Seeing*. New York: Simon & Schuster, 1996

Gombrich, E. H. *The Image and the Eye: Further Studies in the Psychology of Pictorial Representation*. Ithaca, NY: Cornell University Press, 1982.

Gregory, Richard L. *The Inquistive Eye*. New York: Oxford University Press, 1981.

———. *Eye and Brain: The Psychology of Seeing*. 5th ed. Princeton: Princeton University Press, 1997

Lindberg, David C. *Theories of Vision from Al-Kindi to Kepler*. Chicago: University of Chicago Press, 1976.

Nelson, Robert S., ed. *Visuality Before and Beyond the Renaissance: Seeing as Others Saw*. Cambridge: Cambridge University Press, 2000.

Sacks, Oliver. *An Anthropologist on Mars*. New York: Vintage, 1995.

Shusterman, Richard. *Performing Live: Aesthetic Alternatives for the Ends of Art*. Ithaca, NY: Cornell University Press, 2000.

Trevor-Roper, Patrick. *The World Through Blunted Sight*. London: Penguin Books, 1988.

 Section 2

Icon

The Image of Jesus Christ and Christian Theology

People are sexually aroused by pictures and sculptures; they break pictures and sculptures; they mutilate them, kiss them, cry before them, and go on journeys to them; they are calmed by them, stirred by them, and incited to revolt. They give thanks by means of them, expect to be elevated by them, and are moved to the highest levels of empathy and fear. They have always responded in these ways; they still do.

David Freedberg, The Power of Images

As if his attack on Chris Ofili's *Holy Virgin Mary* was not enough, New York City mayor Giuliani again made artistic headlines in February 2001, this time attacking a picture depicting a nude, black woman standing in for Jesus Christ in a contemporary rendition of Leonardo da Vinci's *Last Supper.* The image, entitled *Yo Mama's Last Supper* by Jamaican-born photographer Renée Cox, attracted the criticisms of the mayor when it was put on exhibition, again, in the Brooklyn Museum of Art. The mayor called the piece "outrageous," "disgusting," and "anti-Catholic," while the artist—who was raised Roman Catholic—defended the image with her own theological language, suggesting, "The Bible says we are created in the image of God."[1]

Here again, the heart of the controversy revolves around an image. Strip away the political ambitions, the cultural relativities, the desires of art collectors and curators, the shocking sensibilities of the artist, and we are left

with a physical, visual object: a five-panel photograph, 15 feet in width, in which the artist herself poses nude with outstretched arms in the midst of 12 black apostles. In a very real sense, Cox's photo is simply a gathering together of physical materials: photographic paper developed to reveal shapes and shades and colors, which is then framed and hung on a wall. There is nothing provocative, or even interesting, about these substances in and of themselves. What becomes interesting, and elicits both rage and desire, is the way these materials invoke a prior presence—in this case, the central holy figure of Christianity: Jesus Christ. Again, critical issues are raised in the passage from "original" presence to re-presentation. Meanwhile, this re-presentation causes viewers to stop and think once more about what that "original presence" actually was.

In the previous section it was mentioned that art and religion continue to exert influence due to gaps in seeing: the series of translations and interpretations that take place between the outside world, the eye, and the meaning-making activities in the mind. However, humans don't just see, they need to be seeing some*thing;* and while representation occurs internally between eye and mind, it also occurs externally between the material world and a created image representing that world. There is the natural environment of mountains, trees, and fields existing in the world that are then represented in a landscape painting. In this second section, therefore, it becomes necessary to discuss some of the characteristics of the representational *image*.

Taking the idea of representation into the Christian context, we can find no better term to indicate the representational process than that of *icon*, for in the icon we find a mixture of material and immaterial, earthly and divine, intellectual ideas and sensory experience. In the Christian context, an icon, as opposed to a mere image, bears religious significance in that it brings worshipers into relation with God through representations of sacred stories or persons (saints, the Virgin Mary, Jesus). There are important discrepancies within Christianity concerning the role and status of icons, but for now the term icon is used in its broadest sense, allowing the religious divergences of representational imagery to come forth. Our primary concern is with material images, but particularly with those images that also evoke mental (and "spiritual") images. As eye and mind are connected, so are eye and image, and image and mind.

As a way to understand this component in the overall project of "religion, art, and visual culture," this section will focus on the way images have been understood and interacted with in the Christian religious tradition, specifically in Europe and North America. And as this is a book not only about "art," but also about "visual culture," we are interested both in images themselves and in the responses people have to the images. While tra-

ditional art history pays attention to the production of images, a visual culture approach attempts to balance this view by looking at both sides of an image: its production *and* its reception.

CHRISTIAN IMAGES

In the Christian and Hebrew Bible we find the Ten Commandments. The second commandment reads:

> You shall not make for yourself an idol, whether in the form of anything that is in heaven above, or that is on the earth beneath, or that is in the water under the earth. You shall not bow down to them or worship them; for I the Lord your God am a jealous God . . . (Exodus 20.4–5)

Many have assumed that due to this commandment Christians (and Jews) are not, and should not be, concerned with images. All images are *idols,* they would say, as they re-present the world created by God alone. Others have seen various ways in which the second commandment is not a banishment of *all* images; rather, it depends on the *use* of images. There is nothing inherently wrong with an image by itself, some have argued, but what becomes problematic is the way in which people use images as a replacement for the "invisible" God. Still others have seen no problem in utilizing images in the midst of one's devotion to God; after all, if God is the creator of all things then he is the creator of images as well—we cannot despise what God has created. This spectrum of responses will surface at various points in the following readings.

Recent archaeological evidence suggests that many early Christians *did* use images in religious devotion, and it was most likely through the incessant use of images by Christian laypersons that theologians finally had to make a stance on them. This suggests to us how practice often precedes doctrine, with the further implication that an emphasis on visual culture reveals a different religious structure than that obtained by looking only at the writings of theologians in a study of church history.

The Christian Church, while still retaining a deep disparity over the role of icons, has spent countless amounts of energy working through doctrines of images in ways rarely seen in other religious traditions. This does not mean Christianity is more, or less, agreeable to images than other religions, it is just that, for whatever reasons, Christians have spent more time talking and writing about images than other traditions, establishing a vast theological corpus of doctrines on images. In Christianity, the idea of the image is intimately tied to doctrines of humanity and original sin, as well as doctrines on the divine and human nature of Jesus Christ.

With Christianity one must confront the paradoxical problem of the Incarnation of Jesus Christ that stands at the heart of the faith. Certainly the Almighty God cannot be depicted. (What kind of visible representation could one even make of this invisible presence? The old man with a beard doesn't really get us very far.) But if Jesus Christ was fully human and fully divine, as the Council of Chalcedon confirmed as orthodox in 451, then surely that "human" part could be depicted. One of the greatest defenders of images in Christian history was John of Damascus who in the early eighth century took up this very point, declaring, "I boldly draw an image of the invisible God, not as invisible, but as having become visible for our sakes by partaking of flesh and blood."[2] This is in accordance with Christian scriptures where we read regarding Jesus, "We declare to you what was from the beginning, what we have heard, what we have seen with our eyes, what we have looked at and touched with our hands, concerning the word of life" (I John 1.1). Aesthetic knowledge, as discussed in the previous section, is in evidence here as God enters the world of human, sensate experience in the figure of Jesus Christ. Knowledge, at least for this New Testament author, is based in the body and its senses. Furthermore, John of Damascus elsewhere claims, "If, because of love for human beings, the shapeless receives shape in accordance with our nature, why should we not outline in images that which became evident to us through shape, in a manner proper to us and with the purpose of stimulating the memory and inciting the emulation of what may be represented?"[3] John outlines the possibilities for a reverence of images here in ways that have been convincing to many, though he by no means solved the problem of the role of images in the Christian Church.

The Iconoclastic controversy, of which John of Damascus was a vital part, waged through the eighth and ninth centuries, finding its high point in the Second Council of Nicea in 787 in which images were declared to be orthodox and the worship of them God-pleasing. This ecumenical council, however, did not end the debate; it kept on, eventually becoming one of several issues leading to the first major schism in the Christian Church when in 1054 the Eastern Orthodox Church (based in Constantinople) split from the Western Latin Church (based in Rome). At the risk of oversimplifying, a key difference between the two sects of Christianity can be said to revolve around the status of representation: the Eastern Church tended to see the icons as "manifestations" of heavenly archetypes, where the sacred is actually present in the material image; the Western Church understood the images to be representations that aided in worship, but always pointed beyond themselves and are not to be confused with the true presence of God.

The theological view of icons is also imbedded within the controversies leading to the other great split in Christendom instigated in the sixteenth century by protesters who wanted to reform the church, an event that would eventually become known as the Protestant Reformation. The key reformers, Martin Luther, John Calvin, and Ulrich Zwingli, each had their own distinct take on images. Protestant reformers triumphed the *Word of God,* which primarily signified the human-divine figure of Jesus Christ (who was understood as post-Resurrection and therefore no longer a material substance but rather an invisible presence in heaven), but the Word also suggested the continuing revelation of God in the words of scripture and the preached word from the pulpits of churches. Luther was the most moderate and not against images per se, but stood opposed to the use of images for worship, particularly when the material image became confused with the invisible presence of the divine—that is, when the split between the "original presence" and the "re-presentation" became muddled. Nonetheless, Luther also claimed that "A right faith goes right on with its eyes closed, it clings to God's Word; it follows that Word; it believes that Word." Calvin, Zwingli, and especially some of their followers, were a good deal harsher in their views of images, and many of the Protestant denominations that formed in the wake of the Reformation had strict bans on the use of images for any kind of worship. The representation of holy saints, the Virgin Mary, and even Jesus Christ himself was considered bad practice and bad theology. Yet again, as will surface in the final excerpt in this section by David Morgan, the official doctrinal stance is often at odds with the unofficial practices of the religious faithful as the power of images continues to surface in spite of all protests by the authorities.

Iconoclasts (opponents of images) from whatever time period and location understand images to constitute real power. They do not oppose images because they don't believe in them; to the contrary they oppose them because they realize the power of images to incite religious devotion in ways not fully controllable and conformable to the institution of the church. Similar beliefs occur in modern cosmopolitan cities like New York. Images, as already suggested at several points in this volume, are often considered threatening, mainly because they seem to touch on something that the strict controls of religious or political authority cannot tap. Hans Belting begins his mammoth work *Presence and Likeness* with these words:

> Whenever images threatened to gain undue influence within the church, theologians have sought to strip them of their power. As soon as images became more popular than the church's institutions and began to act directly in God's name, they became undesirable. It was never easy to control images with words because, like saints, they engaged deeper levels of experience and

fulfilled desires other than the ones living church authorities were able to address. . . . Only after the faithful had resisted all such efforts against their favorite images did theologians settle for issuing conditions and limitations governing access to them. Theologians were satisfied only when they could "explain" the images.[4]

Images are dangerous, out of control, linked to passions rather than reason, linked to the body rather than the mind, linked to the earthly rather than the heavenly. As the epigraph to this section from David Freedberg claims, people are incited, aroused, scared, and moved to gratitude, devotion, and destruction by images. For these reasons and more, the Christian Church, with its deeply ingrained binary mode of thinking, has had to constantly review and rethink the role of images for the Christian believer. Doctrine and practice continue to butt heads, and today we find a Christian Church that displays a full array of doctrines *and* practices.

THE READINGS

Image, as we have already seen, is not an easy word to define and has meant many things to many people at many points in history. An excerpt by Margaret Miles describes some of the nuances of the image in relation to Christian theology. She highlights the differences that early church leaders made between "image" and "likeness," a distinction found in Genesis 1.26: "And God said, 'Let us make humankind in our image, according to our likeness.'" The difference, to put it briefly and in relation to other concerns of this volume, is that image is thought to be *physical* (and thus visible), while likeness is *spiritual* (and thus invisible). Humans are related to God through the physical incarnation of Jesus Christ, but because of sin are separated from God in terms of our spiritual likeness. Unfortunately this view stems from and promotes a view of the body and the material as subordinate to the spiritual. Sin (impurity) is related to the body; purity is related to the soul or mind.

Miles, however, argues for a physical religious practice. She claims that what is crucial in an understanding of the image is not merely the theology *behind* the image, but the viewers' interaction *in front of* the image, or, as she puts it, "the religious use of vision." She suggests that the frontal presentation of holy figures in sixth-century images encouraged viewers to engage with the images in new and more intimate ways than they had before. And it is the interaction between viewer and image that continues to be important for a *religious* use of images on into the twenty-first century. The problem with media images in the contemporary age, Miles suggests, is not so much *what* is depicted but *how* the images are presented. With

quick edits flashing images by on the television screen, the viewer has lit-
tle choice but to remain passive and detached from the images; there is no
possibility for a sustained interaction with an image. A religious seeing, to
the contrary, is one of touch, involving an intimacy, a "conceptual and
emotional investment" in the activity of vision.

The next excerpt takes us further into such a visual investment. John
Drury is an Anglican priest in Oxford, England who takes art out of the
museum and into the liturgical setting of the church. One Christmas, he
decided to use an image (Poussin's *Adoration of the Shepards*) as the focus for
his sermon, distributing postcard reproductions of the painting to the con-
gregants as they filed in. Carefully describing the picture, its symbolism,
theological and biblical references, and its overall meditational use, Drury
felt that "A religious picture was restored to its native context of worship."
We must realize that there were no museums at the time of the Renais-
sance and Baroque; painters did not make "art" to show in exhibitions, and
in fact many images were created for worship purposes. And while the
"originals" now hang in modern, secular museums, Drury has been able to
resituate images through technologies of reproduction. In its new-but-old
context of the worshiping congregation, the picture takes on new mean-
ings. This is not, it should be stressed, to pit the church against the mu-
seum, the Christian priest against the art historian, but rather to highlight
the movements back and forth, the borrowings from one to the other and
back again.

Drury did a series of sermons this way, as well as a series of lectures at
the National Gallery of Art in London. The sermons and lectures were
collected in a book entitled *Painting the Word*. The excerpt included here
from that book looks at Italian Renaissance artist Fra Filippo Lippi's *The
Annunciation*. Here we have the type of reverent depiction of Mary, the
mother of Jesus, that protestors of Chris Ofili's *The Holy Virgin Mary* must
have had in mind when they thought the latter was impure. In classic Re-
naissance perspective, Filippo Lippi portrays the intimate scene of Mary's
conception of Jesus. Drury looks at this image and argues for the active na-
ture of vision in worship, thus putting into practice Miles' accounts of a
"religious use of vision." At the same time, with such subject matter we
also see again the relation of the invisible and the visible, for as Janet Mar-
tin Soskice claims in ways echoing John of Damascus, "The story of the
Annunciation in Luke's gospel is the manifesto for religious art—a visible
God in a certain sense demands to be represented visually."[5]

Turning then to images of Jesus Christ, the final two excerpts chart the
way humans interact with images, also how images and Christian doctrine
interact at specific points in time. Leo Steinberg raised a few eyebrows
when he published his art historical study in 1983, *The Sexuality of Christ*

in Renaissance Art and in Modern Oblivion. He touches on the fact that early church and Medieval paintings of Christ shied away from Christ's human nature, in part for theological reasons and in part because artistic styles of the time did not emphasize a mode of naturalistic representation. By the time of the Renaissance (usually understood to begin around 1350), the theology was all worked out—Jesus Christ was mysteriously fully divine *and* fully human—and artistic styles began to allow for a whole new way of representing the world. Thus, as Steinberg argues, Renaissance art "became the first Christian art in a thousand years to confront the Incarnation entire, the upper and the lower body together, not excluding even the body's sexual component."

According to the words of Christian theologians and the words of the scriptures, Christ was without sin and therefore like Adam and Eve in their pre-fallen state: naked and without shame—a notion that photographer Renée Cox seemed to have in mind when she defended *Yo Mama's Last Supper.* In the Renaissance, then, Christ was portrayed naked, and in his nakedness there was no shame and no guilt. It is only with sin that guilt and shame can occur. Christ, in other words, retained *both the image and the likeness* of God the Father. Humans can relate to the "image" of God in Christ, but are divided from the likeness. Ironically enough, once the Renaissance was over many of the paintings of the naked Jesus were again covered up as loincloths were painted over his "private parts," connoting again the battle between religious authority and images.

Moving into the twentieth century and shifting from the "high" art of Michelangelo and Filippo Lippi to popular, mass-produced art, an excerpt by art historian David Morgan displays how images of Christ continue to provoke viewers to all manner of theological response. In 1940 Warner Sallman painted an image of Christ that has been reproduced tens of millions of times on posters, magazine covers, ceramic plates, and in other popular media. And while much of the reception of the image has been positive, the excerpt below tells of some of the more negative responses. Morgan takes these negative responses and uses them to highlight cultural debates in the United States over issues of gender, sexuality, and ethnicity, and how these issues are tied to theological understandings of Jesus Christ. In Morgan's excerpt we again see how images pose a threat: they are threatening because they cannot be pinned down with straightforward definitions given in verbal language, and threatening because their very visibility connects the spiritual with the physical, the mind with the body. We return here, then, one last time to the differences of meaning imbedded in the term *icon:* differences between "image" and "likeness," and differences between a "spiritual image" and a "material image."

In this last excerpt, however, these differences are redefined in a contemporary environment, and one of the significant underlying elements of Morgan's excerpt is the fact that the influence of this image is due to mechanical reproduction. Unlike the other images discussed in this section, Sallman's *Head of Christ* is widely recognized outside of the museum, the church, and academia, because of its massive reproductions. Sallman's image is basically always seen in a representational form of the "original" oil painting, a painting that is itself a representation. The image as reproduced becomes a representation of a representation, and yet, as Morgan carefully illustrates, the image nonetheless allows viewers to participate in pietistic devotion with the sacred. The image well represents the importance of the relation between religion and visual culture, a relation that crosses cultural boundaries as it redefines the spaces and times where the sacred and the profane exist. Here, as in the other examples, the image relates to its viewers in ways untouchable and unreachable by the doctrines of religious authorities. This does not make images a simple democratic medium that should be embraced by all, but it does resituate present conditions of power, and it causes the study of religion to have to look again at its subject.

Notes

1. See *The New York Times,* February 15 and 16, 2001.
2. John of Damascus, *On the Divine Images: Three Apologies Against Those Who Attack the Divine Images,* trans. David Anderson (Crestwood, N.Y.: St. Vladimir's Seminary Press, 1980), 16. Quoted in Moshe Barasch, *Icon* (New York: New York University Press, 1992), 209.
3. From the *Patrologia Greca* 94, col. 1260. Quoted in Margaret Miles, *Image as Insight* (Boston: Beacon Press, 1985), 143.
4. Hans Belting, *Likeness and Presence,* trans. Edmund Jephcott (Chicago: University of Chicago Press, 1994), 1.
5. Janet Martin Soskice, "Sight and Vision in Medieval Christian Thought," in *Vision in Context,* ed. Teresa Brennan and Martin Jay (New York: Routledge, 1996), 35.

Margaret R. Miles, from "Image"

Augustine remarked in his *Confessions* that he knew what time was until he tried to explain it. Similarly, "image" is a perfectly transparent and straightforward term, until one begins to consider its complex past and present usages. Affected not only by inevitable drifts in denotation and connotation but also by technological changes, the meanings of image have changed dramatically from ancient times to the modern West. Moreover, changes not only in meaning but also in the value ascribed to image complicate the term. As a critical term in religious studies, "image" is singularly difficult to define even if the discussion is confined, as is this essay, to the Christian and post-Christian West.

[. . .]

The Hebrew Bible account of creation was appropriated by Christians as the decisive statement about human nature. According to Gen. 1.26, God ordained humans in God's own "image and likeness." But a vast crevasse separates the original condition of humanity from its present condition. Patristic authors developed the idea of a distinction between the Greek terms image (*eikon*) and likeness (*homoiosis*). After the Fall caused by Adam and Eve's disobedience, they said, humanity lost its likeness to God, retaining only the image of God irreversibly given with creation. Origen's treatment of image was decisive for Greek Christian authors like Gregory of Nyssa as well as for Latin authors like Ambrose and Augustine. He insisted that humanity's imaging of God was purely spiritual, and he emphasized that the restoration of image and likeness depended on the Christian's conscious imitation of Christ, God's first image.

[. . .]

THE PRACTICE OF IMAGE USE

In seventh- and eighth-century Eastern Orthodoxy, in controversy over the use of religious images, a theology of image was articulated. The practice of image use was by then well established, but as occurred repeatedly

in the history of Christianity a fully rationalized theology emerged only when questions arose about practice, in this case the legitimacy of venerating icons of Christ, the Virgin Mary, the apostles, and the saints, both in communal liturgies and in private devotions.

Charles Murray was the first scholar to point out that it is likely that images were used from the earliest days of Christian worship. Although others had assumed that the absence of massive evidence for image use indicated that the second commandment's prescription of images was adopted by Christians as it had been by Jews, Murray surveyed the extant literature of the Christian movement to show that no such general proscriptions existed. Indeed, in every known worship setting before the Peace of the Church, traces of wall paintings can be seen, while the underground catacombs of the Roman Empire preserve figures and scenes from the third century forward.

The Eastern iconoclastic controversy seems to have arisen only when portrait busts came to predominate over narrative representations in the sixth century. An increment of viewer engagement, and thus of potential for worship of the icon itself, was inaugurated by the frontal presentation of holy figures. In frontal presentation, the icon's large eyes held the worshipper's gaze, encouraging devotion to the icon rather than to its prototype. Beyond the politics and practices of icon use, however, lay the issue of an icon's relationship to its prototype. The iconoclast controversy was the first debate over representation:

> The iconoclasts held that a material object could be the habitation of a spiritual being—that the *ouisiai* of both coalesced into one *ousia*—thus worship of any image was inevitably . . . idolatry. Against this the Iconodules [icon lovers] labored to show that, however close the connection between image and original, their *ousiai* were different—hence the worship of images was legitimate, as this worship would be referred to the prototype. This was essentially a Platonic view. [Lesley Barnard, "Iconoclasm"]

Traces of the Platonic idea of image underlie this rationale for the legitimacy of image use. In C.E. 787, the Second Council of Nicaea successfully reestablished the liturgical and devotional use of icons in the Eastern Churches, defining carefully the kind of veneration allowable for icons of divine figures, apostles, and saints. For Christians of the Eastern Churches, the issue was settled; it arose again in the West, however, in the Protestant Reformation with an intensity equal to that of the iconoclast controversy. Moreover, although the Platonic basis has disappeared from contemporary discussion, many of the issues and arguments of iconoclasm are still detectable in twentieth-century debates over the power of images in media cultures.

THE IMAGE IN THE TWENTIETH CENTURY

In historical Christianity, image was seen as dependent (in varying degrees) on its original. Its primary use was in describing humanity's relationship to God through Christ. In twentieth-century media culture, however, the meaning and value of image have altered dramatically. The media image often stands alone, without a referent, reflecting nothing but its creator's imagination. Even if, as in photojournalism, an image still represents a scene or a person, the image is equally capable of *mis*representing or falsifying the original. It can present a prettified and superficial representation, misleading the viewer; or it can focus on or eliminate features of the original scene according to a political agenda. Mass-produced images create their own "world," or "reality," unconnected, or only tangentially connected, to a referent. Images, produced from "miniaturized units" by simulation, have no origin or reality, but are, in Jean Baudrillard's term, hyperreal. In political campaigns, entertainment, and news coverage, the image has become a locus of concern about manipulation of a public with no access to realities other than the image.

Augustine's concept of image as a cloudy mirror in which, nevertheless, traces and suggestions of its original can be found has come under serious question in twentieth-century discussions of images. Baudrillard sketches the "successive phases of the image":

> it is the reflection of a profound reality;
> it masks and demonstrates a profound reality;
> it masks the absence of a profound reality;
> it has no relation to any reality whatsoever; it is its own pure
> simulacrum.

[. . .]

Is representation substitution or replacement? Is it "a stand-in or replacement for someone who would not otherwise appear," or does it symbolize a *presence,* imitating and localizing all unseen reality? In contrast to the modernist claim that media images present the world of experience, postmodernist critics claim that they actually represent, or replace, a world that is missing. One early film spectator is said to have walked to the front of the theater to look behind the screen for the people displayed on the screen. But there is nothing but light beams; there is nothing to touch, and there are no bodies. Film theorist Dudley Andrew has called film "the presence of an absence." Again, comparison with a devotional image user will be instructive. Christians, past or present, who use images religiously believe that their images represent a "world" that is not absent but invisible: a world that is present but unseen. For believers, the religious image con-

figures a world that is more real than the visible world, a reality that has created and that informs and sustains the visible world.

Another difference between religious image use and media viewing may be even more decisive. It is ultimately not the image itself but the viewer's committed and trained labor of imagination that connects the devotee to the religious painting. It is neither the subject nor the style of the painting that makes its use religious, but the viewer's conceptual and emotional investment in it. Looking at a painted narrative scene in the context of devotional practice, the devotee must imaginatively reconstruct a moment in a story, a moving scene. What gives the captured moment its intensity is the viewer's knowledge of what came before and what will come after. In the case of a scene in which sacred figures are posed for the viewer's gaze (a Christ in Majesty or a Madonna and Child, for example), she must reconstruct in imagination the figures' heavenly context and their import for human life. By contrast, media images usually require little engagement of the imagination; the possibility of watching them passively, with little investment of imaginative embellishment, is greater.

Contemporary theories of vision that emphasize the viewer's distance or separation from the object do not describe adequately the religious use of vision. Rather, the use of religious images presumes an ancient theory of vision in which a quasi-physical visual ray streams from the eye of the viewer to touch its object. The form of the object then moves back along the visual ray to imprint itself on the memory of the viewer. This theory of vision emphasizes the viewer's initiative and active engagement, an intentional appropriation of the object that permanently connects viewer and object (in memory). Lacking such concentrated attention, a religious painting is simply a painting with a religious topic. The location of an image is also important to the use made of it. Paintings that once aroused religious devotion in churches now, on museum walls, attract artistic appraisal and admiration that may have nothing at all to do with religious interest.

Like paintings, media images do not function iconically unless viewers augment the image, that is, imagine how it would feel to be in the protagonist's situation, imagine the smells, the tastes, the touch the film character experiences. In fact, some spectators do contribute sensory imagination and reflection to film viewing. It is not, then, impossible for media images to act iconically, attracting the viewer to imitation; it is just less likely that they will do so. Moreover, Christians who use icons gaze at the same image again and again; most people see a film only once, though some people see a few films again and again.

Orthodox Christians make the connection between icon and viewer even more explicit than does visual ray theory, by kissing their icons,

thereby acknowledging the presence of the icon's prototype and establishing an intercorporeal connection between the once-living bodies of the sacred figures and their own living bodies. The ultimate goal of religious desire is not vision but touch, the metaphoric touch of the visual ray or the literal touch of a kiss. In turn, the worshipper expects to be touched by the object of vision as its image moves back along the visual ray to impress itself on the soul through memory.

In short, though media spectatorship and devotional image use are formally similar, their differences are substantial. Most of us do not imitate the violence we may see repeatedly, though a troubling number do. But people who are alarmed enough about the effects of media to urge censorship do so because they assume that spectators relate to media images as an Eastern Orthodox or Roman Catholic Christian relates to an icon. This, I believe, exaggerates the power of media images.

What, then, *is* the real power of images in a media culture? No image, I have said, has iconic power unless it is related to rather atypically. Assuming that the worshipper's imitation of the virtues and values suggested by a religious image was an incontrovertible good, historical Christians did not examine the social conflicts of their religious images. But the repetitious representation of similar images *across* media weaves those images into the fabric of the common life of American society, influencing everything from clothing styles to accepted and expected behavior. Media conventions, of which most spectators are never consciously aware, cumulatively afflict Americans' self esteem, expectations, attitudes, and relationships. Moreover, media culture has established global networks with the capacity to export images around the world. That is why it is important to examine and question them, to ask of them the ancient question of the Holy Grail: Whom does it serve? Responses to this question define the importance of image to religious studies.

John Drury, from *Painting the Word:*
Christian Pictures and Their Meanings

A house is a kind of extra, or surrogate, body which dignifies the body we have already—extends it and makes up for its shortcomings: "someone's idea of the body/that should have been his" (W. H. Auden, *Collected Poems*). In this picture, Lippi has carefully designed an architectural setting which is a mixture of enclosure and openness, seclusion and availability to the world outside [fig. 2.1]. As such, it is a poem of the focal body in the painting, Mary's. As virgin she is closed, inviolate. To be the mother of God's son, she is open and submissively available in her inmost self, heart and soul. The buildings which surround her frame and echo these aspects of her body.

The picture is divided, not quite in half, by a wall. It is solid and buttressed at the back. As it comes towards us, it is pierced by a large opening. Then it drops down a step and becomes very low. It stops at the plinth supporting the usual vase of lilies, in the foreground there is no barrier at all. So we have a diminuendo: from complete separation, through a piercing, to a very slight barrier, and finally the total availability of the whole mystery to us as spectators.

Having read the lay-out from back to front, let's now read it from side to side. On the left there is an enclosed garden. As it is written in the Song of Solomon, "A garden enclosed is my sister, my spouse" (4.12). Such is Mary in Catholic Christian myth, a *hortus conclusus.* In front of this there is an open garden with a path into the house. But Gabriel does not use this ordinary way. He comes by way of the gap in the low wall behind him (apparently there in the first place to admit him) and lands so lightly on the turf that he does not crush a flower. The two kinds of garden on the left are answered by two kinds of building on the right. At the front is the open, paved courtyard where Mary sits. But up the step beyond her is her bedroom, open to the enclosed garden through the doorway in the wall. Beyond that there is a more mysterious feature: the bottom steps of

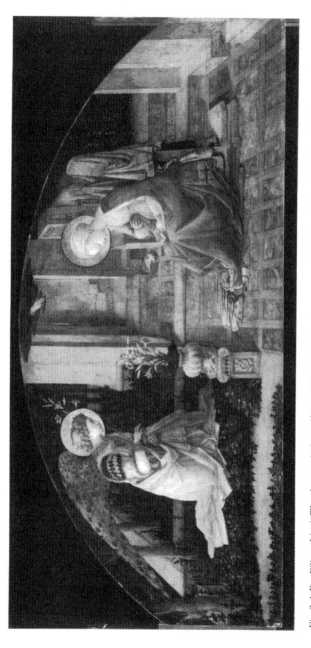

Fig. 2.1 Fra Filippo Lippi. The Annunciation. About 1449–1455? Egg tempera on wood, 68.5 x 152 cm. © National Gallery, London.

a staircase. Where does it lead? The answer jumps us from domestic architecture to God. From the middle of a cloud, representing the overshadowing in the text, God's hand reaches down in blessing. Its wrist is the picture's absolute center, and it dispatches the dove which drops steeply down past the staircase to the level of Mary's womb. This descent and Mary's response to it answer her question "How shall this be?" [cf. Luke 1.34]. But before we look into it, we should notice that the stairwell, like the rest of the scenery, is an accompaniment to the drama of bodies, to which this descent of the spirit and the Virgin's response is central. And the stairwell has a depth of spiritual significance which is apt to its spatial depth. As the most secluded and inward part of her house, it suggests the intimacy of Mary's relation to God as spouse.

But still, "How shall this be?" We have got an answer of some general value. A human body is like a house. Private and public life, inward and outward worlds, meet there. It, not banks or money, is the primary place and means of exchange. It encloses our inmost thoughts and feelings. It also lets them out and reveals them. It "deals out that being indoors each one dwells" (G. M. Hopkins, "As Kingfishers Catch Fire"). Lippi has taken care, with the setting of his figures, to enable an exchange between the most secluded self, the Virgin, and the open world of space and time. The fruit of this exchange will be the body which is uniquely central in Christian devotion, the means of exchange between humanity and divinity: Christ's. And this reminder brings us back to Mary's question "How shall this be?" We need rather more than a similitude of houses and bodies to answer it.

Luke's own answer, from the mouth of Gabriel, is less than adequate to the physicality which the question implies. The "coming upon" of the Holy Spirit and the "overshadowing of the Highest" have the majesty of mystery, but its vagueness too. Many Christian teachers warded off attempts to pry further into the "how" as irreverent. There are mysteries which we are not meant to see into, from which even the angels veil their faces. But when theologians use this ploy it is all too often a signal that they are in difficulties which they want to escape under the cover of theological smoke. This is particularly hard on painters commissioned to depict the moment of the incarnation, and it is hardly appropriate that divine self-disclosure should be answered by ecclesiastical or academic obfuscation. Painters have to show things physically, as God did in Christ, and therefore need to know exactly what they must show. We have already seen how they had got used to borrowing the dove from Christ's baptism to help them out. Leo Steinberg, pioneering the understanding of this picture, made the point deftly:

Of all Christian mysteries none demanded more tact in the telling. [Figures and types were deployed] to shield an unsearchable secret from too diligent investigation. Accordingly, in traditional exegesis, inquisitiveness was deflected, and the sensuous imagination was disoriented, by citing successively the types of the Virgin's conception prefigured in the Old Testament: her womb, it was said, was bedewed like Gideon's fleece; enkindled like the burning bush seen by Moses; budded without cultivation like Aaron's rod, and so forth.

But painters must make decisions which more modest Christians are spared; and it is remarkable to see Fra Filippo Lippi . . . emerge as the keenest in seeking to visualize what previously had been veiled and misted in figures of speech. (Leo Steinberg, "'How Shall This Be?' Reflections on Filippo Lippi's Annunciation In London")

The moment in Luke's story which Lippi depicts relieves him of Duccio's problem of representing spoken dialogue by silent figures. He shows the end of the story. Everything has been said. Mary has uttered her "be it unto me according to thy word." So the mouths of both participants are firmly closed. The painter is free to work in purely visual terms on the great problem "how shall these things be?" His imagination provides more than a brilliant figural solution of that pictorial and theological problem. It is a profound description of seeing at its purest and most dedicated.

Gabriel looks at Mary. And Mary looks at the dove just above her knees. Clearly this is where we should look too, and the hand of God at the top of the picture points to it decisively. That hand and the dove are connected in a way which has been obscured by the damage of time. We can see that the dove is contained in an airy, transparent disk, and that there are more such disks overlapping one another above and behind it. They originally formed a continuous spiraling chain, like a loosened spring, which connected the dove to the divine hand which dispatches it. This is how Lippi's contemporaries in the fifteenth century believed an image of a form to travel, through the air, to the eye of the beholder. Roger Bacon of Oxford's theories about optics and vision had been retailed in Florence by Ghiberti, Lippi's contemporary. Bacon believed that an object or form "produces a likeness of itself in the second part of the air, and so on" (third, fourth, fifth . . .), until it reached its destination. These intermediate images had no dimension of their own but were "produced according to the air." So Lippi paints them with the transparent delicacy which was one of his particular skills.

So far, so good. The chain of airy images tells us that Lippi imagines the medium of the Annunciation to be light and sight rather than sound and hearing: a poetic coup based in confidence in his own calling. And it has brought the dove closer to Mary's body than was customary in Annunci-

ation pictures—it was usually put in the air above her head—and there is a new intimacy. But there is still a gap. What happens there? The answer will resolve Mary's great question "How?"

Careful inspection reveals a spray of golden particles issuing from the dove's beak. At their center, one little jet of them carries forward horizontally and meets—contact at last!—an answering golden spray from Mary's womb, issuing through a tiny slit in her tunic. The word "tunic" in fifteenth-century ophthalmological parlance was borrowed from everyday dress to denote the layered membranes which surround and protect the eye's central *humor crystallinus,* which received the image through a parting of the tunics called *il foro,* the opening or doorway. (We recall Lippi's architectural parable of this, the opening in his central wall.) Perfect vision occurred when the image came in level with *il foro* and the *humor crystallinus.* That is why Lippi brings the dove right down to be level with the center of Mary's womb, where there is a little parting of her tunic. Her womb is like—very like—an eye. The eye does more than receive. It is active and out-going. So out of the aperture in Mary's tunic comes a golden spray which meets the emission of golden light from the dove's beak.

The Florentines called seeing "noble," the noblest of all the faculties. In Lippi's understanding the eye is not inactive, passively receiving signals. It is an agent which "makes something," and possibly something more or even better, of what it is given. When we see, is it the outside world coming to us, or us going out to the outside world? The question has interested people for ages. A reasonable answer seems to be that it is something of each. So noble, so receptive yet creative, is our faculty of seeing, that it goes out, like a courteous host to a welcome guest, to meet and dignify whatever comes to it. For the incarnation itself to occur, divinity (being love and not tyranny) waits for that little moving-forward in consent, that slight but momentous action of Mary's in saying "Be it unto me according to thy word." Light rather than speech being Lippi's medium, this has become "Be it unto me according to thy light." Mary's momentous response, just made in words, is decisively and pictorially "uttered" by the little spray of light from her womb/eye and the slight forward tilt of her body.

It is a wonderful answer to her question "how?" It makes the creation of natural light at the beginning of Creation continuous with the conception of Christ, the spiritual light of the world. By making the womb like the eye, Lippi does justice both to Mary's perpetual virginity and to her willing part in the scheme of salvation. And all the careful mixing of openness and enclosure in the setting which surrounds the two quiet figures— the outdoors and indoors, barriers and access—find their definition and resolution in the meeting of the two golden sprays.

It is all imagination. Not just Luke's story, which Lippi himself believed to be factually true, and the optical science of Bacon and Ghiberti, which he believed in the same way. Also his lovely picture. But that is to say that it conveys truth about experience, available to enlighten us in hundreds of similar experiences of encounter and exchange. Outdated science can become poetry when it already holds symbolic value.

Taking our cue from the liquid interchangeability which symbols and poetry allow, we may reflect that, when someone looks well at a picture, an inner purity, which does not get much exercise in the ordinary way of things because it has something of the virgin about it, becomes receptive and active. The eye begins to take in the picture and to go out to it in active response and exploration. When such an annunciation and conception has occurred, it leaves a quite physical sense of enlightenment and fruition. "The light of the body is the eye: if therefore thine eye be single [pure in concentration and response] thy whole body shall be full of light" (Matthew 6.22).

Leo Steinberg, from *The Sexuality of Christ in Renaissance Art and in Modern Oblivion*

The eternal, by definition, experiences neither death nor generation. If the godhead incarnates itself to suffer a human fate, it takes on the condition of being both deathbound and sexed. The mortality it assumes is correlative with sexuality, since it is by procreation that the race, though consigned to death individually, endures collectively to fulfill the redemptive plan. Therefore, to profess that God once embodied himself in a human nature is to confess that the eternal, there and then, became mortal and sexual. Thus understood, the evidence of Christ's sexual member serves as the pledge of God's humanation.

[. . .]

As for the sexual component in the manhood of Christ, it was normally left unspoken, suppressed originally by the ethos of Christian asceticism, ultimately by decorum. In theological writings the matter hardly appears, except, as we shall see, in connection with the Circumcision. The admission of Christ's sex occurs commonly only by indirection or implication. Thus the humanity taken on by the Word in Mary's womb was said to be—in the locution current from St. Augustine to the seventeenth century—"complete in all the parts of a man." From the preacher or theologian, no further anatomic specification was needed.

But for the makers of images the case stood otherwise. We have to consider that Renaissance artists, committed for the first time since the birth of Christianity to naturalistic modes of representation, were the only group within Christendom whose métier required them to plot every inch of Christ's body. They asked intimate questions that do not well translate into words, at least not without disrespect: whether, for instance, Christ clipped his nails short or let them grow past the fingertips. The irreverent triviality of such inquisitions verges on blasphemy. But the Renaissance artist who lacked strong conviction on this sort of topic was unfit to fashion the hands of Christ—or his loins. For even if the body were partly draped, a

decision had to be made how much to cover: whether to play the drapery down or send it fluttering like a banner; and whether the loincloth employed, opaque or diaphanous, was to reveal or conceal. Only they, the painters and sculptors, kept all of Christ's body in their mind's eye. And some among them embraced even his sex in their thought—not from licentiousness, but in witness of one "born true God in the entire and perfect nature of true man, complete in his own properties, complete in ours" [fig. 2.2].

My second consideration pertains to the Christ of the Ministry. When they visualized Jesus adult and living, artists did not, as a rule, refer to his sex—except perhaps in the manner chosen at certain times to render Christ's nudity at the Baptism. For the rest, the sexual reference tends to polarize at the mysteries of Incarnation and Passion; that is to say, it occurs either in Infancy scenes or in representations of Christ dead or risen. [. . .]

Between these poles lies the earthly career of Jesus of Nazareth. And that he, the Christ of the Ministry, was ever-virgin no sound believer may doubt. "A man entirely virginal," says Tertullian (c. 160–230). St. Methodius (third century) dubs him Arch-virgin and Bridegroom, whose success in preserving the flesh "incorrupt in virginity" is to be viewed as the chief accomplishment of the Incarnation. St. Jerome calls Christ "our virgin Lord"—"a virgin born of a virgin"; and explains that "Christ and Mary . . . consecrated the pattern of virginity for both sexes." Photius (ninth century) urges "those not yet married [to] offer virginity; for nought is so sweet and pleasing to the Ever-Virgin." The doctrine draws scriptural support from the passage in Matthew (19.12), where Christ commends those who have made themselves "eunuchs for the sake of the kingdom of heaven."

Needless to say, this precept was not meant to be taken literally; it was not to be misconstrued as a plea for physical disability or mutilation. Virginity, after all, constitutes a victory only where susceptibility to the power of lust is at least possible. Chastity consists not in impotent abstinence, but in potency under check. In Christological terms: just as Christ's resurrection overcame the death of a mortal body, so did his chastity triumph over the flesh of sin. It was this flesh which Christ assumed in becoming man, and to declare him free of its burden, to relieve him of its temptations, is to decarnify the Incarnation itself. It follows that Christ's exemplary virtue and the celebration of his perpetual virginity again presuppose sexuality as a *sine qua non*.

My third consideration concerns Christ in the character of Redeemer. His manhood differs from that of all humankind in one crucial respect, which once again involves the pudenda: he was without sin—not only without sins committed, but exempt from the genetically transmitted stain

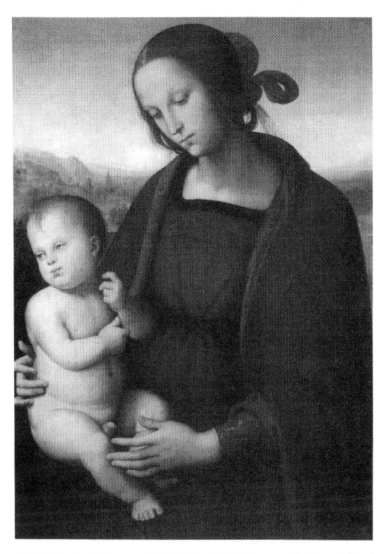

Fig. 2.2 Perugino, Madonna and Child. *After 1500. Oil on panel, 70.2cm x 50.8cm. Samuel H. Kress Collection. Photograph © 2001 Board of Trustees, National Gallery of Art, Washington.*

of Original Sin. Therefore, applied to Christ's body, the word "pudenda" (Italian: *le vergogne;* French: *parties honteuses;* German: *Schamteile*—"shameful parts") is a misnomer. For the word derives from the Latin *pudere,* to feel or cause shame. But shame entered the world as the wages of sin. Thus St. Augustine: "We are ashamed of that very thing which made those primitive human beings [Adam and Eve] ashamed, when they covered their loins. That is the penalty of sin, that is the plague and mark of sin; that is the temptation and very fuel of sin, that is the law in our members warring against the law of our mind; that is the rebellion against our own selves, proceeding from our very selves, which by a most righteous retribution is rendered us by our disobedient members. It is this which makes us ashamed, and justly ashamed."

But before their transgression, Adam and Eve, though naked, were unembarrassed; and were abashed only in consequence of their lapse. And is it not the whole merit of Christ, the New Adam, to have regained for man his prelapsarian condition? How then could he who restores human nature to sinlessness be shamed by the sexual factor in his humanity? And is not this reason enough to render Christ's genitalia, even like the stigmata, an object of *ostentatio?* In the incarnate Word—"whom sin could not defile nor death retain" (St. Leo)—flesh did not war against spirit, no bodily member suffered the incurred punishment of disobedience. For, in the words of Pope Honorius I, writing in 634 to the Patriarch of Constantinople: "our nature, not our guilt was assumed by the Godhead." Therefore, no shame.

Modesty, to be sure, recommends covered loins; and the ensuing conflict provides the tension, the high risk, against which our artists must operate. But if they listened to what the doctrine proclaimed; if even one of them disdained to leave its truth merely worded, wanting it plain to see in paint or marble; if such a one sought to behold Christ in a faultless manhood from which guilt was withdrawn, that is to say, as a nakedness immune to shame; if one such Renaissance artist held his idiom answerable to fundamental Christology so as to rethink the doctrine in the concretion of his own art; then, surely, conflict—if not within himself then with society—was unavoidable. He would be caught between the demands of decorum, lest the sight of nobly drawn genitalia further inflame the prurience of human nature, and the command, deeply internalized, to honor that special nature whose primal guiltlessness would be disgraced by a "garment of misery."

We are faced with the evidence that serious Renaissance artists obeyed imperatives deeper than modesty—as Michelangelo did in 1514, when he undertook a commission to carve a *Risen Christ* for a Roman church [fig. 2.3]. The utter nakedness of the statue, complete in all the parts of a man,

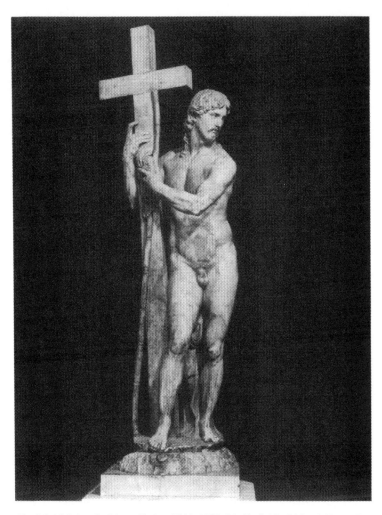

Fig. 2.3 Michelangelo, Risen Christ. *1514–1520. Marble (height 205 cm). Rome, Sta. Maria sopra Minerva. Photo credit: Alinari / Art Resource, New York.*

was thought by many to be reprehensible. It is hardly surprising that every sixteenth-century copy—whether drawing, woodcut, engraving, bronze replica, or adaptation in marble—represents the figure as aproned; even now the original statue in Sta. Maria sopra Minerva stands disfigured by a brazen breechclout [fig. 2.4]. But the intended nudity of Michelangelo's

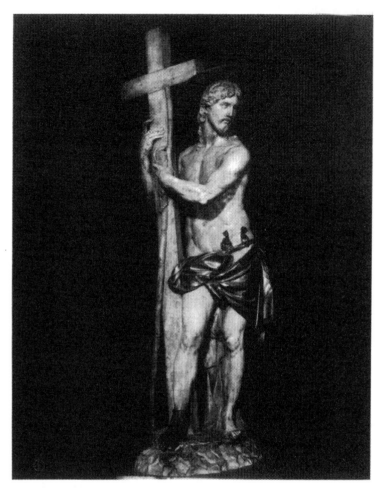

Fig. 2.4 Michelangelo, Risen Christ. *1514–1520. Marble (height 205 cm). Rome, Sta. Maria sopra Minerva. Photo credit: Alinari/Art Resource, New York.*

figure was neither a licentious conceit nor thoughtless truckling to antique example. If Michelangelo denuded his *Risen Christ,* he must have sensed a rightness in his decision more compelling than inhibitions of modesty; must have seen that a loincloth would convict these genitalia of being "pudenda," thereby denying the very work of redemption which promised to free human nature from its Adamic contagion of shame.

That Michelangelo conceived his figure of Christ *all'antica* is evident; the common charge that he did so to the detriment of its Christian content does not cut deep enough. We must, I think, credit Michelangelo with the knowledge that Christian teaching makes bodily shame no part of man's pristine nature, but attributes it to the corruption brought on by sin. And would not such Christian knowledge direct him to the ideality of antique sculpture? Where but in ancient art would he have found the pattern of naked perfection untouched by shame, nude bodies untroubled by modesty? Their unabashed freedom conveyed a possibility which Christian teaching reserved only for Christ and for those who would resurrect in Christ's likeness: the possibility of a human nature without human guilt.

[. . .]

The Incarnation of the Trinity's Second Person is the centrum of Christian orthodoxy. But we are taught that the godhead in Christ, while he dwelled on earth, was effectively hidden—insufficiently manifest for the Devil to recognize, obscured even from Christ's closest disciples (Mark 8.27–30; Matthew 16.13–20), apparent only to a handful of chosen initiates and a few beneficiaries of his miracles. By the testimony of Scripture, the manhood in Christ, though free from ignorance and sin, was otherwise indistinguishable—not because the protagonist of the Gospels assumed a deceptive disguise (like a godling in pagan fable), but because he took real flesh in a woman's womb and endured it till death.

This much Christendom has professed at all times. Not so Christian art. For when a depictive style aims at the other-worldly; when the stuff of which human bodies are formed is attenuated and subtilized; when Christian representations of Christ, repelled by the grossness of matter, decline to honor the corporeality God chose to assume—then, whatever else such art may be after, the down-to-earth flesh of the bodied Word is not confessed. It is arguable from a stylistic viewpoint—at least in retrospect and from a Renaissance vantage—that the hieratic Christs of Byzantine art are better adapted to Gnostic heresies than to a theology of Incarnation; for, to quote Otto Demus again, "The Byzantine image . . . always remained a Holy Icon, without any admixture of earthly realism."

But for those Western Christians who would revere the Logos in its human presence, it was precisely this earthly "admixture" that was needed to flesh out the icon. And because Renaissance culture not only advanced an incarnational theology (as the Greek Church had also done), but evolved representational modes adequate to its expression, we may take Renaissance art to be the first and last phase of Christian art that can claim full Christian orthodoxy. Renaissance art—including the broad movement begun c. 1260—harnessed the theological impulse and developed the requisite stylistic means to attest the utter carnality of God's humanation in

Christ. It became the first Christian art in a thousand years to confront the Incarnation entire, the upper and the lower body together, not excluding even the body's sexual component. Whereat the generations that followed recoiled, so that, by the eighteenth century, the Circumcision of Christ, once the opening act of the Redemption, had become merely bad taste. When Goethe reports on Guercino's *Circumcision of Christ,* a painting he admired in the artist's birthplace at Cento in mid-October 1786, he speaks of it in the simper of polite conversation: "I forgave the intolerable subject and enjoyed the execution." And a standard modern reference work by Louis Réau explains that the Circumcision dropped out of Christian iconography because of the subject's "indecency." Both authors unwittingly abrogate the special status of the body of Christ—the exemption of Christ's nakedness from the mores of Christendom.

We are left with a cultural paradox: renaissance artists and preachers were able to make Christian confession only by breaking out of Christian restraints.

David Morgan, from "'Would Jesus Have Sat for a Portrait?' The Likeness of Christ in the Popular Reception of Sallman's Art"

Negative Response and the Case against Likeness: Iconophobia, Iconoclasm, and the Masculinity of Jesus

Although many see in Sallman's *Head of Christ* [fig. 2.5] a reflection of their own experience or likeness, others have summarily dismissed the image for the difference they see separating the Christ they espouse from the one they find visualized in Sallman's pictures. [. . .]

The greatest number of complaints about Sallman's image were theological. Idolatry was the most frequent charge—either because of an implicit ethnocentric claim of Anglo superiority or because Scripture proscribes the creation and use of images of God in worship, prayer, or devotion. These two claims of idolatry generally were made by people who fall into two opposing theological camps: conservative and fundamentalist Protestants who reject images per se, and more liberal Protestants who regard Sallman's images as an instance of cultural accommodation. Both acknowledged the power of images to form character and direct worship, and therefore approached the use of images with great seriousness. A Lutheran woman wrote that "Christ is in our heart, not visions." She insisted that "no images of Christ anywhere [are] authentic." She further contended that visual images are especially misleading to children and recalled an incident from her own youth when she was frightened by a reproduction of Sallman's *Christ at Heart's Door* in her family's Bible: "Since I couldn't read I thought he was the devil trying to carry me off if he got in." Without the anchor of the accompanying text, the image could be made into whatever the child wanted. Many Protestants believe that this power of images to generate meanings, in a way that textual codes preempt by virtue of their specificity, must be controlled.

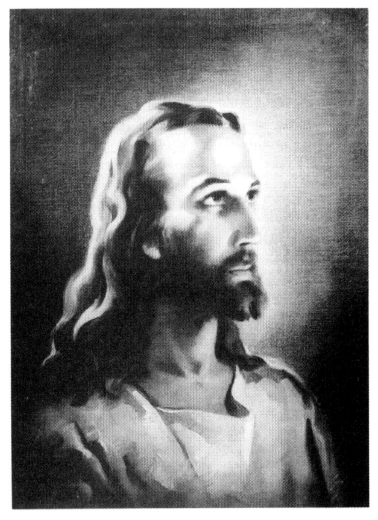

Fig. 2.5 Warner Sallman, Head of Christ. *1940. Oil on canvas, 28 1/4" x 22 1/8." Collection of Jessie C. Wilson Galleries, Anderson University, Indiana.*

Such iconophobia is certainly implicit in the stark contrast that many Protestant respondents drew between biblical word and visual image. Many stressed that Sallman's picture was "only an artist's conception" and could not bear any direct relation to the appearance of the historical Jesus.

Many went so far as to quote, misquote, or paraphrase a variety of scriptural texts that they believed demonstrated the unrepresentability of Christ: 2 Corinthians 5.7: "For we walk by faith, not by sight"; John 4.24: "God is a Spirit: and they that worship Him must worship Him in spirit and truth"; 1 John 4.12: "No one has ever seen God for he is a spirit"; Galatians 3.28: "There is neither Jew nor Greek, slave nor free, male nor female (black nor white), for you are all one in Christ Jesus." In contrast to the claims for the historical accuracy of Sallman's image, other respondents found the picture inaccurate when judged from scriptural evidence: Isaiah 53.2, understood as a prophetic description of the messiah, states that "he . . . had no beauty that we should desire him" and 1 Corinthians 11.14 states that it is degrading for a man to have long hair.

Citation of the second commandment (Exodus 20.4–5) among respondents followed the traditional exegeses of Luther and Calvin, who split on their explanation of the Exodus text. Luther took the proscription of all images in the fourth verse to be modified by the fifth verse's specific application of any image to worship. Therefore, depictions of Christ or God the Father were acceptable as long as they were not worshiped. Calvin, in contrast, read the biblical text as a strict proscription of any image of the deity. Accordingly, respondents could cite the second commandment against any image of God whatsoever or against only the idolatrous use of images: "To my understanding, the picture 'Head of Christ,' when placed where people look at it when praying or worshipping God, is a graven image and we are doing or encouraging what we are told in the commandment NOT to do." Other letter writers insisted that Sallman's picture remained a "work of art" and a "good wall picture." As art, it posed no danger. Iconophobia, or the fear of images, arises in some Protestants when the image is made visible during worship or prayer and itself, as the focus of vision, is taken for the object of worship. The mind is captured by what the eye sees. To have the image present is to risk mistaking it for what it only represents.

"Would JESUS have sat for a portrait?" one respondent asked. "I don't think HE would have. HE wasn't vain, HE was without sin." The assertion that the use of images is vanity, the product of human pride, links this modern Methodist man with the Reformation heritage of iconoclasm. [. . .] Calvin attributed the use of pictures in churches to human hubris and argued that it was an insult to God, "corporeal images" being unworthy of divine majesty. God must remain free of the human mind, that "perpetual forger of idols," radically other, exalted, transcendent, sublime—visually unrepresentable. God is like no other. To suggest otherwise by making him appear in the likeness of a human being is to insult the majesty and glory of God. This accommodation to human needs creates idols by removing the

vaunted distance between God and humanity. Humanity's submission as impotent, fearful, and unworthy before God is exchanged for one of power over God. For this reason, Calvin asserted that images "diminish reverential fear and encourage error."

Opponents of Sallman's images will certainly find abundant evidence of the psychological accommodation of Christ in the responses that we have previously examined. A great deal of the Protestant critique of culture from Calvin to H. Richard Niebuhr represents an attempt to secure theology from such accommodation. But those who respond negatively to Sallman's work exhibit their own rhetorical configuration of divinity, which must be included in our analysis if we are to arrive at a fuller understanding of the anatomy of response.

Prominent in the negative reception is a rhetoric of the sublime deity that reveals a gendered conception of God. The record of negative response to Sallman's art is clear that the sublime, untouchable, unrepresentable, disembodied, impersonal, and universal God of Calvin and latter-day Protestant iconoclasts is unambiguously male. Favorite epithets for Sallman's depictions of Christ are *pretty, sweet, weak, soft, anemic, sentimental, syrupy,* and *effeminate*. All these contrast markedly with the masculine rhetoric of the sublime that many used to denounce Sallman's work. A clergyman wrote that this "namby-pamby Christ" was not equal to the prophetic tradition of social Justice in the Jewish Scriptures or the words of judgment found in Matthew 25, where Christ condemned to hell those who failed to love him through their service to others. A writer who objected that Sallman's picture of Jesus substituted "one person's impression of Jesus" for the "Christ who is timeless and omnipresent . . . and who cannot be limited to any one physical form," stated the case for most antagonists: Sallman's picture "portrays Christ as sweet, insipid, bland, passive, and pretty, rather than as a strong, active person whose earthly existence was in an earthy, primitive (by our standards) culture and whose mission was (and still is) to change the world."

Occasionally the response is even more intensely gendered. In such instances revulsion at the image is directed against the emasculation of Jesus. This is the claim of one respondent, a self-described five-point Calvinist who referred to the image as effete: "This is a Jesus who would be aghast if you tied your shoes wrong. If our Lord had been anything like the man in this portrait, Galilean fishermen and publicans would have given him a sound thrashing rather than following him, which only a handful of spiritual masochists would have done." A United Church of Christ clergyman told a group of colleagues at a pastoral conference in Nebraska that some of his fellow clergy "couldn't have Sallman's portrait of Christ in their churches because the finely spun hair of Christ as portrayed in the paint-

ing was too much of a come-on for the homos in the parish and the community. These pastors felt Sallman had made Christ much too effeminate." A Methodist clergyman also worried about gay association with the image: "With the Culture Wars heating up, and homosexuality emerging as the point issue, this Head of Christ may prove a considerable embarrassment, given the *popular* image of the homosexual." Whatever that image might be, this writer was clearly worried that Sallman's picture was a compelling visualization of it, which Christians, given the picture's popularity, would find hard to explain to non-Christians and perhaps to gays who wished to be officially recognized as gay within the fellowship of the church.

Homophobia, like iconophobia, is a fear of likeness, a fear of emasculating God, of denying to the divinity the manhood that distinguishes "him" from humanity and creation. The rhetoric of the sublime seeks to preserve this difference. This view depends on the assumption, clearly laid out in Calvin's doctrine of God, that humans can revere only a divinity whose power infinitely exceeds theirs, before whom they are submissive and impotent. This notion of power, because it accommodates the patriarchy in American culture, will inevitably demand that women and homosexuals, historically the powerless or those who must conceal their difference, are not like God. Any image that suggests such a likeness will be suspect, idolatrous, and denounced as an accommodation to culture or psychology.

The image of Christ thus inevitably becomes like those whose faith it is appropriated to assist, whether they seek the comfort of a friend or maternal figure, or the inspiration of a sublime hero. Response to Sallman's imagery suggests that charges of cultural accommodation cut both ways. Negative response is motivated by a deep opposition to what these respondents consider the image to represent: the domestic Christianity of women. One critic likened the Sallman picture to the Precious Moments figurines sold in greeting-card stores. Such gifts are typically purchased by women for women for the purpose of display in the home. Further, the frequent observation that Sallman's Christ is effeminate—a remark made largely by men, and by male clergy in particular—is revealing when we consider that Sallman's pictures are used predominantly in the home, whose decoration and daily care has traditionally been the domain of women. Significantly, female respondents to the query in this investigation outnumbered male respondents by a factor of two to one. In short, what many of Sallman's critics may resent in the image is an icon of feminine Christianity: a "sentimentalization" of a lofty Christ as the personalized, intimate Jesus of popular strains of conservative Christianity. The nurturing, "effeminate" Jesus that many see in Sallman's pictures of Christ reminds

them of a religion dominated by women: their mothers, aunts, grand-mothers, and most Sunday school teachers. They oppose to this a sublime Christ. As undeniable as it is unsurprising, Sallman's detractors, no less than his admirers, assimilate their deity to a cultural construction. But for the many more male respondents who cherish the *Head of Christ,* men who do not discern anything effeminate about the depiction but rather see a Jesus who is both manly and accessible, it would appear that Christ as both friend and virile man makes Christianity safe for men, secures it as a do-main where male power and nurturing, authority and intimacy are possi-ble. This no doubt appeals to many wives and mothers within conservative Christianity for whom the family and the formation of youth are well served by a visual interpretation of Jesus that stresses both authority and intimacy, and does so in a way that lends itself to display and devotion in the home.

Judging from the appearance of Sallman's *Head of Christ* in the media during the 1990s, the relevance of the picture for many Christians is no longer Christ's masculinity. Instead, Sallman's image of Jesus has reaffirmed two themes in its previous popular reception: deliverance from personal ill-nesses and deliverance from cultural ones. In tabloid print and television Sallman's and similar religious imagery has been linked to miraculous ap-pearances and to a cure for such ailments as cancer and depression. More-over, in a much publicized court case in Michigan, in which the American Civil Liberties Union charged that a public high school violated the First Amendment's establishment clause by displaying the *Head of Christ,* the image was regarded by supporters as a symbol of political opposition to secularism and an intrusive federal government in the culture war between Left and Right.

The Jesus sought by believers during the fin de siècle appears to be a healer and an icon of old-time religion. Sallman's most well-known im-ages have been issued as collectible plates, perhaps in the attempt to capi-talize on the nostalgia of a graying American populace at the end of the twentieth century. Given the continuities with evangelical needs earlier in the century, the *Head of Christ* seems to envision the Jesus whom many seek, which suggests that Warner Sallman's Jesus may enjoy the light of a new millennium.

Suggestions for Further Reading

Barasch, Moshe. *Icon: Studies in the History of an Idea*. New York: New York University Press, 1992.

Belting, Hans. *Likeness and Presence: A History of the Image before the Era of Art*. Translated by Edmund Jephcott. Chicago: University of Chicago Press, 1994.

Dillenberger, John. *A Theology of Artistic Sensibilities: The Visual Arts and the Church*. New York: Crossroad, 1985.

———. *Images and Relics: Theological Perceptions and Visual Images in Sixteenth-Century Europe*. New York: Oxford University Press, 1999.

Drury, John. *Painting the Word: Christian Pictures and Their Meanings*. New Haven: Yale University Press, 1999.

Eire, Carlos. *War Against the Idols: The Reformation of Worship From Erasmus to Calvin*. New York: Cambridge University Press, 1986.

Frank, Georgia. *The Memory of the Eyes: Pilgrims to Living Saints in Christian Late Antiquity*. Berkeley: University of California Press, 2000.

Freedberg, David. *The Power of Images: Studies in the History and Theory of Response*. Chicago: University of Chicago Press, 1989.

Kessler, Herbert L. *Spiritual Seeing: Picturing God's Invisibility in Medieval Art*. Philadelphia: University of Pennsylvania Press, 2000.

McDannell, Colleen. *Material Christianity: Religion and Popular Culture in America*. New Haven: Yale University Press, 1995.

Merback, Mitchell B. *The Thief, the Cross, and the Wheel: Pain and the Spectacle of Punishment in Medieval and Renaissance Europe*. Chicago: University of Chicago Press, 1998.

Miles, Margaret. *Image as Insight: Visual Understanding in Western Christianity and Secular Culture*. Boston: Beacon Press, 1985.

———. "Image." In *Critical Terms for Religious Studies*, edited by Mark C. Taylor. Chicago: University of Chicago Press, 1998.

Mitchell, W. J. T. *Picture Theory*. Chicago: University of Chicago Press, 1994.

Morgan, David. *Protestants and Pictures: Religion, Visual Culture, and the Age of American Mass Production*. New York: Oxford University Press, 1999.

———, ed. *Icons of American Protestantism: The Art of Warner Sallman*. New Haven: Yale University Press, 1996.

Pelikan, Jaroslav. *Imago Dei: The Byzantine Apologia for Icons*. Washington, D.C.: National Gallery of Art / Princeton: Princeton University Press, 1990.

Stafford, Barbara Maria. *Good Looking: Essays on the Virtue of Images*. Cambridge: MIT Press, 1996.

Steinberg, Leo. *The Sexuality of Christ in Renaissance Art and in Modern Oblivion*. 2nd ed. Chicago: University of Chicago Press, 1996.

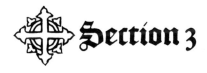

Section 3

Qalam
Word and Image in Islamic Calligraphy

The Pen of Qalam is the Active Pole of Divine Creation. . . . Islamic calligraphy is the visual embodiment of the crystallization of the spiritual realities contained in the Islamic revelation. This calligraphy provides the external dress for the Word of God in the visible world but this art remains wedded to the world of the spirit, for according to the traditional Islamic saying, "Calligraphy is the geometry of the Spirit." The letters, words, and verses of the Quran are not just elements of a written language but beings and personalities for which the calligraphic form is the physical and visual vessel.

— Seyyed Hossein Nasr, *Islamic Art and Spirituality*

At first sight, graffiti and seventeenth-century Iranian metal arts seem to have little in common [figs. 3.1 and 3.2]. Graffiti is typically created by disenfranchised youths who "deface" public property with spray paint, while Iranian metalwork is created with fine materials, often by royally decreed artists. Yet, looking closely we see some startling similarities, particularly in the way each renders verbal language in highly stylized visual forms. Graffiti tags display the identity of the tagger, yet the characters are so abstracted as to be illegible to the uninitiated. Likewise, Iranian calligraphic forms translate verbal language into highly visible "images." In each example, nonetheless, words do not entirely disappear, but mutate into word-image hybrids. Meant to be *seen* as much as *read,* graffiti and calligraphy share uncanny similarities.

On a broader scale, visual culture cannot be studied apart from verbal culture, particularly in its religious context. The Western religious traditions of Judaism, Christianity, and Islam have been bound together under

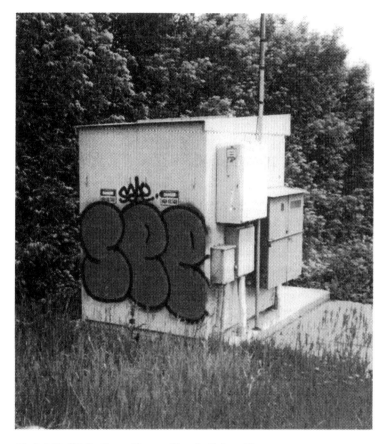

Fig. 3.1 Graffiti. Burlington, Vermont. Photo by S. Brent Plate.

the Quranic phrase "Religions of the Book,"[1] and each is generally un-
derstood to have strong iconoclastic currents coursing through their his-
tories that have led to many theological arguments over words and images.
Meanwhile, common historical wisdom has suggested that each of these
religious traditions prefer words to images. But if we look closer at words
and images, and at the material history to which words and images belong,
we find that words cannot simply "win" over images because the two can-
not actually be kept separate. It is ultimately in the Islamic tradition's most
vital art, calligraphy, that this section will center its focus, finding the image
rising up out of a word-oriented religion.

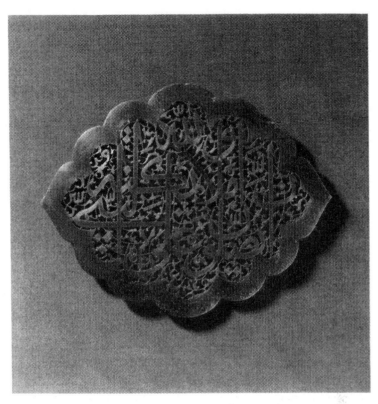

Fig. 3.2 Inscription Panel. *Iran, c. 1693. Forged steel cut to shape, pierced, 35 x 27 cm.* © *The Cleveland Museum of Art, 2001 Andrew R. and Martha Holden Jennings Fund, 1994.1.*

CALLIGRAPHY IN ISLAM

The title of this section, *Qalam,* is also the title of a *surah* (chapter) from the Quran. *Al-Qalam* is Arabic for "pen." The emphasis on the pen highlights the substantial powers of the word of Allah, but the pen also highlights *the practice of writing* the word as well. The "word" in the Muslim tradition is not a static object that exists in a stationary place and time, but is an ongoing, active performance. Indeed, we must recall that pens, which are now usually made of plastic, were at one time formed from reeds, and contemporary calligraphers still use pens made from specially grown river or marsh reeds. Reeds are also used for musical wind instruments, and thus

the writing made by the pen is associated with music and with the "sonoral" universe; one common metaphor is that "calligraphy is music for the eyes." Such an understanding of writing points out a dynamic creativity. Moreover, the creation of the world, in Islamic tradition as in many other religious traditions, is also bound up with *sound* (compare, for example, the sacred syllable "Aum" in Hinduism). Thus, to generate such musical writing is to be submerged in creation itself.

Another metaphor of calligraphy is that "writing is the tongue of the hand." Along with the musical connotations, we begin to gain an understanding of the written word that spans the opposition between oral language and written language. As commonly understood, in oral language words are *sounds* that engage the sense of *hearing* and exist in *time*—words fade out of existence once they are spoken. This is in distinction to a world of written language where words exist as *images,* engaging *vision,* and existing in *space;* there is stability and permanence to the written word. When language is made visible—that is, put down on a material substance like paper, as opposed to its invisible, temporal existence as spoken words—it takes on an air of inevitability. What is written cannot be changed, or so a culture begins to believe.

In Islamic calligraphy the oral world and the written world meld together. This is furthered by the understanding that Muhammad was illiterate. And we also must recall that the word Quran itself means "recitation," and its first word is "Recite!" The Quran was revealed to Muhammad orally by the angel Gabriel, and he in turn recited it to his community, who duly wrote it down. To say that Muslims are a "people of the book" is, therefore, quite different from what European "literate" cultures would understand to be "of the book"[2] (i.e., books with printed typeface and neatly laid-out margins, like the one you are now reading). The Word, in Islam, is alive and filled with music, song, and image. In fact, there are Imams who recite verses from the Quran during daily prayers, who are praised like famous opera singers might be in Italy. There is an immediacy implied in this understanding of the words of the Quran, giving the reader access both to written-visual-spatial and also to oral-aural-temporal modes of communication. Calligraphic writing, as Oleg Grabar's excerpt here notes, "is a way to bridge space as well as time."

Calligraphy, to give an initial simple definition, is a stylized writing of words done by hand. However, one does not simply sit down and make up scripts; rather, one must follow centuries of tradition that went on before. If a student wants to learn calligraphy he or she (calligraphy is not reserved for men alone) must undertake training with a master calligrapher who will write out sections of scripts (called a *mashq*), and the student will copy the master. This is repeated over and over again, with the training taking

from three to ten years before the student receives his or her *ijaza* (permission license). There are a number of rules involved in calligraphy. One of the first systematizers of calligraphy, Ibn Muqlah (died 939 C.E.), created a geometrical relation between the characters. Taking the first letter of the Arabic alphabet, the *alif*, as the standard, all other characters would be based on its dimensions, while "the perfection of a script is judged according to the relation of the letters to each other, not simply to their shape."[3] Many of the systematic reforms in the history of calligraphy in Islamic culture had to do, as with modern typography, with legibility. The text, while beautiful, had to be readable. The precision of tradition still allows for creativity, and there is a telling story of a famous Persian calligrapher, Mir Ali Tabrizi (died c. 1420 C.E.), who one night dreamed of flying geese and woke up the next day and set to work inventing a script that came to be called *nastaliq,* which gives a formal impression of geese in flight [fig. 3.3]. Thus, new invention is possible within the tradition, but one must be careful to point out that *nastaliq* script is a hybrid of two previously institutionalized scripts, *naskhi* and *taliq.* To create something new, Mir Ali Tabrizi had to work with what was already there in the tradition.

Not all calligraphy, however, is concerned with legibility. Getting to the relation of words and images in calligraphy, Martin Lings points out how "It is a wide-spread practice in Islam to gaze intently at Quranic inscriptions so as to extract a blessing from them, or in other words so that through the windows of sight the soul may be penetrated by the Divine radiance of the 'signs of God,' as the verses are called. Questions as to how far the object is legible and how far the subject is literate would be considered irrelevant to the validity and to the efficacy of this sacrament."[4] So, besides spanning the difference between the oral and the written, calligraphy can be seen to span the opposition between the verbal and the visual. As Qadi Ahmad states in a treatise on calligraphy and painting written in the sixteenth century and still often referred to today: "If someone, whether he can read or not, sees good writing, he likes to enjoy the sight of it."

But this brings up a curious point in reference to Islam, for the standard view is that the religious tradition is fundamentally iconoclastic. So, before turning to introduce the readings more specifically, it is prudent to review some of the general Islamic attitudes toward the arts and visuality in general. In his art historical account, *The Formation of Islamic Art,* as in several other of his publications, Grabar argues that there is no single Islamic doctrine of images, either for or against, in Islam. (He has also been careful to point out that there is no single thing that can essentially be called "Islamic Art.") There have been "attitudes," Grabar notes, "rather

Fig. 3.3 Shahnama. *Persia, eighteenth century. Nastaliq script. Collection of the Robert Hull Fleming Museum, University of Vermont. Photo by Edna M. Rodríguez Mangual.*

than doctrines."[5] While Christianity through the seventh and eighth centuries was embroiled in bitter battles over the status of images, resulting in a major split within the Christian Church, Islam had no such theological wars. There are plenty of what could be called iconoclastic events within Islam and several examples of pious rulers destroying images, but Grabar suggests that these generally developed later in Islamic history (usually post-twelfth century C.E.), and arose from particular historical and social circumstances rather than from theological edicts. Indeed, there is a long-standing legend that when Muhammad conquered Mecca and rode around the Kaba he destroyed all of the idols that the former Arab inhabitants had set up, except one; he left intact an image of the Virgin Mary and infant Jesus.

Grabar makes clear that the Quran itself "is totally silent on images except insofar as they were used as idols which are most forcefully condemned."[6] The debate surrounding images in Islam is typically centered on how the images are used. Clearly there are prohibitions on worshipping images as idols, presuming them to be representations of the divine. Yet he suggests that the Muslim prohibition of images is not, at heart, a fundamental theological prohibition contained in the Quran or early Islamic doctrine, but that the prohibitions have been *read into* the Quran by later commentators. Even the Hadith, the Traditions and "sayings" of the Prophet, which have acquired near-canonical status, while speaking out primarily against the *maker* (*musawwir*) of images, does not ban images straight out. Injunctions against the makers are due to a perceived challenge to Allah's own singular creative powers.

Nonetheless, fairly early on in Islamic history representational figures of animate objects (animals and humans) were excised from art and design. Even though there are a number of examples of representations of animals and humans throughout Islamic art, they are de-emphasized in the overall artworks. What did occur in early Islamic art, according to Grabar, was a reinvented type of symbolism. Beginning in the eighth century C.E., *ornamental* (usually vegetal or geometric, in other words, non-representational) motifs take precedence in textiles, coins, ceramics, wood carvings, wall designs, metals, and other aesthetic works. Even though *representation* is minimal and mostly avoided, ornament itself takes on a symbolic and even iconographic function. As Lois Ibsen Al-Faruqi concurs: "The Muslim artist, therefore, sought to express the nonrepresentableness, the inexpressibility, of the divine; and in this pursuit he created structures in the visual arts, music, and literature to suggest infinity."[7]

This raises certain questions which bring us back to several themes already brought up in this volume. Grabar wonders how meanings can be produced from abstract and nonfigurative signs: "If abstract and nonfigurative signs can indeed acquire symbolic meanings, how can we learn to read

them?"[8] One way to rephrase his questions and put them in the broader context of visual culture would be to ask: When does representation end and decoration begin? Or vice versa? Is it necessary to *recognize* an image for it to be meaningful? And thus, how "life-like" should it be? (Recall the face-vase trick in section one: the eye is tricked and oscillates between two figures, but the eye is also tricked since this image is neither a face *nor* a vase, it is just two squiggly lines with differentiations of white and black.) Grabar suggests the Islamic attitude emphasizes the relationship that occurs *in front of* the visual work. Concluding one of his essays he suggests, "Islam, by leaving the choice of interpreting visual creativity to men rather than by creating a doctrine of visual interpretation, may have succeeded in setting the nature of the arts in a totally different direction."[9] The interpretation, one must hastily add, is bounded by the fact that its aim or goal is to aid the community of the faithful. So, one might see why calligraphy comes to the fore as a key artistic medium within Islam, for it both venerates the word and is non-representational. Its basic forms, the Arabic alphabet, are abstract, non-representational figures that yet produce meaning in the eyes of its beholders.

THE READINGS

As if to answer some of his own questions about the line between *mere* decoration and meaningful representational figures, Grabar takes up the notion of ornament in his *Mediation of Ornament,* from which our first excerpt comes. Beginning with Jacques Derrida's ideas on *grammatology,* Grabar considers writing as a kind of "game" with a set of rules. For example, the student of calligraphy must undertake years of training consisting primarily of copying, or must follow the geometrical relations of characters based on the *alif.* But those rules do not predict the outcome of what gets communicated. (By analogy, in baseball there are foul lines, innings, and infield fly rules, but these rules do not let us know who will win the game.) Utilizing certain rules, writing can be manipulated for various purposes. Of course, sometimes scripts are written to be read, but there are many times when the purpose of including scripts on various objects has much more to do with decorative purposes. At times form follows function. At times the opposite is true. Meanwhile, in true Islamic art, neither exists without the other.

In the end, Grabar's interest in writing has to do with the two-fold interpretive possibilities available to the reader/viewer. While the tenth-century systematizing of Ibn Muqlah and others designed script for *legible purposes,* later uses of scripts allowed for *visual pleasures* to be taken from the imaged words. And these two possibilities—what could be called the ra-

tional and the emotional in one register, or the verbal and the visual in another—show both the polysemic quality of writing itself and the ways in which verbal culture and visual culture are again tied to each other. Grabar's excerpt is concerned more with the systematizing aspects of calligraphy, while the following excerpts extend the possibilities of the illegible, and thus visual.

Taking off from the mystical Islamic theology of the primordial "Well-Preserved Tablet," on which is written all events of the world, Annemarie Schimmel's excerpt provides an interesting discussion of how writing is bound up with a sense of inevitability and determinism. The term *fate* itself literally translates as "writing," or "writing on the forehead," in Arabic, Persian, and Turkish, thus implying the link between destiny and the permanent nature of the written word (as opposed to the oral word). As human fate has been written down for all eternity in Islamic belief, a number of questions regarding free will and determinism are triggered: If our destiny is written and thus permanent—ink is permanent in a way that speech is not—how can we have the freedom to act on our own accord?

The primordial Pen needs an earthly writing surface for its revelations, and that surface, mentioned by poets and theologians alike, is none other than the human body. The writings of the Well-Preserved Tablet exist in Heaven, but have been revealed to earthly existence and can be discerned, for example, in the lines on one's face. Human actions—love and suffering—are already written on hearts and foreheads. While humans would seem to have no free will since all is already written down in one's lifebook, the human response also becomes a bodily response as one's tears may wash away the bad marks against oneself. Ink is permanent, but also water-soluble. Notice in Schimmel's excerpt how tears that smear the pages of inevitability slip into the illegibility of writing itself, where ink and tears are conflated. More tears, and more writing, produce an illegible page that can no longer be read but only looked at. The escape from determinism is linked to an escape from the written and read word.

Ultimately, Schimmel's excerpt ends on the importance of the visual-material nature of the Arabic characters. Not only were calligraphers who could write well praised, but the Arabic alphabet became a unifying factor across the vast and diverse geographical space of the growing Muslim empire as other cultures adapted the Arabic alphabet to write down their own languages. And while the visual nature of the characters is highlighted, it cannot be overlooked that these very characters are sacred, and are valued for what they say *and* for how they look, thus linking word and image. The visual form of the script is vital for its bestowing of *baraka* (blessing) upon its receivers.

The excerpt from Seyyed Hossein Nasr picks up where the Schimmel excerpt leaves off: with the sacred nature of writing. Nasr's language hints toward an incarnational nature of calligraphic script, where the divine and the earthly commingle. While it would be going too far to say that the incarnation implied in Arabic script functions the same as the incarnation of the figure of Jesus Christ in Christianity (of the manner: Calligraphy is to Islam as Jesus is to Christianity), some comparisons seem unavoidable. And when Nasr further quotes the saying "calligraphy is the geometry of the Spirit," we may be reminded of the Renaissance paintings of Masaccio and Michelangelo, among others, who revolutionized Western painting by naturalizing their figures, doing so through geometric means. Geometry, for Renaissance artists, was a cosmic language that revealed the divine order of the world. The geometric relation that links the cosmic and earthly also links written characters to each other, as in Ibn Muqlah's establishment of guidelines on how to write the characters. If geometric relations are followed in calligraphy, as in painting, the cosmic is revealed in the earthly. And then we must also be reminded of the historical fact that the European Renaissance interest in geometry was dependent upon the Islamic empire's earlier interests in, among other things, ancient Greek culture. It was the Muslims who were ultimately responsible for the "rebirth" of Greek culture in that they preserved texts of Euclid, Aristotle, and others during the Middle Ages.

Nasr also follows Schimmel in his emphasis on the mystical thought of the Sufis. (Here it is important to note that the ideas surrounding calligraphy given by Schimmel and Nasr should not be understood as being the views of all Muslims at all times; they are each relating the interaction of humans and writing often within a mystical, Sufi context.) The Sufi relation to calligraphy takes this section's interests to even greater lengths as Nasr quotes Sufi poets who sit and contemplate calligraphic letters. The discussions here show the extremes of the word-become-image, where any difference that might be claimed between words and images becomes meaningless as various alphabetic characters have meanings according to their shapes. Thinking about this in relation to Grabar's questions about the line between non-representational decoration and mimetic representation, we find again a deep-seated human desire to make meaning out of what we see. Even when the shapes are as abstract as can be, we see recognizable forms—as one does when lying one's back and finding familiar shapes in the clouds in the sky, or interpreting squiggly lines as faces and vases. And once we see them in a particular way, we have a difficult time seeing them otherwise.

Calligraphy is an aid in contemplation, allowing the viewer/reader "to pierce through the veil of material existence." The Islamic quest for im-

mediacy is revealed, a desire for a unity not hampered by any intermediaries. There is a strong sense in which the physical and visual are ultimately eliminated in Islamic devotion, but this does not detract from the very necessity of physical and visual forms in true devotion. As was already detected in reference to Christianity, and as we will see in the next section with relation to Buddhism, humans need the material world even if their religious language denies it.

Finally, we turn to the contemporary age and find that calligraphy itself provides a sense of tradition and continuity for Islamic art, and thus perhaps for Islam as a whole. In her book, *Modern Islamic Art,* Jordanian artist and art historian Wijdan Ali investigates twentieth-century arts from across the "Islamic world" (though she uses this term, she understands the severe ambiguity of it at the same time), from Iran to Egypt, India, Sudan, Turkey, and other places in between. It is through calligraphy, and what she terms the "Calligraphic School of Art," that contemporary artists have been able to reinterpret their own heritage in modern and individual ways. In the excerpt she states, "It was the central nature of calligraphy as a medium of Islamic art and aesthetics that led Muslim artists to return to the Arabic alphabet in a search for an artistic identity." Artists in this school of art are not necessarily unified in their pursuits, but typically have received Western artistic training, bringing this to bear on their own culture and history. Within this school, Ali charts several subjects and styles, including religious, sociopolitical, literary, and decorative subjects.

Ali's comments on cross-cultural fertilization are pertinent in this context, as they are to this volume as a whole. Influence from one culture to the next is not to be bemoaned, as if something intrinsic were lost, but should be seen as a dynamic site for creative potential. Artists have responded to new changes and new influences in very interesting ways, working both within the tradition and in modes that push the visual into new perspectives. Like Mir Ali Tabrizi's dream of flying geese, the old is used to reinvent something new. Ali sees such dynamic potential in the Calligraphic School. This opens the way for artists to search for and express their identity, meanwhile strengthening the general culture's historical roots. We are left, then, with a tradition that pays homage to the word, even as it oftentimes simultaneously twists the word into an image that is no longer legible, producing new significations that straddle the line between representation and decoration, and between past and present.

Notes

1. The phrase *ahl al-kitab* (from the Quran 29.46) is perhaps more accurately translated as, "people of a previous revelation," however the notion of

"people of the book" has been a way to think about similarities between Judaism, Christianity, and Islam.

2. One must hastily point out that the "Word," in both Christianity and Judaism, is also considered more dynamic and more linked to a performative tradition than the broader notion of a literate culture designates. While fundamentalism may be seen as the logical extreme of print culture, the Christianity of Luther and Calvin, as well as the Roman Catholic Church, situated the Word within the performance of liturgy.

3. Annemarie Schimmel, *Calligraphy and Islamic Culture* (New York: New York University Press, 1984), 18–19.

4. Martin Lings, *The Quranic Art of Calligraphy and Illumination* (London: World of Islam Festival Trust, 1976), 16.

5. Oleg Grabar, *The Formation of Islamic Art,* rev. ed. (New Haven: Yale University Press, 1987), 74.

6. Oleg Grabar, "Islam and Iconoclasm," in *Iconoclasm,* ed. Anthony Bryer and Judith Herrin (Birmingham: Centre for Byzantine Studies, 1975), 45.

7. Lois Ibsen Al-Faruqi, "An Islamic Perspective on Symbolism in the Arts: New Thoughts on Figural Representation," in *Art, Creativity, and the Sacred,* ed. Diane Apostolos-Cappadona, rev ed. (New York: Continuum, 1995), 173.

8. Grabar, *The Formation of Islamic Art,* 95.

9. Grabar, "Islam and Iconoclasm," 52.

Oleg Grabar, from *The Mediation of Ornament*

The most brilliant recent statements on writing have been made by Jacques Derrida in his *Grammatologie* [*Of Grammatology*]. From his rambling, at times irritating, but usually quite scholarly text, I would like to pick up four threads for our purposes. One, implied by the neologism "grammatology," is the existence of a science of writing. What I understand by this is that the various processes that lead to the making and then the reading of something written possess principles and attitudes shared by all literate cultures, even if the specific manner in which these principles and attitudes appear may well vary to the point of incompatibility. The second thread is that writing is not simply, within semiotic theory, the signifier of something signified, the expression of an object or of a thought. It is in fact twice removed from its subject matter, as the word, spoken or recalled, comes between the object and its written form. As Derrida put it, writing is the signifier of the signifier. I shall argue later that the idea of beautiful writing allows us to get around this particular difficulty, but, as it is logical to assume that the reading of a meaning is the primary expectation of something written, the property of writing that is by definition twice removed from its subject has several consequences. One is a greater freedom of expression as well as greater opportunities to communicate. For instance, on a simple level of direct messages, abbreviations or mistakes can be handled in writing more easily than in speaking. Abbreviations do not need to subscribe to a requirement like that of vowels, and mistakes are avoided through an automatic system of correctives, as in the case of the plural, which is usually written more often than it is uttered. Another consequence is a potential for permanence and, therefore, for diachrony. The possibilities of remaining and of being used and reused were unavailable to a speaker of words until the invention of recording machines.

One implication of these properties of writing is that writing more than speaking is or can be a game. I use the term in the technical sense of an activity obeying a set of rules whose outcome is not predictable from the nature and identity of those involved in the activity. To use or write

profanities in a sacred place is blasphemous, but it is not blasphemous to
use the same script or the same letters for sacred or profane words. The act
of writing is independent of the letters, words, or characters it uses and,
with early pictographic exceptions notwithstanding, different from the
meanings of letters, words, and characters. And another implication is my
fourth and last thread derived from Derrida. Writing, he argues, is *"une trace
instituée"* (built-in [or institutionalized] remains). I understand this to mean
that time is always an acknowledged part of writing. It can be the short
time it takes for a note to go from one desk to another or the eternal mes-
sage of a divine revelation. Writing does not possess the immediacy of
sound, but it can be made eternal.

The point of these remarks inspired by the leading deconstructionist of
today is that the act of writing lends itself to a specific and finite range of
manipulations by virtue of a number of inherent properties of that act.
Without even trying to be complete, one can say that writing, being mov-
able, is a way to bridge space as well as time; it can proclaim the most vul-
gar thoughts and the most inspired ones; it can be beautiful or ugly; it can
communicate openly or secretly; it can be majestic and visible from afar or
fill the head of a pin. To subsume all these different actions of writing
under the single term of calligraphy only confuses the meanings of writ-
ing. In order to identify alternate terms, the experience of a concrete tra-
dition of writing is the guide I propose to follow.

[. . .]

By the end of the seventh century, the establishment of the Muslim em-
pire from the Atlantic to Siberia required a common means to transmit
both the prescripts of the faith and the needs of government and of con-
trol. The requirement was initially met, among other ways, by the Arabic
language and, in a more permanent way, by the Arabic script, which, at var-
ious points in time, became the only script or one of the scripts for Per-
sian, Turkish, Urdu, Malay, Swahili, and nearly every language practiced by
Muslims.

Two other cultural features of the first Islamic centuries are pertinent to
our purposes. One is the rejection of mimetic representation in anything
official or formal. The concomitant result of the rejection was the eleva-
tion of writing into the main vehicle for signs of belief, power, legitimacy,
and any one of the functions for which images were used elsewhere. The
best-known early examples of these "images of the word," as they have
been called, are the coins of late seventh-century caliphs with ideologically
loaded statements about the faith and the long inscription on the Dome
of the Rock in Jerusalem with its proclamation of Islam's doctrines on
Christ and Christology and with a statement of the new faith's ultimate
victory. [. . .]

The second cultural factor of early Islamic times that explains the growth of writing is the one most consistently mentioned by all writers on the subject. "Proclaim," says the Holy Book in the first statement to have been revealed to the Prophet, "and thy Lord is most Bountiful, Who taught by the pen [*bi-l-qalam*], taught man that which he knew not" (94.3–4). Or, elsewhere, "By the Pen, and what they [men] inscribe, thou art not, by the blessing of the Lord, a man possessed" (68.1). And a third passage from the divine message is more poetic and equally powerful (31.27): "And if all the trees on earth were pens and the sea—seven seas after it to replenish it [in a striking image of the sea as ink]—, yet would the Words of God not be spent." The point is simple. God has sent His message through writing and yet no writing will ever express the plenitude of the divine message. From the very beginning, the act of writing is at the same time a means of transmission and the only way one can even attempt to become aware of the limitations of man's perception of the divine. Practical and mystical themes will play their role in the interpretation of writing in Muslim lands and even more in contemporary interpretations of that writing, but the more important point is that, as writing was the vehicle of God's message, so God's message became a hallowed piece of writing and many an early (and late) manuscript of the Quran contains the information that it consisted of 114 *surahs,* or chapters; 6,236 *ayas,* or verses; 77,460 words; 321,250 letters; and 156,051 diacritical marks. From this sort of knowledge pertaining to the text of the Revelation itself, it was easy to imagine or assume that every letter or word had in it a particle of the divine, and thus that writing itself was holy. Later sects like the *hurufiyah* assigned a particular and unique significance to each letter, simply numerical at times but also characteriological or mystical.

[. . .]

Between the middle of the seventh century and the early tenth, a variety of scripts came into being with standardized general shapes of letters easily defined in formal terms like vertical or horizontal, rounded or angular, above or below a basic line, alone or attached to other letters. A typology of Arabic writing was established, and it acquired a series of complements, dots for the most part, serving to clarify distinctions between sounds that are not expressed by the shape of the letter alone. Because it is not known how systematic and consistent the dots were, the number and variants of these scripts are also unknown. What is, on the other hand, certain is that a new verb was introduced, which is absent from the Quran and which may or may not have a pre-Islamic past. The verb is *khatta,* whose verbal noun *khatt* is frequently translated as "calligraphy," . . . [though] the root has no implication of qualitative judgment, nor does it always imply writing. What it does mean is "to mark out," "to outline," as

in its well-known use for urban planning, where it refers to the fixing of boundaries between plots to be settled or built upon. In this last sense it comes up in the descriptions of the earliest new Muslim settlements in Iraq. The root *khatta* introduced into the action of writing, which was normally expressed by the much more common root *kataba,* something new that can perhaps best be imagined as an attribute of order and of reasonable consistency—in short, as a typology, a set of more or less consistent ways of doing things.

[. . .]

Something changed in the tenth century. To put it more accurately, later times attributed to the early tenth century and to the vizier Ibn Muqlah, who died in 939 under tragic circumstances, a series of changes whose existence and effects can be visually demonstrated in manuscripts and other written sources from the eleventh century onward. The invention was a new method, a new approach, a new way (the Arabic word used in the sources is *tariqah,* which means "path") for *khatt,* the orderly typology of ways to write. It was known as *khatt al-mansub,* a "proportioned script." In it the module for constructing letters was the dot, or rather the square or rhomb, produced by a pen put on paper and pushed open, then closed. A key, in the musical sense, to any piece of writing was given by the number of dots (three, five, or more) in the single vertical letter *alif,* and all other letters followed suit, thereby creating what was presumably lacking until then, a rationally thought out system of composing letters, words, pages, and, by extension, whole books. The method could also be repeated because an abstractly definable mechanism or canon existed for writing and for the evaluation of the writing of others. Like nearly all celebrated scribes after him, Ibn al-Bawwab, the next in line after Ibn Muqlah of a succession of celebrated and inventive scribes, is supposed to have been able to imitate any type of writing without being recognized as original. His own manner was also frequently imitated and even his signature was forged in a manuscript now in Istanbul. He died in Baghdad in 1022.

The recognition of the hand of any one scribe has remained a difficult task even in much better documented later centuries, but the same difficulty no longer applied to scripts, since from circa 1000, if not as early as Ibn Muqlah himself, a succession of clearly identified and individually named scripts appears. These scripts almost never replaced each other but remained part of a cumulative written legacy of Islamic culture. Individual times, areas, artists, patrons, and perhaps even topics could choose their manner of expression from a variety of types and that legacy was still powerfully effective in the nineteenth century. The components of that legacy—the many ways of writing in Arabic characters texts composed in Arabic, Persian, Turkish, Urdu, and Malay—have often been listed, illus-

trated, and discussed. Their majestic clarity limpidly proclaims the divine message of the Quran in the large volumes of the fourteenth and fifteenth centuries from Egypt or Iran, or recites in perfect legibility the Iranian epic of the *Shahnama* [fig. 3.3]. The delicate and curvaceous stringing of letters and words in Iranian scripts from the early fifteenth century onward creates subtler and more intimate settings for the reading of lyrical works or else, like the miniatures of the same time, lyricizes the epic. At times several scripts are used together, and some ideological or cultural meaning is probably to be discovered in these recalls of past scripts.

Annemarie Schimmel, from
Calligraphy and Islamic Culture

By "Nun and the Pen" and by the honor of the illiterate
Prophet but for whom the Pen would not have been created!

More than any other religion, Islam stresses the importance of the Book and is in fact the first religion in which the distinction between the *ahl al-kitab* ["people of the book"] and those without a written revelation was clearly stated to form part of its legal system.

Yet, the bearer of this message, Muhammad the Prophet, is called in the Quran *ummi,* which came to be interpreted as "unlettered" or "one who needs no learning," because for the preservation of the true essence of the Divine message, for the "inlibration" of God (as Harry Wolfson calls it), the Prophet's mind had to be absolutely pure, just as Mary had to be a virgin to become the vessel of incarnation. For this reason the mystics loved to dwell on the illiteracy of the Prophet; and as proud as they were of the revealed Book, they also realized that letters might be a veil between themselves and the immediate experience of the Divine, for which the mind and the heart have to be like a blank page. Muhammad is therefore praised in ever changing images:

> The orphan, who recites the Quran without lesson,
> drew the line of abolition [*naskh,* or "a line of *naskh* calligraphy"]
> over the ancient pages,

for the message which he brought abrogated all previous revelations.

However, this message itself, the Quran, abounds in allusions to writing. At the very beginning of the revelation, in *surah* 96, God appears as He "who taught man by the pen," and the first words of *surah* 68 read:

"Nun, and by the Pen!" This sentence has inspired poets and mystics throughout the centuries and is alluded to in many verses, all the more as the last three verses of this *surah* are recited against the evil eye.

Everything, the Quran holds, has been written from all eternity on the *lauh al-mahfuz,* the Well-Preserved Tablet, by means of the preexistent Pen. Such formulations led of necessity to discussions about predestination and free will, and they color the religious history of early Islam. "The Pen has already dried up," says a tradition that was quoted in defense of the idea that whatever had been decreed in pre-eternity cannot be changed. Maulana Rumi, who felt that such an interpretation would be dangerous for man's development and hamper him on his way to higher levels of spiritual progress, interpreted the saying differently. The fact that the Pen has dried up does not mean that everything is preordained but rather that there is written once and for all that good actions will be recompensed while sins will be punished; this is the unchangeable rule according to which man should act. There is also another tradition: when the Pen was about to write down the punishment for the disobedient Muslims who were going to hell, a terrible voice came, shouting, "Behave, O Pen!" and from fear the Pen was split—which is why every pen has to be split in order to write.

Since, according to general belief, all man's actions are written on the Tablet, in Islamic languages fate is generally termed *maktub,* "written," or "written on the forehead"—*sarnivisht* or *alin yazisi,* in Persian and Turkish, respectively. The lines engraved on man's face could then be interpreted as telling of his fate, as constituting, as it were, the title page of his destiny, which could be deciphered by those with insight. The warrior-poet Khushhal Khan Khatak says in a fine Pashto quatrain that "the true men of God in this world read from the tablet of the forehead the script of the heart."

Poets have often complained that the "writers of pre-eternity" have written the fate of lovers in black or considered the image of the beloved they carry in their minds as drawn by the pen of destiny on the tablet of their heart. Over and over have suffering lovers cried out like Sassui in Shah Abdul Latif's Sindhi verse:

> Had I known that the disaster of separation would befall me,
> I would have washed off the writing of destiny in the very
> beginning!

But mystically inclined writers would rather agree with Ruzbihan Baqli, who saw the Pen of the decision (*fatwa*) of pain take the ink of loving friendship from the inkwell of ecstatic experience to write letters of love on the heart of the lovers.

For a rebel poet like Ghalib the "writing on the forehead" is the mark left by the prostration before his idol. (In Islam the dark mark on the forehead caused by frequent prostrations is regarded as a sign of special piety; see *surah* 48.29.) And how should man not act improperly, *munharif* (lit., "slanted"), when the Pen that wrote his fate was cut in a crooked way?

The Pen, which was able to write everything on the Tablet, is, according to a Prophetic tradition, the first thing that God created. For the Sufi theoreticians and some philosophers it was therefore at times regarded as the symbol of the First Intellect or, rather, the First Intellect itself. Ibn Arabi, combining this idea with the beginning of *surah* 68, *Nun wal-qalam,* speaks of an angel called *an-Nuni* who is "the personification of the First Intellect in its passive aspect as the container of all knowledge." That corresponds to the common interpretation of *nun* as the primordial inkwell, to which its shape indeed can be compared [ن]. The fifteenth-century Shia thinker Itm Abi Jumhur, who closely follows Ibn Arabi's system, considers the Divine Throne, the Pen, the Universal Intellect, and the primum mobile as one and the same, whereas much earlier the Ikh-wan as-Safa had interpreted *aql* (Intellect) as God's "book written by His Hand" and developed a whole mythology of the heavenly Book and the Pen. It is, therefore, not surprising that calligraphers would regard their own profession as highly sacred, since it reflects, in some way, the actions of the Primordial Pen, as a Persian writer says:

> The world found name and fame from the Pen;
> If the Pen were not there, there would not be the world.
> Anyone who did not get a share from the Pen—
> Don't think that he is noble in the eyes of the intelligent.

Besides speaking of the mystery of Pen and Tablet, the Quran places man's whole life under the sign of writing. Did not God make the angels act as scribes? There is no moment that the *kiram katibin,* the noble scribe-angels (*surah* 83.11), do not sit on man's shoulders to note down all his actions and thoughts, and on Doomsday finally his book will be presented, more or less filled with black letters. For this reason the calligrapher Ibn al-Bawwab instructs the adept in his rhymed epistle to write only good words:

> For all the acts of man will meet him tomorrow,
> When he meets his outspread book!

But since most ink is soluble in water, Persianate poets who were afraid lest their songs about wine and love might have blackened the book of their

actions too much found the solution—tears of repentance will wash off
the pages. Rarely would a rebel poet claim that he was no longer afraid of
the Day of Judgment because

> I have blackened the page so much that it cannot be read!

an allusion to the *mashq* in which letter over letter, line upon line, fills the
page and makes it finally illegible. (Rumi too speaks of writing one text
on top of another.)

It was the letters of the Quran that became the true sign of the victory
of Islam wherever the Muslims went, and when they were adopted by peo-
ples with non-Semitic languages they endowed these idioms with some of
the *baraka* that Arabic and its letters bear, owing to their role as vessels for
the revelation. It therefore became incumbent upon the pious to write the
Divine Word as beautifully as possible and, as an often quoted *hadith*
promises, "He who writes the *basmala* beautifully obtains innumerable
blessings" or "will enter Paradise." Indeed, a famous calligrapher appeared
after his death to a friend in a dream to tell him that his sins were forgiven
because he had written the *basmala* so well.

The Arabic script of the Quran is therefore the most precious treasure
for the Muslim. As a modern Turkish author writes, "Even though foreign
artists could build mosques, yet they could not write a copy of the Quran.
Calligraphers have been regarded as destined for Paradise for writing the
Quran, while painters who wrote 'the script of the infidels,' that is paint-
ing, were considered food for Hell." Although the Prophet himself had
employed some non-Muslims as teachers of writing, certain orthodox
Muslims regarded it as—to say the least—abhorrent to show reverence to
a non-Muslim teacher of calligraphy, as our best Ottoman source states.
The same attitude is expressed in Mustaqimzade's remark that neither the
Quran nor a *hadith* should be written on European (*firangi*) paper.

Since the Arabic letters are the badge of identity for the Muslim peo-
ples, a break with this tradition is completely different from an exchange
of Roman letters, in the West, for another alphabet. The example of
Turkey, where the Arabic script was given up in 1928, is well known, and
it may be that one facet of the numerous tensions that eventually led to
the breakup of Pakistan was the fact that Bengali, contrary to the West Pa-
kistani languages that use the Arabic alphabet, is written in a Sanskrit-
based alphabet (although some orthodox circles tried to introduce the
"letters of the Quran" for this language too).

The all-embracing character of the Arabic letters contributed greatly to
the feeling of unity among Muslims. Allusions to the Arabic alphabet were
understood by everyone who was able to read, and the idea of an early Sufi

that "there is no letter which does not worship God in a language" furnished mystics and poets with almost unlimited possibilities for interpreting the letters and discovering ever new meanings in them, which in turn were expressed by artistic means. Did not the Quran itself state: "And if all the trees on earth became pens, and all the oceans ink, the words of thy Lord would not be exhausted" (*surah* 31.28)?

Owing to the sacred character of Arabic letters, anything written in them has to be treated carefully. As in the Christian and Jewish traditions, one finds Muslim, and particularly Sufi, stories about people who picked up each scrap of paper with Arabic letters because the name of God or a sacred word might be written on it, the *baraka* of which should not be destroyed. Perhaps even some of the early Kufic Qurans were, as Martin Lings thinks, meant to be contemplated like icons to partake of their *baraka* rather than to be read [fig. 3.4]. (The example of a Turkish *haifiz* who refused to learn Arabic grammar because "the Quran is not Arabic," but rather a sacred object in itself, immediately comes to mind.) The reverence for the written word, in which the illiterate villager participates as much as the scholar or the calligrapher, permeates Muslim life and becomes visible in the minute inscriptions on seals and bezels as well as in the enormous Quranic inscriptions that were arranged between the minarets of Ottoman mosques in Ramadan where they would be illuminated to make the Divine Word shine in the darkness.

Fig. 3.4 Page from a Quran. *Iran, 1000–1100s. Kufic script. Ink, gold, and colors on paper. © The Cleveland Museum of Art, 2001. Purchase from the J.H. Wade Fund, 1939.507.*

Seyyed Hossein Nasr, from "The Spiritual Message of Islamic Calligraphy" in *Islamic Art and Spirituality*

The beauty of writing is the tongue of the hand and the elegance of thought.

---Ali ibn Abi Talib

Handwriting is jewelry fashioned by the hand from the pure gold of the intellect.

Abu Hayyan al-Tawhidi

In the same way that the psalmody of the Noble Quran as the sonoral sacred art of Islam *par excellence* is the origin of the traditional sonoral arts, so is the art of calligraphy, which reflects on the earthly plane the writing of His Word upon the Guarded [Preserved] Tablet, the origin of the plastic arts. Quranic calligraphy issues at once from the Islamic revelation and represents the response of the soul of the Islamic peoples to the Divine Message. The points traced by the Divine Pen created at once the celestial archetype of Quranic calligraphy as well as the lines and volumes of which the cosmic order is constituted and from which issues not only natural space, but also the space of Islamic architecture. In the mystery of the Point, represented by the diacritical point under the first letter which opens the Noble Quran, namely the letter *ba* [ب], is to be found the principle of both Islamic calligraphy and Islamic architecture, the principle of both the sonoral and plastic arts, the root of both of which is to be found in the Sacred Book. The points and lines of Islamic calligraphy with their inexhaustible diversity of forms and rhythms are related to that Supreme

Divine Precinct at whose center resides the first Point which is none other than His Exalted Word. The Master of Illumination, Shihab al-Din Suhrawardi, begins one of his prayers with these words: "O Master of the Supreme Circle from which issue all circles, with which terminate all lines, and from which is manifested the First Point which is Thy Exalted Word cast upon Thy Universal Form."

The Guarded Tablet contains the archetypes of all earthly forms and more particularly of traditional Quranic calligraphy, all of whose styles are made possible by, and reflect, the sacred character of the Revealed Book. Islamic calligraphy is the visual embodiment of the crystallization of the spiritual realities (al-haqa iq) contained in the Islamic revelation. This calligraphy provides the external dress for the Word of God in the visible world but this art remains wedded to the world of the spirit, for according to the traditional Islamic saying, "Calligraphy is the geometry of the Spirit." The letters, words, and verses of the Quran are not just elements of a written language but beings or personalities for which the calligraphic form is the physical and visual vessel. Through the writing and reading of these letters, words, and verses, man enters into contact with these beings and talismans which have come ultimately from the far "other" shore of universal existence to guide man back to the abode of the One. For he who understands the significance of the Quran in both its spoken and written form, "it is easy to understand the capital part played in the life of the Muslim by those sublime words—the verses of the Quran; they are not merely sentences which transmit thoughts, but are in a way, beings, powers or talismans."

Inasmuch as there resides a Divine Presence in the text of the Quran, calligraphy as the visible embodiment of the Divine Word aids the Muslim in penetrating and being penetrated by that Presence in accordance with the spiritual capabilities of each person. The sacred art of calligraphy aids man to pierce through the veil of material existence so as to be able to gain access to that baraka that resides within the Divine Word and to "taste" the reality of the spiritual world. "Calligraphy and illumination are as it were compensations for such contingencies as ink and paper, a 'step up' which makes it possible, in a flash of wonderment, to approach more nearly and penetrate more deeply the Divine substance of the Quranic text, and thus to receive a 'taste,' each soul according to its capacity, of the Infinite and the Eternal."

Although calligraphy has developed in numerous forms and has embraced functions and domains not directly related to the text of the Quran, something of this principal wedding between calligraphy, which began in a purely Quranic context, and the spiritual substance of the Quran has survived within all aspects of traditional Islamic calligraphy. It

has come to occupy a position of special privilege in Islam to the extent
that it could be called the progenitor of the traditional Islamic visual arts
and the most characteristic feature of the visible aspect of Islamic civi-
lization. It has become identified over the centuries with culture itself,
good calligraphy being taken as a sign of a cultured man and a disciplined
mind and soul as well as hand. Calligraphy has continued to be the cen-
tral visual art, with its numerous applications ranging from architecture to
poetry. Calligraphy is the basic art of creation of points and lines in an
endless variety of forms and rhythms which never cease to bring about
recollection of the Primordial Act of the Divine Pen for those who are
capable of contemplating in forms the trace of the Formless.

> Through the *qalam* existence receives God's orders,
> From Him the candle of the *qalam* receives its light.
> The *qalam* is a cypress in the garden of knowledge,
> The shadow of its order is spread over the dust.

The Pen or Qalam is the Active Pole of Divine Creation; it is none other
than the Logos which manifests all the possibilities or Divine Archetypes
hidden in the "Treasury of the Invisible" by imprinting the Guarded Tablet
with the letters and words which are the *paradigma* of all earthly forms. The
calamus with which the human hand writes is a direct symbol of that Di-
vine Qalam and the calligraphy it traces on paper or parchment an image
of that Divine Calligraphy which has written the very reality of all things
upon the pages of the cosmic book, leaving an imprint upon all creatures
by virtue of which they reflect the celestial origin of their existence. For as
the sixth/twelfth-century poet Mir Mu izzi has stated,

> Inscribed upon the pages of the earth and sky
> The line: Therefore take heed, you who have eyes.

The human calamus is usually a reed and thus evokes not only the
beautiful lines and forms of traditional calligraphy but also the haunting
melody of that sacred music of the lovers of God which calls them back
to their origin in Divine Proximity. It is the reed to which Rumi alludes
in that immortal verse that opens his *Mathnawi:*

> Harken to this Reed forlorn,
> Breathing, ever since 'twas torn
> from its rushy bed, a strain
> of impassioned love and pain.

[. . .]

Islamic calligraphy reflects through the symbolism of its very forms this intertwining between permanence and change that characterize creation itself. The world consists of a continuous flow or becoming, yet becoming is nothing but the reflection of Being and the immutable archetypes contained in the Divine Word or Intellect. Islamic calligraphy recreates this metaphysical reality inasmuch as, in "embodying" the text of the Quran, it repeats the contours of creation itself. Hence, "as in weaving, the horizontal movement of the script, which is a rippling movement, corresponds to change and becoming, whereas the vertical represents the dimension of the Essence or the immutable essences." Or from another point of view it might be said that the vertical symbolizes the Unity of the Principle and the horizontal the multiplicity of manifestation.

All the traditional styles share in combining these two dimensions of verticality and horizontality but each in a different manner. Some styles are almost completely static and others almost completely flowing. But in each case some element of each principle must be found no matter how much the other is emphasized.

The Universe can also be symbolized by a tree, which according to the Quran has "its roots firm and its branches spread in the heavens." The World Tree is one of the most universal symbols of cosmic manifestation. Since the Quran is the prototype of creation and itself the world of multiplicity as issuing from and returning to Unity, Islamic art was bound to combine these two symbols, that of the Word and of the World Tree, in combining calligraphy with stylized plant forms. Many of the mosques and other architectural edifices of the Islamic world from the Cordova mosque to the Minareli school in Anatolia, from the Gawhar Shad mosque in Mashhad to the mausoleums and mosques of Agra, display this intertwining of calligraphy and arabesque forms whose meditation recalls the correspondence between the Quran and the world of nature and also the primordiality of the Quranic revelation throughout which the theme of "creation-consciousness" is repeated.

Islamic patterns also often combine calligraphy with both stylized plant forms or arabesques and geometric patterns. Here the calligraphy, related directly to the Divine Word, may be said to symbolize the Principle of creation, the geometric element symbolizing the immutable patterns or masculine aspect while the arabesques, related to life and growth, represent the living, changing, and maternal aspect of creation. Seen in this light, the calligraphy can be contemplated as the principle from which the two other elements of Islamic patterns, namely the geometric and the arabesque, originate and into which they become integrated as all cosmic dualities become integrated in the unity of the Principle.

[. . .]

Since the verses of the Quran are powers or talismans, the letters and words which make possible the visualization of the Quranic verses also play the role of a talisman and display powers of their own. Putting aside the numerical symbolism and esoteric significance of the letters and phonemes of the Arabic alphabet and language which comprise a vast science of their own, one can turn to the visible forms of the calligraphy as themselves representing "beings" as well as direct symbols of spiritual realities to the Muslim mind. Each letter has a "personality" of its own and symbolizes in its visual form a particular Divine Quality since the letters of the sacred alphabet correspond to features and qualities of God as the Divine Scribe.

The letter *alif* ([ا]) by its very verticality symbolizes the Divine Majesty and the Transcendent Principle from which everything originates. That is why it is the origin of the alphabet and the first letter of the Supreme Name of God, *Allah,* whose very visual form conveys the whole of the Islamic metaphysical doctrine concerning the nature of Reality for, "in the written form of the Name *Allah* ([الله]) in Arabic we distinguish a horizontal line, that of the very motion of writing, then the upright strokes of the *alif* and the *lam,* and then finally a more or less circular line, symbolically reducible to a circle; these three elements are like indications of three 'dimensions': serenity, which is 'horizontal' and undifferentiated like the desert or a blanket of snow; majesty, which is 'vertical' and motionless like a mountain; and mystery, which extends 'in depth' and relates to the divine ipseity [identity] and to gnosis. The mystery of Ipseity implies that of identity, for the divine nature, which is totality as well as transcendence, includes all possible divine aspects including the world with its numberless individualized refractions of the Self" [F. Schuon, *Understanding Islam*].

He who loves God empties his heart of all but Him: the *alif* of Allah pierces his heart and leaves him no room for anything else. That is why Hafiz sings in a famous verse,

> There is no trace upon the tablet of my heart save the
> alif of the stature of the Friend.
> What can I do, my master taught me no other letter.

One need only "know" this single letter in order to know all that is to be known, for the Divine Name is the key to the Treasury of Divine Mysteries and the path to the Real. It *is* that Reality by virtue of the essential identity of God and His sanctified Name. That is why in Sufism meditation upon the calligraphic form of the Name is used as a spiritual method for focalizing the Named.

As for *ba* [ب], the second letter of the alphabet, its very horizontality symbolizes the receptivity of the maternal and passive principle as well as the dimension of beauty which complements that of majesty. The intersection of the two letters constitutes the point which stands below the *ba* and which symbolizes the Supreme Center from which everything issues and to which everything returns. In fact all manifestation is nothing other than that point, for how can the One bear otherness to that which would compromise its oneness? That is why the *alif* and *ba* themselves together with all the letters which follow them in the Arabic alphabet are constituted of that point which, while being one in itself, is seen as many in the mirror of multiplicity.

Wijdan Ali, from *Modern Islamic Art*

By the second half of the twentieth century, a new art movement began
to take shape out of the need felt by Arab and Islamic artists to ground im-
ported art styles in the local environment. They had already proved their
aptitude in learning the theories and in applying Western aesthetics as well
as refining their ability in diverse media. Artists had reinterpreted their past
heritage in a modern artistic language but had reached a stage in their de-
velopment where they had to rebuild their own artistic personality in
order to develop their individuality. They were no longer satisfied with
drawing on figures and signs taken from their traditions. They wanted to
supersede all that had been done and to reach a truly original context in
both execution and content.

The solution was to develop a style that would relate to their cultural
heritage while benefiting from their Western artistic training. The answer
emerged in what I term the Calligraphic School of Art (al-Madrassa al-
Khattiya Fil-Fann), which includes calligraphic painting (*taswir khatti* or
lawha khattiya) and calligraphic sculpture (*naht khatti*), as opposed to the art
of classical Arabic calligraphy—*fann al-khatt al arabi*.

The Calligraphic School of Art is based on the use of the Arabic al-
phabet. Although the common term used by most Arab art historians and
critics is *al-Madrasa al-Huruffiyah,* the term proves to be both inadequate
and inelegant, for it literally translates as "School of Letterism." The foun-
dation of the calligraphic movement in modern Islamic art is the tradi-
tional Islamic art of calligraphy. It was the central nature of calligraphy as
a medium of Islamic art and aesthetics that led Muslim artists to return to
the Arabic alphabet in a search for an artistic identity. It is the application
of the calligraphic Arabic letter that gives these works their aesthetic value.

[. . .]

The popularity of Arabic calligraphy among Islamic artists can be at-
tributed to several causes. First, calligraphy not only forms a link with the
artist's religious, literary, and artistic heritage, but it is also a living presence
that is still effective. Second, the versatility of Arabic calligraphy, in either

its regulated or its free styles, offers the modern artist unlimited plastic and graphic possibilities, which can be manipulated and executed through traditional as well as modern techniques and media. Likewise, calligraphy can be employed in the depiction of spiritual as well as commonplace subjects. Finally, Arabic calligraphy appeals to and satisfies the literary aesthetic of Muslims, especially Arabs, whose artistic expression since pre-Islamic times has been mainly poetry. What an artist cannot express figuratively, he can express in writing. Likewise, what a viewer cannot comprehend visually, he can read in a work of art. One word can explain a plastic composition by conveying a mental image from the artist to the receiver.

[. . .]

Many Arab and Islamic artists move freely between different calligraphic styles and branches of the same style. An example of such versatility is the Iraqi artist Issam El-Said (1939–1988), a rare talent who succeeded in establishing himself in the West.

El-Said's paintings contain pure calligraphy (modern classical, calligraffiti, and freeform) as well as abstract calligraphy and calligraphic combinations. In his painting *God the Omnipotent* [fig. 3.5] a verse from the Quran is written in classical Thuluth script, yet the execution is totally modern in composition, color, and media, putting the work within the modern classical category. In an untitled work from the 1960s, the composition is reminiscent of the Ottoman *tughra* (the seal of Ottoman sultans, in elaborate, intertwined script), but the writing is simply abstract calligraphic shapes, with no meaning whatsoever.

Although El-Said was not a practicing Muslim until the early 1980s, he was always attracted to the Quran by the mental imagery called up by its verses. Its rich language appealed to his artistic sensitivities, and he transformed the words into colors and shapes by means of calligraphy. In his painting *Quranic Verse,* freeform calligraphy and calligraffiti are used to represent the meaning of the religious text in a desert-like landscape.

[. . .]

Westernization is a state of mind. It takes place only when the recipient is psychologically ready to cross cultural boundaries, abandon Eastern traditions, and adopt those of the West. It differs from the process of cross-cultural fertilization because it requires a total shift from the theoretical and cultural framework of the East.

The decline of traditional Islamic art, however, is not related to the extension of Western culture into the Islamic world that began with the Crusades of the tenth and eleventh centuries. On the contrary, a strong civilization is receptive only to positive influences, which should enhance its own modes and traditions. Although Muslims responded to earlier influences coming from Greece, Iran, India, and China, they did not make a

Fig. 3.5 Issam El-Said, God is Omnipotent *[Quranic verse]. 1986. From the collection of The Jordan National Gallery of Fine Arts.*

complete cultural switch, as they did in the twentieth century, but adapted the newly acquired cultural patterns to their own aesthetics.

Since the turn of the century, Western art forms have displaced traditional Islamic artwork throughout the world of Islam. Islamic artists of the twentieth century have embarked on a new experience, with a radical change in their creative expressions. For them, the introduction to academic training was in itself a revolutionary step.

Paradoxically, Western aesthetics was one part of the new culture that the Islamic world wholeheartedly embraced. Although at the beginning artists approached three-dimensional easel painting with apprehension, it

soon became the main mode of visual expression. Their training in Western art forms and techniques, at institutions abroad or at home, gave them the basis for developing their own contemporary aesthetics, by combining their Western education with their cultural heritage. Through Western-style painting, Islamic artists worked at creating their own artistic identity, either by depicting local subject matter or by borrowing traditional signs and motifs from their past.

After five decades of following international styles in painting and sculpture, modern Islamic artists succeeded in developing a new aesthetic with which they could identify: the Calligraphic School of Art. Their Western-oriented training has served them well in drawing upon their Islamic cultural background. A new cultural personality has evolved, in the form of the Calligraphic School.

The majority of Islamic scholars and traditionalists perceive a continuity only in architecture—if they see any continuity at all. The development of certain architectural features such as the dome and the arch, which have been reemployed in modern mosques and dwellings, is accepted as the natural evolution of traditional shapes. Even newer building materials such as cement and aluminum are not looked down upon. This acceptance may be related to the functional quality of a building, which complies with the Islamic requirement that every creative effort serve a practical as well as an aesthetic purpose.

However, art in its global definition has greatly changed. The evolution that has taken place in the West since the Middle Ages and during the Renaissance has moved art from the realm of the soul to that of the senses. The same applies for Islamic art. Since the last century, Islamic artists have turned to Western aesthetics. The devitalizing of Islamic civilization, coupled with the spread of Western culture and superior Western technology, has caused an evolution of technique and mode of expression among artists in the Islamic world. In other words, contemporary Islamic art has been divorced from utilitarian use.

Islamic artists in the twentieth century had the choice of either aping the West or evolving their own style while benefiting from modern training. The search for identity has led artists back to their Islamic roots, where they find a basis for successful evolution. The love-hate relationship with the West could have led the Islamic artist to isolationism, which would have killed any creativity. However, in the quest for a means of individual expression that would draw on Western training and materials, the contemporary Islamic artist has found a middle ground in the modern Calligraphic School of Art. Through its principles, artists can continue to be creative without severing themselves from either the past or the present. Thus, the Calligraphic School of Art is a combination of both Islamic and

modern Western teachings, provided it abides by certain Islamic aesthetics that prevent it from reaching a degree of vulgarity and ugliness.

Islamic art has borrowed from previous civilizations throughout its history. Even after its own styles matured, the intercultural exchange continued, without having a deleterious effect on Islamic aesthetics. For example, the influence of Chinese painting on Ilkhanid miniatures of the thirteenth century seeped down to Persian miniature painting of the sixteenth century and after and was considered part of the Islamic Safavid school of miniature painting. Similarly, when contemporary Islamic artists develop new and sometimes revolutionary styles by borrowing from Western principles and techniques and mixing them with Islamic art traditions, their work should also be acknowledged as Islamic.

Had there not been an art of calligraphy in Islamic civilization, there would be no modern calligraphic art. Therefore it is irrelevant whether or not the various styles of the Calligraphic School adhere to classical traditional scripts. Any development in style must evolve from a foundation. As long as the foundation and the aesthetics are clearly established, there can be continuity. One should also take into consideration the worldwide changes that have occurred in the concept of art in this century, as well as the conditions in which contemporary Islamic artists live.

Given the attempts in the Islamic world to ground contemporary art in a local environment, a new question must be raised: What is the relationship between national and international art? How can a contemporary Islamic artist relate to international art, in an ever-shrinking global village, and at the same time preserve his or her cultural identity?

Artists such as Henri Matisse, Paul Klee, and Wassily Kandinsky were inspired and influenced by the East. In turn, their works have been instrumental in revealing the graphic value of Arabic calligraphy and two-dimensional painting to Islamic artists such as Jawad Salim, Jamil Hamoudi, Nja Mahdaoui, Mohamed Chebaa, Shaker Hassan Al Said, Khalid Khreis, and Rafa al-Nasiri. The chain of smooth artistic exchanges between East and West continues with a younger generation of Western artists such as Hans Hartung, Brion Gysen, Soulage, Georges Mathieus, Jean Degottex, André Masson, Juan Miró, Lee U Fan, Henri Michaux, Simon Hantai, and Jean Fautier. Inspired by Arabic calligraphy, they in turn have created abstract works that fall within the definition of international art. There is no way contemporary artists can isolate themselves from external influences in a world dominated by such advanced means of communications as we have today.

However, there are two major differences between Western artists influenced by Arabic calligraphy and Islamic calligraphic artists. Once more, it should be mentioned that each letter of the Arabic alphabet is associated

with the beginning of certain words or with the opening verses of the Quran. The association takes place in the subconscious of the literate viewer. If the artist using those letters is himself or herself illiterate in Arabic, then to both the artist and the viewer they are no more than silent abstract shapes.

The Islamic artists closest to the Western artists who pursue calligraphy are Easterners who have adopted abstract calligraphy, in particular the pseudoscript. Nevertheless, the two artists cannot produce identical works because the intention or *niyya* of each is different. The transformation that the Islamic artist brings about in the Arabic characters, from the legible to the incomprehensible, comes first and foremost as a result of understanding their inherent significance, be it apparent or esoteric. On the other hand, given the absence of the dimensions of meaning and literary association, the Western artist's employment of the same characters is superficial, except when the artist is versed in the language.

The second point that separates the Western abstract artist from the contemporary Islamic calligraphic artist is tradition. Each of the two belongs to a different civilization and has lived and grown in a distinctly different environment. Tradition cannot be transplanted or acquired, for it is built into one's subconscious. No matter how much either artist tries to borrow from the other, their respective heritages will interfere with their artistic output.

The art of Arabic calligraphy is an integral part of Islamic art and will always be part of the tradition of Islamic artists. At this point a quotation from James W. Allan, the keeper of Eastern Art at the Ashmolean Museum in Oxford, seems appropriate: "For to me, as a western Christian curator of Islamic art collections, it is above all in Arabic calligraphy that Islamic identity belongs. And it is my belief that it is the ability of contemporary artists to express that calligraphic tradition in a contemporary way that will bring Islamic art once again into the forefront of artistic expression world wide."

The contemporary Calligraphic School of Art, prevalent throughout the Islamic world, is grounded in its own culture and has an aesthetic value that pleases both the eye and the soul. It is the natural continuation of Islamic art in the twentieth century.

Suggestions for Further Reading

Ali, Wijdan. *Modern Islamic Art: Development and Continuity.* Gainesville: University Press of Florida, 1997.

Atiyeh, George N. *The Book in the Islamic World: The Written Word and Communication in the Middle East.* Albany: State University of New York Press, 1995.

Bayani, Manijeh, Anna Contadini, and Tim Stanley. *The Decorated Word: Qurans of the Seventeenth to Nineteenth Centuries.* New York: Azimuth Editions/Oxford University Press, 1999.

Blair, Sheila S. and Jonathan M. Bloom. *The Art and Architecture of Islam: 1250–1800.* New Haven: Yale University Press, 1994.

Clevenot, Dominique. *Splendors of Islam: Architecture, Decoration, and Design.* New York: Vendome/St. Martins, 2000.

Derman, M. Ugur. *Letters in Gold: Ottoman Calligraphy from the Sakip Sabanci Collection, Istanbul.* New York: Metropolitan Museum of Art/Harry Abrams, 1998.

Ettinghausen, Richard, Oleg Grabar, and Marilyn Jenkins. *The Art and Architecture of Islam: 650–1250.* 2nd ed. New Haven: Yale University Press, 2001.

Grabar, Oleg. *The Formation of Islamic Art.* Rev. ed. New Haven: Yale University Press, 1987.

———. *The Mediation of Ornament.* Princeton: Princeton University Press, 1992.

Graham, William. *Beyond the Written Word: Oral Aspects of Scripture in the History of Religion.* Cambridge: Cambridge University Press, 1987.

Gutman, Joseph. *The Image and the Word: Confrontations in Judaism, Christianity, and Islam.* Missoula, Montana: Scholars Press, 1977.

Hillenbrand, Robert. *Islamic Art and Architecture.* New York: Thames and Hudson, 1999.

Irwin, Robert. *Islamic Art in Context: Art, Architecture, and the Literary World.* New York: Harry Abrams, 1997.

Lings, Martin. *The Quranic Art of Calligraphy and Illumination.* London: World of Islam Festival Trust, 1976.

Madigan, Daniel A. *The Quran's Self-Image: Writing and Authority in Islam's Scriptures.* Princeton: Princeton University Press, 2001.

Nasr, Seyyed Hossein. *Islamic Art and Spirituality.* Albany: State University of New York Press, 1987.

Safwat, Nabil F. *The Art of the Pen: Calligraphy of the Fourteenth to Twentieth Centuries.* New York: Azimuth Editions/Oxford University Press, 1996.

Schimmel, Annemarie. *Calligraphy and Islamic Culture.* New York: New York University Press, 1984.

———. *Islamic Calligraphy.* New York: Metropolitan Museum of Art, 1992.

Section 4

Shinjin

The Seeing Body-Mind in the Japanese Zen Garden

The view of the human being espoused by [East Asian philosophy] maintains that the human being is not a homo faber who conquers nature, but is an ecological, receptive being made alive by the invisible power working beyond nature, for the human being is originally a being born out of nature.

Yasuo Yuasa, *The Body, Self-Cultivation, and Ki-energy*

In the Oriental garden it is nature and not the gardener which does the creating. The line of stone, the mass of a tree, the contour of a hillock— all of these things are observed and worked into a pattern which the garden architect has perceived, a pattern which, because it is natural, is unique. Since he is always inside his garden, the viewer is surprised by a new vista, an unexpected view— he arranges for it. His natural garden will change with the seasons, just as those who see the garden will change with the years.

--Teiji Itoh, *The Japanese Garden*

The seeing human does not sit passively waiting for images to pass in front of the eyes; rather, eyes that see are eyes that are connected to the mind and to the body. The eye-body-mind moves and exists in material, spatial dimensions, perceiving the world around itself. In this way, perspectives are constantly altered. Clearly, none of the visual interactions discussed in the first three sections can take place without the human body. Section one expanded on the notion that the eye and the mind are

intertwined; seeing is both a psychological *and* a physiological process. Section two presented images of particular bodies—Jesus Christ's and the Virgin Mary's—that spoke theological doctrine. Section three presented evidence for the physical-visual nature of written words; particularly with Islamic calligraphy, words are looked at, listened to, and even tasted, while one's fate is itself written on the body.

All of this suggests again the material nature of *aesthetics:* that which pertains to sense perception. And to relate to sensual perception, we must relate to the body, for where else are the senses located but within the body? The body *situates knowledge,* meaning that our vision of the world, our worldview, is always understood from one particular perspective. And yet, that perspective can change as the body moves. Moreover, "bodily knowledge" allows us to make ever-new connections between things and allows us to remain open to the unexpected: unexpected ways of understanding the world, or, as we will see, unexpected vistas in the garden.

To highlight the import of the body, this section will shift its focus to Japan and to the space of landscape gardens and their relation to Buddhism (chiefly Zen Buddhism). The title of the section here, the Japanese word *shinjin,* literally means "body-mind." This term, however, does not imply a dualist philosophy as Western thought might understand it wherein the body and mind are separate though linked. Western philosophers—most importantly Plato and Descartes—have esteemed the "mind" and/or "soul," an *invisible* and *immaterial* entity that links humans to God/Truth/Ultimate Reality (depending on how one phrases it). This estimation has been to the detriment of the *visible* and *material* "body."

For the South and East Asian traditions there is no predominance of dualistic modes of thought, and in this section and in the next section on Hinduism we will see some striking differences to the West with regard to the relationships between the body and mind, between the material and immaterial, and between the visible and invisible. According to one of Zen Buddhism's most important thinkers, Dogen (1200–1253 C.E.), "Buddhadharma maintains that the mind and the body are one [*shinjin ichinyo*] without separating the appearance from its nature."[1] Any separation between mind and body is an illusion to be overcome through meditative awareness.

Yasuo Yuasa reinterprets Dogen's ideas, and Zen more broadly, in the contemporary age, noting particularly how Buddhist self-cultivation (*shugyo*) is practiced in relation to the visual arts. And the idea of "cultivation" proves to be an interesting perspective from which to begin an exploration of several interlinked relationships pertinent to our study here. For Yuasa, self-cultivation conjoins the mind and the body. But in English, "cultivation" also carries connotations of working with the land, with the natural environment. Hence, cultivation also becomes a springboard from

which to see a strong link between *nature* and *culture,* implying a link between humans and the natural world. Therefore, as the epigraphs to this section suggest, mind and body, nature and culture, are interconnected. Consequently, the space of the garden, which is none other than "cultivated nature," becomes an ideal place from which to see such relations. For it is in the garden that the cultivated mind and body merge with nature on the way to *satori* (enlightenment). The garden designer is not a creator *ex nihilo* ("out of nothing") but *works with* nature, merging the body-mind with the environment, cultivating nature while simultaneously being cultivated *by* nature. As Teiji Itoh states about garden cultivation, "The beauty is there from the first. It is not created; it is merely allowed to express itself in a louder voice and in plainer terms."[2]

Historical and Philosophical Background to Japan, the Gardens, and Zen Buddhism

Before turning to further implications of the garden and the body-mind, we can gain some vital understandings of these relations through a brief history of the gardens. Religion and aesthetics in Japan are unique for a number of reasons, historically, geographically, and culturally speaking. Some of the chief attributes of Japanese Buddhism stem from its indigenous religious roots. Before Buddhism arrived in Japan, many people on the Japanese islands practiced what is now called Shinto religion, which takes nature to be the setting of the sacred. According to Shinto belief, *kami* (spirits) dwell within mountains and rocks, as well as the sun and the moon, suggesting nature as an important starting point for religion. Shinto was also important for Japanese artistic evolution due to the fact that the religion stresses *practice* rather than *doctrine,* and its emphasis on ritual performance lent itself marvelously to the development of arts such as the theatrical tradition of Noh drama.

The history of Buddhism on the Japanese islands is coterminous with the history of gardening there: both garden design and Buddhism came from China via Korea around the sixth century C.E. Shintoism already had many "nature shrines" in place, and when Buddhism and Chinese gardening practices came they did not simply replace the practices of Shinto, but grafted themselves on to them, eventually developing unique, hybrid religious and aesthetic practices. Meanwhile, the styles of gardens evolved along with new religious thoughts. So, for example, when Pure Land (*Jodo*) Buddhism, with its strong emphasis on the Paradise of the next life, took root in Japan in the tenth and eleventh centuries, the gardens became representational glimpses of the world to come—people could get a hint of this otherworldly beauty in the here and now.

Eventually Zen Buddhism came to the island, again from China via Korea, where it took on its own unique identity, mixing and merging in various ways with Pure Land Buddhism as well as Shinto practices. While Zen ideas had migrated from Korea as early as the seventh century, it was not until the twelfth and thirteenth centuries, under the influence of figures like Eisai and Dogen, that Zen really took hold. In the garden this resulted in a new class of Zen "priest-gardeners" who took the older Paradise gardens and refashioned them in a way congruous with Zen aesthetics. Under the influence of Zen, gardeners began to change their aesthetic focus. While the earlier gardens used great lakes and waterfalls to convey the natural element of water within the space of the garden, Zen-inspired gardens proceeded through abstraction. Water was diminished to trickling brooks and often excised altogether, replaced by moss or dry stones. Stones would be laid out in a bed, *suggesting* (but not *symbolizing,* this is an important distinction) a river of water. The *sansui* (landscape; literally, mountain-water) garden evolved into the *kare-sansui* (dry landscape) garden [fig. 4.1]. However, both styles continued to exist and there are examples of both styles today, sometimes within the same garden.

In the Zen garden, rocks, water, and plants were no longer used as imitations or representations of another world; instead, the "inner forms" of nature were sought and brought to light. One of the key terms for such an aesthetic, as the excerpt from Yuasa will highlight, is the term *yugen,* which in its simplest translation means something like "profound, suggestive mystery." Through it, the eternal is found in the earthly. *Yugen* cannot be put into words or be grasped easily; rather, it is intuited. Experiencing it is akin to looking at a faint star in the night sky: if you try to look at it and grasp it directly it becomes invisible, but if you look just to the side of it you may be able to see it, however indirectly. One may sense *yugen,* but cannot turn around and explain it; it relies on experiential knowledge rather than symbolic or idealist knowledge. *Yugen* connects the observer to a deeper reality, helping to lead to the truth of the interconnectedness and non-difference of all things. This aesthetic of *yugen* encourages contemplation, and knowledge ultimately comes through the sensual body—the walking, hearing, seeing body—coextensive with the mind.

There are strong religious-philosophical ideas behind such theories of garden design; one of the most important being the basic Buddhist belief that life itself is constantly in flux. Mutability, or impermanence, is a fundamental condition of the world, as the Buddha himself suggested. Along these lines, another of the distinguishing traits of Japanese gardens throughout history is their *irregularity,* most typically played out through designs that are asymmetrical. The straight lines and clear boundaries

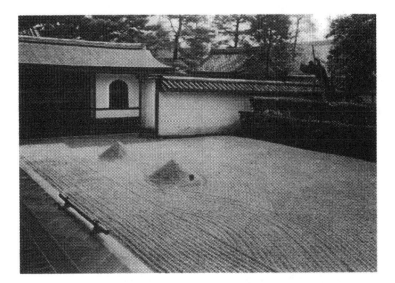

*Fig. 4.1 A "dry" garden (*kare-sansui*) at Daisenin, Kyoto, Japan. Photo by Lynn Perry Alstadt.*

found in Western gardens are absent from the Japanese garden. In their stead are curved paths, or rocks bunched together in one area and missing in another—a space, in other words, in which the viewer is surprised by something he or she did not expect. "Throughout the garden," Mark Holborn suggests, "the asymmetrical patterns of bridges, stones and trees retain the impression that there is no design at all. The garden becomes the accident of Nature."[3] Irregularity thus leads us to the connecting point between nature and culture, where nature is cultivated. But this cultivation is not achieved by domineering nature; rather, as Itoh says, "The gardener merely makes this beautiful garden more visible."[4]

Still, even with irregularity, there is a quest for harmony, for a reconciling of opposites. With the Chinese thought of Daoism and *feng shui* (Chinese: "wind-water") in the background, Japanese garden design sought to take contrasting forces and bring them together in the garden. For example, Shinto beliefs included the notion that rocks, trees, mountains, and other natural objects are endowed with genders; thus the garden designers would work with female and male objects and bring them together in the same space to achieve a balance. Or, on a grander cosmological scale, gardens were modeled so as to be in balance with the rotation of the stars and oriented according to the four directions.

Intriguingly, by further extension, what this harmonizing must also account for is the bringing together of perfection *and* imperfection. Holborn outlines the paradox:

> Absolute perfection, in which no trace of the imperfect was found, would fail to embody beauty. It was through imperfection that perfection was recognized and beauty appreciated. A form that was perfect would be static and dead.[5]

Or, as the fourteenth-century Shinto priest Kenko writes in his *Essays on Idleness,* "In everything, no matter what it may be, uniformity is undesirable. Leaving something incomplete makes it interesting, and gives one the feeling that there is room for growth."[6] Incompleteness and imperfection always entail that there is space for growth, for change, for nature along with the gardener to continue in the process of cultivation—cultivation of self, and cultivation of nature.

What is even more important to note is that by creating an irregular, incomplete garden, the *observer* is able to become a *participant*. This allows a deeper connection to the object, until there is finally no distinction between subject and object. Here we come to some of the heart of Zen itself, the privileging of experiential knowledge over and against a cerebral knowledge that works through mere symbols. To experience *yugen* is to become a participant, delving into the mysteries that connect nature and culture, mind and body; experiencing the point where such differences disappear. A perfect garden (if such a thing were even possible) would be complete unto itself with no space for change, and no space for the alteration that a human body would bring to it. Instead, through its irregularity, the observer is invited into the garden to become a participant, physically, mentally, and spiritually.

The Readings

An excerpt from Richard Pilgrim starts off the readings by providing a brief overview of some of the ideas found in Japanese Buddhism at various times and places. In surveying these Buddhist ideas, Pilgrim strategically emphasizes the role that "forms" play in Buddhist thought, whether that is "enlightenment" Buddhism's forms of thought and feeling (e.g., Zen), or "rebirth" Buddhism's forms of symbols and signs (e.g., Pure Land). While a cursory glance might see "rebirth Buddhism" as more attendant to the forms that are of interest to us in this volume, Pilgrim makes clear that both types of Buddhism actually use forms, though in different ways, while the ultimate goal of Buddhism is to get to the *formless*.

Forms, we might say, are the earthly, material "containers" for Reality (or the Sacred, depending on how one puts it). They are the intermediaries through which Truth is revealed and takes shape in the earthly realm. Words and images; thoughts and imaginations; rocks, trees, and water; natural objects and the body; all are forms. Implied in the idea of a form are limits or borders, analogous to the way a painting is "framed," suggesting where art ends and the rest of the world begins. One thought, word, or tree is separate in some sense from other thoughts, words, and trees. Yet, the borders between things are illusions and are overcome when one reaches enlightenment (*satori*). Enlightenment would be the experiential knowledge that all things are interconnected, and division does not exist. Just as ultimately a subject is not separate from an object, so are body and mind intertwined.

Pilgrim then turns to look at the role of the arts within the practice of Buddhism. The arts are crucial due to their *transformative* potential, moving the participant from one point to another. As such, they function as a tool, or "vehicle," for cultivation. But the arts are not simply "representations" of the sacred, they also make the sacred present, as he states, "whereby sacrality is manifested in the experiential power of the moment." The arts are both the finger pointing at the moon, and an embodiment of the moon itself.

In the next reading, Yuasa picks up on several of the artistic traditions in Japan, including Noh drama, and discusses the training of the mind by the body. He suggests that Western dramatic and athletic tradition attempts to train the body through the mind (the practice of "visualizing" is a good example), while the Eastern tradition works the other way: the body is a form that transforms the mind through physical, and artistic, practices. The body is primary for knowledge.

We also read further about the notion of *yugen,* as Yuasa charts the ways this is invoked in the arts of words and images. In either word or image, *yugen* is sought after by artists similar to the methods in which *satori* is sought by monks in meditative practices. Utilizing separate yet parallel paths, both monk and artist pursue the practices of self-cultivation. Yuasa is clear that the training practices for either meditation or aesthetic production involve a transformation into "mind-body oneness" (*shinjin ichinyo*). In addition, Yuasa's excerpt highlights the difference between the producer of the arts and the viewer/audience of the arts. Particularly with regard to the connection between mind and body, the artist (whether painter, actor, or landscape gardener) practices self-cultivation in the creation of the art. Even if the audience's cultivation is secondary to the artist's own self-cultivation, there is a transformative potential that remains. The viewer still participates in self-cultivating practices through the arts, and as

we move to the next two excerpts we see the possibilities of cultivation within the experience of the Japanese garden.

The next excerpt, by Shigenori Nagatomo and Pamela Winfield, explores the meaning of "micro-macrocosmic correlativity" in the Japanese Zen garden. In other words, they discuss the two-way relationship between the cosmic order "out there" in the natural world and the cosmic order "inside" our body-mind. While this relationship is found in many places, here it is set most specifically within the space of the garden. Pamela Winfield first introduces Chinese and Japanese formulations for micro-macrocosmic correlativity, and concretely illustrates this notion in terms of "Cultivating the External Garden" and "Cultivating the Internal Garden." Taking examples from East Asian practices such as Reiki, *feng shui,* Shinto, and Daoism, she notes the transformative potential in the cultivation of energy exchange between the internal cosmos (the body-mind) and the external cosmos (nature).

Shigenori Nagatomo concludes the excerpt with a philosophical reflection on "Time and Space of the Zen Garden" in which he identifies the orientations and goals that inform Zen's cultivation of the earth as a cultivation of the self. The non-duality of Zen Buddhist thought is brought to light, for example, in the way time and space are intimately intertwined in the participant's experience of the garden. Meanwhile, Nagatomo continues, the garden and the participant are brought together in the "here and now" as the participant "rides on the rhythm of nature." The excerpt thus contributes to a further understanding of this volume's emphasis on the dynamic, aesthetic practices of "religious seeing."

Mark Holborn provides a close-up view of three gardens in Japan, relating them through the thought and practice of Zen. The excerpt looks at one of the most famous Zen gardens ever created, Ryoanji, in Kyoto, a garden that is designed at a level of extreme abstraction, where *suggestion* is played out to a high degree. Nonetheless, this design invites the viewer to become a participant, to see and experience the garden (and by extension the entire cosmos) with one's full mind and body. Through techniques mentioned above, Ryoanji paradoxically achieves its balance through asymmetry and a design that implants tensions between opposing forces. Yet, only in this way is the balance accomplished.

Holborn then discusses two other gardens, Ryogen-in and Daisen-in, both attributed to fifteenth- to sixteenth-century painter, tea master, and garden designer, Soami. In each garden, space is constructed in such a way that the participant is led to a greater connection with the world as a whole. Water and mountains are suggested through rocks, stones, and moss, leading the garden-viewer from the micro to the macro, from a dry bed of stones to the great sea beyond. In order to achieve a design of this magni-

tude, the gardener must begin with the grand realm of nature, compressing the natural world to get to its essence. The gardener peels back layers until only that which is absolutely vital remains, and this is incorporated back into the garden. This essence is then seen and experienced by another human who is taken in the opposite direction, as these forms expand back out to the grand realm of nature and, indeed, out to the cosmos.

In broad religious studies terms, Japanese gardens do not simply create cosmos out of chaos (or culture out of nature), but constantly work within the tension between the two. The gardener creates, just as the observer participates, but not by imposing his or her own order on nature; rather, by becoming part of nature, the material and spiritual, body and mind, connect.

Notes

1. From *Shobogenzo*. Quoted in Shigenori Nagatomo, *Attunement Through the Body* (Albany: State University of New York Press, 1992), 124.
2. Teiji Itoh, *The Japanese Garden* (New Haven: Yale University Press, 1972), 140.
3. Mark Holborn, *The Ocean in the Sand* (Boulder, CO: Shambhala, 1978), 22.
4. Teiji Itoh, *The Japanese Garden,* 140.
5. Mark Holborn, *The Ocean in the Sand,* 22.
6. Kenko, *Essays on Idleness,* trans. Donald Keene (New York: Columbia University Press, 1967), sec. 82. Quoted in Donald Keene "Japanese Aesthetics," in *Japanese Aesthetics and Culture,* ed. Nancy Hume. (Albany: State University of New York Press, 1995), 32.

Richard B. Pilgrim, from
Buddhism and the Arts of Japan

BUDDHIST FOUNDATIONS

> The Dharma (Truth) is beyond speech,
> but without speech it cannot be revealed.
> Suchness transcends forms, but without
> depending on forms it cannot be realized.
> Though one may at times err by taking the
> finger pointing at the moon to be the
> moon itself, the Buddha's teachings which
> guide people are limitless.
> —Kukai, 774–835

Historic Foundations

At the most fundamental level Buddhism has consistently understood it-self as a discipline and as a technique for seeking awakening or enlighten-ment (*bodhi*). In one of the Buddha's parables the primary Buddhist disciplines of morality, meditation, and wisdom are seen as a ferry boat for helping us cross the river of ignorance and attachments to the other shore of nirvana, or enlightened wisdom. For most of what we might call nor-mative (elite) Buddhism, this journey and attainment are the ultimate ideal and goal of human existence. However different the specific content of the disciplines or the teachings are from sect to sect, culture to culture, or his-torical period to historical period, the underlying ideal remains.

What complicates the situation, however, and makes Buddhism difficult to understand and characterize, is the very nature of the enlightenment or awakening it seeks. Spoken of variously as extinguishing attachments, real-izing the radical impermanence and mutual dependence of all things, or realizing Emptiness (*sunyata*) and Suchness (*tathata*), the central core of Buddhism is no sacred being, no belief system, and no institution, but

rather a quality of experience and awareness that most Westerners do not knowingly share. This experience represents a transformation at the roots of consciousness and awareness, and an awakening to the immediacy of experienced reality prior to all description, naming, and reflection—prior, indeed, to subject/object consciousness. Such a core reality is, by definition, beyond any objectification, and thus the status of any objective "form" is seriously called into question—whether it be the more subtle "forms" of thoughts and feelings or the more obvious forms of symbols, doctrines, art, scriptures, institutions, language, and so on. In this core reality all things are indeed Empty, and the mind is like a mirror which reflects a world but attaches nowhere and grasps at nothing. This is the pure formless mind; a direct and immediate pointing to true reality which admits of no secondary pointing via names, descriptions, views, doctrines, symbols, images, icons, and the like.

Curiously, yet significantly, this Emptiness can be characterized as a kind of fullness. Emptiness in and of itself is truly Empty, but as lived out or activated in the world of living human existence it is truly non-empty and enlightens or illuminates all things. That is to say, the formless or awakened mind becomes a new or transformed basis for functioning in the world of forms, not a retreat center for withdrawal from that world. It functions in the world of form, but, by being no longer based in subject/object consciousness, it is no longer "stained" by it. The pure mirror reflects directly, immediately, and without subjectivity that which it meets, and it meets the world of form *as it is.* This is what is meant by the Buddhist statement, "true Emptiness, wondrous being." It is also what Buddhism calls *Suchness.*

What may be called enlightenment Buddhism could be restated as follows: the unenlightened mind, by definition bound to forms, rides those forms across the river into the formless. Once awakened to the formless, however, not only do the forms no longer bind one, they become vehicles, as it were, for riding back into the world-activating, embodying, manifesting, and confirming the formless. At least one Buddhist scripture says: "Form is Emptiness, Emptiness is form," or, "this very world in all its multiplicity is nirvana, and nirvana is it."

Of course there are other types of Buddhism that less obviously conform to this characterization. Even within enlightenment Buddhism there are different opinions about nirvana as transcending the world of forms or nirvana as involvement in forms. Outside enlightenment Buddhism, however, there are more popular or lay-oriented kinds of Buddhism for which crossing the river into enlightenment is a distant or even unimaginable goal. Rather, in these cases, the focus of religious activity is shifted to either more immediate and practical goals or to storing away merit for purposes of attaining a better rebirth in one's future lives. In these types of

"rebirth Buddhism" there is greater dependence on forms such as Buddhas and gods, scripture and rituals, priests and temples, or symbols and images. In this context the issue is less to transcend the forms into the formless than to "use" them as invested with sacred power in order to move ahead positively in one's individual or collective life. [. . .]

Artistic Foundations

It might be useful to think of religious art as that type of religious expression which representationally symbolizes, presentationally embodies, and performatively transforms varying life situations within the context of an understanding of sacrality and by use of aesthetic form (visual, performing, and literary arts). Such a way of "defining" religious art allows us to treat and distinguish the religious functions of art while at the same time discussing the arts themselves. To overlook these functions would be to miss the Buddhism in the art, or to risk seeing the arts as merely decorative appendages to what just happens to be a religion.

Perhaps the most important thing to underline at the outset is that most of the arts serving Buddhism have been varying forms of the visual arts (sculpture, painting, architecture), and that these arts have functioned primarily in ritual or meditative contexts where their meaning and power were designed to serve religiously transformative purposes. This is particularly true of the Buddhist arts of the first several centuries, that is, through the twelfth century. The *goma* (fire) rites of Shingon Buddhism, for example, function in part to invoke the symbolic and embodied power of the sculpted figure for internalization and use by the practitioner. However, that power is understood and used (for example for advancing toward enlightenment or effecting more immediate benefits); the art is functioning in a religiously transformative context, and is most definitely *not* "merely decorative."

The statement by Kukai quoted at the beginning of this chapter points to this transformative function: human expressions—for example language or the arts—may not be able to express or explain Dharma completely or satisfactorily as the realized or living truth-awareness (enlightenment), but they are necessary vehicles for transmitting meaning and for guiding people along the proper path. For the Mahayana Buddhism that came to Japan, the arts were not only important manifestations of Dharma but, as such, were important exercises in the *upaya* ("skill in means") by which the Buddhist teachings and practices constituted a *yana* (a "vehicle" for crossing over the river from ignorance to wisdom, or from *samsara* to nirvana). Although some parts of Far Eastern Buddhism were iconoclastic with regard to the use of language and the arts to express Dharma (for example cer-

tain parts of Zen), for the most part the arts flourished within Buddhism as important "fingers" both "pointing to the moon" (of enlightenment) and manifesting that moon in human expression. As such, they were crucial to this transformative (or "vehicular") function.

This transformative function might be understood slightly differently within the context of rebirth types of Buddhism where the Buddhist cosmology and salvific power are seen more literally as "external" powers awaiting invocation and use for personal and communal ends. These types of Buddhism can be called "other-power" (*ta-riki*) Buddhism since salvific power is located in celestial buddhas and bodhisattvas, or ritual words and gestures. In this case the same art work that functioned in enlightenment (or "self-power," *ji-riki*) Buddhism to help one get across the river to *bodhi* ("enlightenment") now becomes the sacred embodied presence of celestial powers, which can be called on to effect powerful (even magical) changes in one's current and future life.

Be that as it may, the Buddhist arts have served transformative functions by virtue of their distinctive ability to powerfully embody and represent Buddhist meaning and experience. Symbolically or representationally, these arts (from statuary to literature, and from architecture to painting) have pointed beyond themselves to Buddhist meanings of immense complexity and richness. [. . .]

The vehicular power of Buddhist art lies not only in its ability to reveal or representationally point to Buddhist meanings, but also in its ability to presentationally embody the very sacrality that forms the *religious* nature of Buddhism itself. If we can refer to the representational function of art as its "theological" function, we might well think of its presentational function as its "theophanic" function whereby sacrality is manifested in the experiential power of the moment. This function features the art work as a religio-aesthetic Presence, an immediate manifestation of Buddhist Truth (however understood), rather than as a symbol "pointing beyond itself."

[. . .]

Zen Art, Zen Aesthetic

> Your form being the form of no-form,
> Your going and coming takes place
> nowhere but where you are;
> Your thought being the thought of no-thought,
> Your singing and dancing is none other
> than the voice of Dharma.
> How boundless and free the sky of Samadhi!
> How refreshingly bright, the moon of Enlightenment! At this
> moment

what is there that you lack! Nirvana presents itself before you,
 Where you stand is the Land of Purity. Your person, the
 body of Buddha.
—Hakuin Zenji (1685–1768)

While both Zen Buddhism and its arts can be overemphasized in a discussion of Buddhism and the arts in Japan, there is no question that they both played a distinctive and important role in Japanese religio-cultural history. Zen's impact on Japan's arts and letters more broadly conceived—even into the contemporary period—heightens that significance still further. Together, the arts directly related to the Zen sect and the arts under the influence of Zen religio-aesthetic ideals constitute a body of material worthy of separate treatment.

The major sectarian forms of Zen Buddhism in Japan, the Rinzai and Soto sects, had their historic roots in the various Chinese forms of Zen which were, themselves, very significant in Chinese religio-cultural history. When these sectarian lines were established in Japan in the early thirteenth century, therefore, they brought with them already sophisticated art forms and aesthetic tastes uniquely related to the Zen institutions. These forms included relatively standard Buddhist iconography (statuary) and architecture (temples/monasteries), but had long since gone beyond such arts to distinctive expressions in painting and poetry. A mutually interdependent relationship between the great Zen institutions and the producers of high culture had already been established in the Chinese context, and thus the great Zen painters and Zen poets of China provided many of the models for the Japanese Zen arts.

These Zen traditions continued and grew in the Japanese context. Zen not only produced its own distinctive artistic forms (especially in painting, calligraphy, poetry, and gardens), but it also became a kind of patron of the arts in the medieval periods (Kamakura and Muromachi periods, thirteenth-fifteenth centuries) of Japanese cultural history. Operating hand-in-glove with the highest levels of social and cultural power, Zen's aesthetic styles and tastes dominated Japanese culture through these periods and remained important beyond them into modern times.

In general these arts played a slightly different role in their temple/monastery contexts than had the arts of Heian Buddhism. While aesthetic forms continued to be affirmed for a variety of reasons, the arts themselves were less central to or important for specific ritual/meditative practices. While we can still discuss these arts as "representative" of Buddhist meaning and/or "presentational" of Buddhist sacrality, the transformational (or "vehicular") role is less obvious.

This shift in the religious functioning of the Zen arts comes out in Zen's long tradition of suspicion (minimally) and iconoclasm (maximally) concerning vesting too much power and meaning in those "fingers pointing to the moon." Since ideational meanings (via language or artistic representations) can never—by themselves—be the lived/living realized Truth (i.e., enlightenment realization), one must be careful in the use of iconic representations. Zen's iconoclastic tradition, exemplified by a Chinese Zen tale in which a Buddha-statue is used for fire-wood, divests particular forms of any objective sacrality/power in order to realize the sacrality/power of one's own awakened experience.

These traditions did not stop Zen from creating art, but *did* stop it from investing too much in that art as a powerful vehicle in its own right for use in progressing along the path toward enlightenment. Most Zen arts are, in fact, more presentational in nature; that is, they give immediate and direct expression to Emptiness/Suchness experience—usually in the context of images of nature. Zen does, however, have its more representational (or even didactic) arts. [. . .]

It is no coincidence that Zen, looking for the most appropriate ways to give expression to Emptiness/Suchness lived out in the midst of the world, gravitated to aesthetic/artistic forms in order to do so. Not only were the Chinese and Japanese historical influences on Zen pressing it in the direction of aesthetic expression, but the very nature of direct, unmediated (enlightenment) experience finds a natural ally in the *aisthetikos* (Greek, "sensing the world") mode of human experiential knowing. If, as in China and Japan, the natural world is beautiful and sacred to begin with, then it is not difficult to see how Zen reaffirms and deepens even further a religio-aesthetic affirmation of the world as "one bright pearl" (Dogen). It is no coincidence, therefore, that the ox-herding pictures are all set within the context of nature as aesthetically perceived and expressed. For the acculturated Zen Buddhism of Japan, religious and aesthetic modes of awareness were often one.

The privileging of aesthetic sensibilities and images, and of specific artistic practices closely related to it, permeated the Zen institutions and practices throughout the medieval period in Japan. After all, *this* world was understood as the Pure Land and the Buddha-reality (as Hakuin says), and artistic expression of that "paradisal perspective" came naturally. Dogen, again, can speak for Zen:

> Not only earthly blossoms
> But this mind, pure as the
> Celestial gardens of an immaculate sky
> Offered to all the Buddhas
> Manifest here, there, and everywhere.

Yasuo Yuasa, from *The Body, Self-Cultivation, and Ki-Energy* [Translated by Shigenori Nagatomo and Monte S. Hull]

Eastern Body-Mind Theory

INTRODUCTION

While primarily studying Eastern intellectual and cultural history with my research centered on Japan, I have been interested in the body-mind relationship as conceived in philosophy, psychology, and medicine. Owing to this orientation I have developed an interest in the idea of a unique body-mind relationship running through the Eastern intellectual tradition. [. . .]

To be more specific, I have developed a special interest in the problem of self-cultivation [*shugyo*] as found in various Eastern religious traditions. In Japan self-cultivation methods have been established and transmitted to later generations ever since Buddhism's acceptance in ancient times. Zen self-cultivation is one example that has become well known worldwide. In addition, there are many other self-cultivation methods which vary from school to school. For example, some people must have heard of the *shugendo* of mountain ascetics which developed in synthesis with the old mountain worship, or *kaihogyo,* which was handed down at Mt. Hiei. These Buddhist self-cultivation methods greatly influenced the development of artistry and the martial arts. Systems of self-cultivation, slightly different from those of Japan, have been transmitted in Buddhist and Daoist traditions in China, and in the Yogic tradition in India.

[. . .]

SELF-CULTIVATION AND ARTISTRY

The theory of Buddhist self-cultivation has greatly influenced Japanese cultural history. It was incorporated into the arts toward the end of the Heian period (794–1185), and from the beginning of the Kamakura period (1185–1333) and extending into the Muromachi period (1338–1573), it shaped theories of artistry in such areas as *waka* poetry, Noh or *Nogaku* theater, and *Sado* (the way of tea). Furthermore, the theory of self-cultivation influenced the martial arts from the period of Warring States (1467 to c. 1568) to the beginning of the Edo period (1603–1876), giving rise to the theory of *Budo* (the way of the samurai warrior).

Generally speaking, artistic expression may be characterized as the pursuit of beauty. *Waka* poetry and literature express an aesthetic sensibility through the use of language or words, while sculpture, painting, and music express it through various sensible materials. In contrast, *Nogaku* or Noh theater and *Sado* attempt to express beauty through bodily movement. The artistic expressions of any ethnic culture are known to have an intimate connection with its religiosity when their origins are traced back, and in Japan a tradition was established to understand the essence of the arts based on the Buddhist self-cultivation theory.

Generally speaking, the goal of self-cultivation is to pursue "satori," and the goal of the arts is to pursue "beauty." Accordingly, the ultimate, ideal condition of aesthetic experience has been sought in analogy or comparison with the experience of satori. The term *"yugen"* (profound, suggestive mystery) is a case in point. Shunzei Fujiwara (1114–1204), a poet toward the end of the Heian period, was the first to use this term, which was suggested by the Tendai text *Makashikan*. (As previously mentioned, this text is a basic text on self-cultivation in Tendai Buddhism.) In short, Fujiwara Shunzei reasoned that a poet can achieve the ideal aesthetic state of beauty, or *yugen,* just as a monk achieves satori through self-cultivation.

In the Kamakura period (1185–1333), however, *waka* poetry was widely theorized in analogy with *dharani* in a theory called *waka-dharani. Dharani* refers to sacred spells used in Buddhism, and in this case, means a sacred word symbolically expressing the world of Buddhas. According to this theory, an excellent *waka* poem expresses the state of *yugen* in words, just as *dharani* expresses the state of satori which ordinary people cannot easily achieve. In this case, a poet pursues beauty, expressed by the word *yugen,* through the practice [*keiko*] of poetic composition, that is, through *training the mind* in attempting to compose better poems, just as the monk attempts to achieve satori through self-cultivation. Accordingly, the theory was formulated such that a poet can reach beauty by training and polishing his or her mind. This is the theory of *"kado,"* the way of *waka* poetry composition, which regards

the method of poetic composition as a kind of culturing and nurturing of the personality.

During the medieval period, this theory had an enormous influence on Noh, which was representative of the theatrical performances of the time. Since beauty is expressed through bodily movement in theatrical performance, unlike the case of *waka* poetry, the body-mind relationship became an important theme in this theater.

Zeami (1363–1443), a great systematizer and formulator of the Noh theatre, symbolically expresses beauty in Noh theatre by the word "flower" [*hana*]. The term "flower" corresponds to *"yugen"* in the way of *waka* poetry composition. In other words, Noh is an art which attempts to express the "flower" through the use of the body. Fundamental to this theatrical art are its performing techniques, which Zeami calls *"waza,"* and its training *"keiko"* (practice). Moreover, he understands *"keiko"* as corresponding to Buddhist "self-cultivation" [*shugyo*]. In other words, just as a monk endeavors to achieve satori through self-cultivation, so a Noh performer endeavors to make the "flower" blossom on stage by repeated practice of performing techniques. How, then, does the practice of performing techniques change the body-mind relationship?

When we are healthy, we do not think about our body, believing that we can move our body as our mind wishes. However, during infancy, a toddler has difficulty walking and is incapable of using even a pair of chopsticks. We have embodied or appropriated how to move our hands and legs through training [*keiko*] since childhood. A craftsman's skill and an actor's performance are acquired by professionally training their bodies in their respective fields, and their freedom of movement is expressed accordingly. With an amateur, the body does not easily move in accordance with the mind's wish. When I was a student, I learned a little dancing for Noh theater, and I recall that it was very difficult for me to synchronize my hands and legs with a song. However, accomplished and masterful performers execute their performing techniques decisively. In short, they can execute their bodily movements as their minds intend without the least miscalculation.

At the beginner's stage, whether in a theatrical performance, dance, or sport, the student tries to move his or her body first by thinking, as it were, through the head. In other words, the student intellectually understands and calculates the teacher's instruction, according to which he or she then tries to control the body. Nevertheless, the body does not move as one's mind wishes. Here, mind and body are lived *dualistically*. The mind *qua* thinking consciousness and the body, which is moved following the command of the mind, are understood separately. However, if one continues to train oneself repeatedly, the body gradually comes to move in accordance with the mind's wishes. When this occurs, the student understands the meaning of the teacher's instructions. This is because the "body" has

learned. When this process is repeatedly and diligently practiced, the student comes to move his or her body freely and unconsciously. The ideal state can be referred to as "body-mind oneness." There is no gap between the movement of the mind and that of the body in the performance of a master, for the master's mind and body are one.

This process of training is, needless to say, the same in Western theatrical performance and sports. However, since the tradition of a body-mind dualistic pattern of thinking is strong in the West, as previously mentioned, there is a strong tendency to train the body through conscious calculation. That is, the assumption is that training proceeds from mind to body, or from mind to form. Contrary to this order, the tradition of Eastern self-cultivation places importance on entering the mind from the body or form. That is, it attempts to train the mind by training the body. Consequently, the mind is not simply consciousness nor is it constant and unchangeable, but rather it is that which is *transformed* through training the body.

A point to be noted in this regard is that beauty in the arts is appreciated by an observer. In a theatrical performance, the audience is aesthetically moved by the drama performed on stage, and this is different from the pursuit of satori in self-cultivation. The pursuit of satori is related to the cultivator himself and not to other people. In contrast, the arts, whether Eastern or Western, presuppose the human relationship between producer and appreciator. Traditional theories of art in the West have understood beauty by emphasizing the standpoint of the observer. For example, according to Aristotle's theory of art, which is the classic theory of theater, the essence of tragedy is catharsis of the soul. The audience watching a tragedy empathizes with the mind of an actor playing a role in the drama, and is led to feel sorrow or lamentation, thus being emotionally moved. Catharsis of the soul refers to this function of being emotionally moved.

Eastern theater, of course, cannot disregard the audience's standpoint. The "flower," which is beauty in Noh theater, is that which the audience feels. However, a characteristic of Japanese artistry is that its fundamental emphasis is placed more on the *standpoint of the performer* than on that of the audience. The theory of *waka* composition maintains that a poet achieves the state of *yugen* through training in *waka* poetry, and Zeami's theory of Noh theater teaches the embodiment of "flower" by a performer. The theory of artistry explains the *catharsis in the soul of the performer* achieved through artistic production; the standpoint of the art appreciator is only secondary. The artist requires the catharsis and enhancement of his or her mind in pursuit of beauty, just as does the cultivator in pursuit of satori.

Zeami characterizes the relationship between the mind and body as "flower is mind, and its seed is performing technique." Performing techniques [*waza*] are bodily expressions. Special attention is needed here to

understand the expression "flower is mind." In order to make flowers blossom, one must sow seeds. The bodily training of performing techniques is comparable to sowing "seeds." When seeds are nurtured and cared for over a long period, flowers will blossom in due time. Zeami contends that the flower which blossoms through bodily training is the Noh mind, the mind of Noh performance. In Zeami's understanding, the body-mind relationship is taken in an order proceeding from the performing techniques [*waza*] *qua* the seeds to the "flower," that is, from the body or the form to the mind. Therefore, the mind is understood as that which is transformed and reborn constantly through the form, as the flower grows and blossoms.

Zeami calls the ideal state of "flower," "no-mind" [*mushin*] or "emptiness" [*ku*]. It is freedom in dancing without consciousness of its performance. In other words, it is a state of "body-mind oneness" where the movement of mind and body become indistinguishable. It is a state of self-forgetfulness, in which consciousness of oneself as the subject of bodily movement disappears and becomes the movement itself that is dancing.

In philosophical terminology, mind and body in ordinary circumstances are in the relation of subject and object. The most representative objects are material substances found in the external world, that is, things. Our body, too, exists as a kind of a material substance or object in this world (space). In contrast, the subject is that which cannot become object; that is, it is the bearer of conscious functions which can move or cognize the object. The mind in this sense is a subject (or more precisely the function of a subject). In short, the mind that is subject dominates and moves the body that is object, and this is conscious bodily movement.

In the state of body-mind oneness, as mentioned above, the mind moves while unconsciously becoming one with the body. That is, there is no longer a felt distinction between the mind *qua* subject and the body *qua* object; the subject is simultaneously the object, and the object is simultaneously the subject. The movement of the object that is the body is such that it is wholly the movement of the mind that is subject. The philosopher Kitaro Nishida (1870–1945) refers to this state as "pure experience" [*jun-sui keiken*] or "acting intuition" [*koiteki chokkan*]. Nishida maintains that "acting" is at the same time intuiting emptiness (absolute nothing [*zettaimu*]). He characterizes it as "becoming a thing, and penetrating into things." The mind becomes entirely a "thing," that is the body, demonstrating to the fullest the capacities and possibilities endowed in the body (a thing), and it moves penetrating things around it. The center of this bodily movement is a "stillness" in the midst of dynamism, just as the center pin of a top spinning at full speed remains stationary. Zeami calls this state "no-mind" [*mushin*] or "emptiness" [*ku*].

Shigenori Nagatomo and Pamela D. Winfield, "The Japanese Zen Garden: Seeing and Cultivating Micro-Macrocosmic Correlativity"

> To see the world in a grain of sand
> And forever in a flower
> To hold the universe in the palm of your hand
> And eternity in an hour.
> —William Blake, "Auguries of Innocence"

PRELIMINARY OBSERVATIONS

According to the Noh master Zeami (1363–1443), the actor who attains the highest rank of artistry possesses "the true flower in the bones." Such an expression correlating the horticultural with the human indicates a profound synergy between the two orders in the Sino-Japanese cultural tradition. In this tradition, the natural world-body and the individual lived-body are believed to transform one another through symbiotic and organic inter-cultivation.

The following examples specify particular Sino-Japanese formulations for micro-macrocosmic correlation, and indicate the transformative potential of cultivating external-internal energy exchanges. Just as *yin* and *yang qi* energies course through the veins of a given topography, so too does *yin* and *yang qi* flow through the acupuncture meridians of the body's interior landscape. Just as gifted *feng shui* geomancers discern and harmonize the auspicious confluence of earthly energies in one's outer environment, so too do sensitive acupuncturists or Reiki practitioners survey and balance the flow of vital energies throughout the body-mind's interiority. Just as Chinese and Japanese indigenous religions venerate sacred presences residing in specific mountains, rocks, trees, waterfalls, and islands, so too do Daoist inner alchemy and certain Shinto-Buddhist practices internally locate the mythic Mt. Kunlun or even the sacred Mt. Fuji at specific *tanden*

energy centers within the body-mind. The syncretic Ominuki school founded by Japanese monk Kakuan (d. 1234?) for example, taught that the cultivated body-mind could "see through" (*minuki*) and "take on" (i.e., internalize, in-corporate) the sacred presence of Mount Fuji into the adept's body-mind. Once we recognize the harmonious interreresonance of vital energies both outside and inside of ourselves, we recognize how the act of cultivating the exterior garden can make the internal body-mindscape blossom, or conversely, how cultivating the self can ultimately mean cultivating the country (*ji shen ji guo*). The Chinese alchemical treatise *The Secret of the Golden Flower* also employs horticultural imagery in proposing its ideal goal for human potential.

Such background information provides an important starting point for our discussion of the Japanese Zen garden. Zen Buddhism too maintains an interconnected web of being where the usual lines distinguishing external macrocosm and internal microcosm can be blurred. Given this worldview, it is easy to see the importance of being a participant in—not just an observer of—the environment. To this effect, the Zen master and garden architect Muso Soseki (1275–1351), versifies:

> Your compassionate mind soars like a summit.
> Some places smooth and gentle,
> Some places rugged and unapprochable.
> The mountain has no wish to be looked up to
> It is only people who look up in wonder.

In his *Dream Dialogues,* Muso further reiterates this unity of cultivating exterior and interior lived-spaces. He writes, "he who distinguishes between the garden and practice cannot be said to have found the true Way." The twentieth-century philosopher Nishitani Keiji echoes this sentiment exactly in commenting, "we are within the garden and are not just spectators, for we have ourselves become a part of the actual manifestation of the garden architect's expression of his own enlightenment experience." If there is indeed a sympathetic correlation between outer and inner and a concomitant energy exchange between the person and his/her environment, how does the Japanese Zen garden outside the person create resonances within? What specific techniques or garden layouts foster this macro-microcosmic correlativity?

CULTIVATING THE EXTERNAL GARDEN

To respond to these questions, let us consider the Japanese "dry landscape" garden (*karesansui*), which presents interesting, dynamic tensions

among the energies of the rocks. According to Yoshikawa Isao, there are
four types of stones, based on their relationship to one another, namely,
(1) the main stone, (2) one to five accessory stones, (3) unifying stones
holding the arrangement together, and (4) linking stones between the
main and unifying stones. The energy relationships among these four
types of rocks can in turn be categorized respectively as receptive, trans-
mitting, pulling, pursuing, attacking, or flowing, based primarily on the
diagonal juxtapositions of the main and accessory stones. (Only parallel
vertical placements constitute "stopping" energy relationships.) The
renowned contemporary Japanese-American sculptor Isamu Noguchi
adds, "Rocks belong . . . they know how to go just the way they're sup-
posed to go—back into the Earth." To the cultivated body-mind sensi-
tized to fortunate rhythms of rock placement (e.g., Ryoanji's melodic
arrangement of 5, 2, 3, 2, 3 stones), the Japanese rock garden becomes a
spatial and temporal matrix where dynamic energy exchanges are orches-
trated to produce a certain music of silence. To one attuned to these silent
rhythms, the garden is experienced as a *temenos,* or sacred place, where
one's lived body-mind (i.e., microcosm) resonates and reconnects with
the larger world-body-mind (i.e., macrocosm).

Zen contemplation gardens (*kanshotei*) like Ryoanji are designed to fos-
ter this micro-macrocosmic correlativity. The practitioner's body may sit
still on the verandah apart from the scene before them, but his/her mind
actively travels through the garden's world-body [fig. 4.2]. The inverse as
well holds true for Zen stroll gardens like Kokeji in Kyoto. Here, the prac-
titioner's mind ideally remains still even though his/her body may actively
travel through the ever-unfolding, ever-evolving world-body of the gar-
den. In short, the former contemplation garden fosters an active mind
within a stilled self-world body; the latter stroll garden fosters an active
self-world body in the midst of a stilled mind. It is because of this holistic
transformation of the participant-observer's body-mind in the micro-
macrocosmic garden that Nishitani claimed: "The garden is my Zen mas-
ter now, and it is your Zen master too." Now, how does this idea relate to
cultivating the internal garden?

CULTIVATING THE INTERNAL GARDEN

In contradistinction to "borrowed scenery" (*shakkei*), which extends the
eye out beyond the confines of the walled Zen garden, the "concentrated
scenery" (*shukkei*) of Zen's enclosed courtyard gardens focuses one's field
of vision within. It condenses natural forms and energies into miniature
containers called *tsubo;* it underlies the arts of bonsai cultivation and ike-
bana flower arrangement. The micro-macrocosmic garden, therefore, does

Fig. 4.2 Garden contemplation. Photo by Edna M. Rodríguez Mangual.

not only lie outside the walls of the house, or the Zen monastery, or even the body, but can also lie intimately within them. The transition between nature "out there" and (human) nature "right here," therefore, is a fluid one. By carefully pruning and regulating the tree's "five goings" (Earth, Water, Air [sun], Wood, and Metal [minerals]), or by arranging three tiers of flowers to suggest the unity of Earth, Human, and Heaven, the cultivated interior gardener can transform these mini-secret gardens into world-embracing meditations.

As Rolf Stein has shown, such holographic or metonymic (part for the whole) symbolisms entered into Japan with Kegon "Flower Garland" Buddhism. Well versed in Kegon doctrines, the sixteenth-century tea master Sen no Rikkyu (1521–1591) for example, knew that the visiting Shogun Toyotomi Hideyoshi expected to see a riot of his famous morning glories in full bloom. Master Sen deliberately cut them all down from his garden fence and placed one single, exquisite bloom in the *tokonoma* alcove for the Shogun to contemplate. According to Kegon Buddhism, that one single bloom mirrored all the other blooms in the entire universe.

From an experiential point of view, what is most important in the process of becoming attuned to micro-macrocosmic correlations is the internal landscape of the human body itself. The term *tsubo* used to describe the interior courtyard garden (*tsuboniwa*) is written with the character for

container. As Mark Keane has pointed out, however, two other homonyms for "tsubo" add related connotations of smallness and *qi* [Jap.; *ki*] energy acu-points. These acu-points, of course, are located within the human practitioner's body.

Daoist illustrations of the inner alchemist's subtle-body geographically map out an interior landscape of *qi* meridians and energy centers [fig. 4.3]. One notices the ocean of *qi* in the lower abdomen, the river of cerebral-spinal fluid, the intricate woods and fires of the digestive tract, a swirling whirlpool of *qi* around the heart, and a multi-tiered pagoda (trachea) leading up to towering mountain cliffs at the crown of the head. Though Zen rarely discusses *qi* and this landscape of the body explicitly, the thirteenth-century Soto Zen Master Dogen (1200–1253) did vividly state, based on his meditation experience: "seeing mountains and rivers is seeing Buddha-nature," for the "mountains and rivers are the body-mind of the Buddha."

What, then, does cultivating the external garden and the internal garden mean? Here we need to enter a philosophical reflection, particularly focusing on the meaning of how time and space of the Zen garden is experienced.

TIME AND SPACE OF THE ZEN GARDEN

We can approach the Zen garden from many perspectives; for example, from the point of a designer, an observer or a participant, or all of these perspectives together. Although each of these perspectives offers an interesting vantage point along with its accompanying theoretical and experiential possibilities, what is primary in living a Zen garden is to be a participant, for Zen emphasizes the direct and immediate experience that only participation can bestow. A designer attempts to artfully capture, in a Zen garden, a "beauty of irregularity" of physical nature by way of asymmetrical composition. He/she attempts to establish a micro-macro correlativity between physical nature and the garden he/she tries to create. On the other hand, an observer might impose a certain ideal image on a Zen garden from a perspective external to the garden itself, while perhaps noting a discrepancy between the ideal and the actual image. The discrepancy arises from an idea of perfection, which does not exist in Zen (or in its gardens), for Zen strives for completion rather than perfection. What makes a Zen garden complete is the actual "being in the garden" of a participant, for without the participant, the micro-macrocosmic correlativity can not experientially be brought to a meaningful attunement and interresonance.

The expression "being in the garden" already presupposes a certain definite way of participation. For example, it suggests that a Zen garden is spatially demarcated from other places of the world, and accordingly the

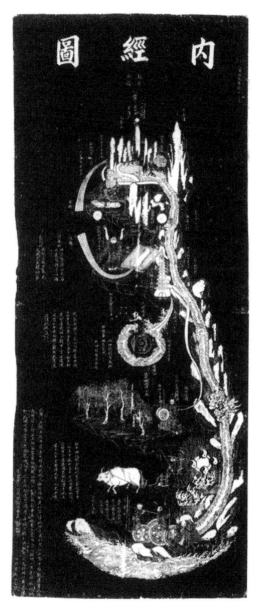

Fig. 4.3 Illustration of Inner Circulation. *China. Qing Dynasty, nineteenth century. Ink on paper. Rubbing. Rosenblum Family Collection, Newton, Massachusetts.*

preposition "in" implies that the garden is a container where the participant is (passively) situated. This is the vantage point of the designer and the observer, which follows the commonsensical understanding of space as a container. With this understanding of space, however, the participatory nature of the Zen garden is obscured, for the participant will be reduced to an object among many other objects in the artfully arranged garden. To avoid this reduction, we need to "see" in both the Zen garden and the participant a vital element of "living" in order to discern an experiential dimension of the micro-macrocosmic correlativity the Zen garden embodies as its *raison d'être*.

To illustrate the correlativity and how it affects us, let us observe the following fact. Ordinarily, our living body receives various stimuli from our living environments, both internal and external, but we as a conscious subject are not consciously aware of all of them, because our living body accepts them unconsciously and indiscriminately. Usually, we process them through our dispositional tendencies vis-à-vis our patterns of habituated emotional response, whose truth we know in negative terms only as stress. What this analysis suggests is that the living body assumes a definite orientation toward its living environments in such a way that it can mingle with them, with either pleasure or displeasure. The orientation of the living human body enables us to be attuned to its living environments so that an ambience is created that is neither internal nor external. What the Zen garden offers to the participant is a peaceful and harmonious ambience in an attempt to achieve, among other things, a reduction of stress. Psychophysiologically, the meaning of micro-macrocosmic correlatively lies in this point.

In this respect, a Zen garden is the ambience of a specific space-time, but time and space in the Zen garden announce themselves in an integration of space-time, that is, in the interfusion of a concrete temporalization and spatialization without making an intellectual abstraction of how time and space are thought, because the living human body rides on the rhythm of nature there. In fact, because of this interfusion in the ambience, space-time is one experience, that is, time and space are inseparable from each other (Dogen). In this ambience, clock time is forgotten, along with the idea of time as having a linear progression from the past to the future through the present. Time cannot be measured in this ambience as a quantifiable homogenous unit. Here, time is not the foundational limiting condition for our experience either (Kant). Nor is it like a "fleeting image of eternity" (Plato). According to Zen, these are all conceptual abstractions, distanced from the immediacy of experience. Space, too, is not a container nor a foundational limiting condition, nor a place of displacement for the volume of an extended thing. To modify the statement of Zen Master Dogen, space in the Zen garden is captured as "a bird flies the sky and the sky flies the bird." What makes this space a

living space is the dynamic, interdependent, bilateral play of both the garden and the participant, from which a living time and space emerges as an ambience. The Zen garden is a dynamic activity in the stillness of motion that discloses its ambience by a non-dualistic "coming-together" of the participant and the garden. To the perspective of a participant, this coming-together is translated into an experience of "here and now."

In this connection, one may reasonably ask, how far and wide is "here," and how long is "now"? Are they each limited by a present perceptual experience? In the case of "now," for example, is it an internal phenomenon of consciousness that allows the participant to experience time sometimes as a "memory" (i.e., retention) and some other times as an "anticipation" (i.e., "protention") in the ever flowing stream of "present"? And in the case of "here," is it delimited by the participant's range of perception within the sensory field, situating the participant as the point of reference? Zen's response to both of these questions is a resounding "No!" and Yes!" however contradictory it may sound. "No," insofar as the perceptual model implies an egological "human, all too human" stance (Nietzsche), and "yes," because the human, while living, cannot depart from the "here and now." Yet, in the "here and now" a Zen garden invites the participant to experience both timelessness and spacelessness; timelessness where there is no distinction between past, present, and future nor between "before" and "after," and spacelessness where there is no distinction between the whole and its parts. Nevertheless, the timelessness and spacelessness for a Zen participant do not result from a logical transcendence like the idea of eternity that stands outside of a temporal series, nor like the space where there is no content of experience. Timelessness and spacelessness are obtained through a non-egological, non-dualistic orientation to the Zen garden, which is experientially achieved by means of a rigorous process of self-cultivation. Timelessness and spacelessness are the natural and original zone of human beings.

In the "here and now," Zen demands its participants to experience its ambience by riding on the rhythm of nature, that is, in the concrete interfusion of temporalizing space and spatializing time. The Zen garden presents an ambience in which the original human nature (or authentic self) is realized for any participant who is willing to enter this zone.*

Note

* Shigenori Nagatomo wants to express his appreciation to Michael Graham of Temple University for his editorial comments, and to Damon Cory-Watson, Arendt Spese, Matthew M'Cockey, Jessa Munion, and Terresa O'Herron of Haverford College for giving him many useful comments to improve the section dealing with "Time and Space of the Zen Garden."

Mark Holborn, from *The Ocean in the Sand*

On the outskirts of Kyoto is the temple of Ryoanji. Originally the site of a villa, in 1473 it was converted to a Zen temple by a military leader, Hosokawa Katsumoto, a powerful general in the Ashikaga government. The first temple was destroyed in the Onin war, but it was rebuilt by Katsumoto's son, Masamoto, in 1488. It is assumed that the garden of the existing temple was laid out during that reconstruction. The temple nestles among the lower, forested slopes of the mountains. A small pond, Oshidori, said to be a thousand years old, lies below the buildings. It was once filled with mandarin ducks; its banks are lined with trees and a bridge links the shore to one of three islands.

The first time I visited the temple, I went in the early morning, at a time when I hoped it would be quietest. It had been raining, the sky was overcast, but a stillness was in the air, like the calm after a storm. I followed a gravel path around the lake, crossed a narrow bridge and climbed the steps to the temple above, with its high roof curving as steeply as the slope of the mountains behind. Once within the temple complex, I walked out on to the polished wooden verandah, which ran alongside the rooms of the abbot. The sliding screen partitions were drawn fully open; the barriers between outside and inside were down.

The verandah faces a rectangular area, about twenty-five yards long and ten yards wide, which is enclosed on three sides by a wall, stained and mottled with age [fig. 4.4]. The wall is made of clay and oil of rape seed, and is roofed with the customary heavy, grey tiles. Within the rectangular area are fifteen stones, which lie as if scattered in five groups on a background of coarse, grey sand. The sand is raked in circular patterns around the groups of stones, and in straight, shallow furrows over the remaining surface. There are no plants except for some moss at the base of the stones. There is a balance of forms between and within each group of stones.

The verandah is raised slightly above the ground and immediately beneath it is a border of round, black pebbles. After the rain the sand

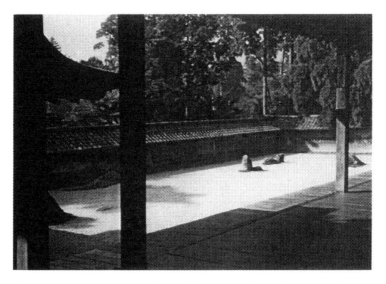

Fig. 4.4 Contemplation garden at Ryoanji, Kyoto, Japan. Photo by Lynn Perry Alstadt.

was a rich, dark color, moisture hung from the leaves of the surrounding trees, water from the eaves splashed on the pebbles. The atmosphere was meditative.

During Tokugawa times the garden was called "The Garden of Crossing Tiger Cubs." This symbolized a Confucian moral of the good ruler protecting his country. But any symbolical analysis misses the vision of an awareness that is far more intuitive. As Matsukura, the Abbot of Ryoanji, said, the garden might better be called "The Garden of Nothingness" (*Mu-tei*) or "The Garden of Emptiness" (*Ku-tei*) than "The Garden of Stones" (*Seki-tei*).

I was alone with the garden. My first reaction was to sit and collect myself. It was tempting to pace the verandah, to stoop and examine what lay before me from innumerable different angles, but there would be time for that later. Someone whose eye was trained to select patterns might have found the situation overwhelming; however, the patterns were striking not because they were in any way obtrusive, but because they emanated calm. The basis of the Zen discipline is the practice of meditation, *zazen,* which involves literally emptying the mind. The gardens, which were infused with the Zen spirit, were designed to be experienced from a position in which the viewer himself was as balanced as the arrangement before him. Such a position was a seated point of rest; you were not required to move

out into the garden—it could be viewed as a complete image from the point of your own equilibrium.

Two hundred years before Ryoanji the cult of Amida had fostered the hope for some future salvation in the Pure Land of the West. The earlier gardens inspired by the Pure Land sought to reproduce the image of the idealized paradise. The imagination had been focused on the future, the fantasy had been nurtured and to see the garden as a complete image, one had to explore the dream. Zen had shifted the imagination from this preoccupation with the future, back to an awareness of the moment and the immediate. The garden, with its inherent balance, guided you to that point of equilibrium, when the sense of moment was captured.

Within the space of the garden, framed by the wall, images are compressed that extend from a view of landscape that is cosmic, to a pinpoint focus on matter which is microscopic. You can refer immediately to the native landscape that is reflected—the rocks stand like the rugged islands in the waves of an ocean, an image so familiar after the native coastline; or they rise with the thrusting volcanic rhythm of the mountains, the sand swirling around their base like cloud lingering on the lower slopes. The garden encompasses the depth of vision, the sense of space, and the grandeur of scale that was explored by the painters, but by virtue of its abstract form, it offers further experience. As the eye closes in from the panorama and the illusory horizon is reduced, the wave-like patterns of the sand flow with the force of the current rushing against the stepping-stones of a river. When you concentrate further on this wave-like motion, the raw image itself is revealed. The ripples of the sand flow as patterns of energy, as lines of force on some molecular scale, polarized around the stones. The wave motion is itself the fundamental image, rising and riffling, but never actually moving, only appearing to move.

Unlike we Westerners, who count out achievements against the measure of time, the oriental vision saw time flow by with the ever-changing season and realized linear movement as only an illusion; the cycle always returned to the source. This was the constancy that contained the human identity. Man, buffeted and stroked by the waves of experience, developed and died, but beneath all that movement there was a factor that never changed, the center of his "being"—his "self" . . . All this has been achieved with a simplicity that we in the West might interpret as austerity.

The asymmetrical arrangement of the stones yields a vital harmony, but to dissect the groups and attempt to analyze the contrasts they contain, would be to deny the spirit with which the garden was created. The design was born not from a calculating sense of appropriate balance, but from a feeling for space, texture, and rock, that had its origins in a more instinctive knowledge. It can be clearly understood that the arrangement of

the stones was an art, and as such it would employ specific techniques. The asymmetry itself was revealing, for there was an odd number of groups and within each group there was an odd number of stones; by means of a technique known as "*hacho*," which meant "breaking the harmony," the actual balance was obtained.

Zen had cut through the social strata, devoid of the symbolism of Esoteric Buddhism, the Zen-inspired art was accessible to those outside government circles and the higher levels of the social hierarchy. The Zen temples moved in the opposite direction to the Esoteric sects, who often criticized the unconventional behavior of the Zen adepts, and the Zen temples patronized social outcasts. In medieval Japan there were four distinct classes: samurai, merchants, farmers, and artisans. But like in the Indian caste system there was a sector of society who were considered "untouchables." (The origins of this class may in fact lie in the Indian system, which could have been introduced by the early Buddhist missionaries.) Their ancestors were said to be vagabonds and thieves. The untouchables were suitable for the impure work of slaughter, tanning, or clearing the drains. They were once referred to as "hinin" or nonhumans. (Today a million of these "untouchables," known as "burakumin," still live in isolated enclaves in Japan.)

In fifteenth-century Kyoto they were known as "Kawaramono," meaning "river-bank" people in reference to the slum area where they lived. These kawaramono often worked in the temple gardens and in time became garden designers. One of Yoshimasa's famous gardeners was a kawaramono called Zen'ami, who had a high reputation for his skilled stonework. On the back of one of the stones at Ryoanji is an inscription of two signatures, Kotaro and Seijiro. Research has revealed that these men were kawaramono working in Kyoto gardens at the end of the fifteenth century. Perhaps the purest and most powerful of all the gardens was shaped by the hands of men who had been regarded as so impure that they were not even human.

The kawaramono probably laid the stones under the direction of Soami (?–1525), a tea master and painter, to whom is attributed the actual design of the garden. Soami came from a line of painters, all of whom employed the wash technique that had been developed by Sesshu. Noami (1397–1471), the grandfather of Soami, had been an attendant to the shogun and had catalogued the shogun's collection of Chinese paintings: he was considered the leading authority of his time. His son Geiami (1431–1485) also had a high reputation as a painter. Seami, the third painter in the extraordinary family line, had been patronized by Yoshimasa and his name is often linked with the Garden of Ginkakuji. He completed his grandfather's catalogue, "Kunai-kan socho-ki" (Notebook of the Shogun's Art Secretary), which was a most authoritative survey of Chinese

art, and was himself highly regarded as an artist. Ironically, though this family worked in the Zen temples, at one time they were certainly Amidists, as "Ami," the suffix of their names, suggests.

Soami's talents were diverse and his Garden skill was not confined to the use of stone and sand. By using moss he created another form of dry landscape, which also contained the image of water. In a quiet, secluded corner of the Great temple complex of Daitokuji in Kyoto is the small Zen temple, Ryogen-in. The original meditation hall, *hojo,* which was built in 1502, still stands. Beside the verandah of the hall is the garden of Ryogin-tei. Again a wall, roofed with tiles, encloses a rectangular space and pebbles border the edge nearest the verandah. The area is even smaller than the garden of Ryoanji. The surface is covered with gently undulating moss. A few stones lie embedded in the moss; azaleas, which have been cut very low, grow around the base of several rocks. About half-way along the Garden, a tall flat-topped stone protrudes close to the far wall. This stone is said to represent *Shumisen,* the core of the universe.

The scale of Soami's moss garden, like that of Ryoanji, could be seen as a huge panorama. Ryogintei has been referred to as an image of the ocean, the waves of the moss gently lapping the rocky islands. But the expanse of green moss immediately struck me in a different way from the other dry landscapes that I had seen. It was certainly an extensive panorama, broken by the towering mountains, but the moss slopes had the texture of the thickly-forested hillsides of Japan. I changed my focus to the detail of the moss immediately below me. Its fine needle structure arranged around the stem was the image of a tree, like the tall Japanese cryptomeria, *sugi* (*Cryptomeria japonica*), which grows in the forests of the hills surrounding Kyoto.

Just as the Amidists projected the image of the paradise mandala from the point in space, the Zen garden of Soami with its detailed focus on Nature also contained an image that we today might find in flight—a view that was aerial; it was a bird's-eye panorama that could compress a hundred miles into a single foot.

Later I turned and followed the verandah of the meditation hall. Where the verandah linked the building with the rest of the temple complex was a still smaller garden only a few feet wide. At one end of the rectangle was a single upright stone; at the other end there were two. A low, flat stone lay on the sand, which spread in circular ripples around it. The stone floated in the pool of sand. In the background was a well; the element of water was all around, though nowhere in Ryogenin is there a stream or cascade. The image of the sea was right there in the sand.

Also within the precincts of Daitokuji is another small Zen temple, Daisen-in, founded by the priest Kogaku in 1513 [fig. 4.5]. The abbot's study faces a garden which is about fifteen yards long and only three yards

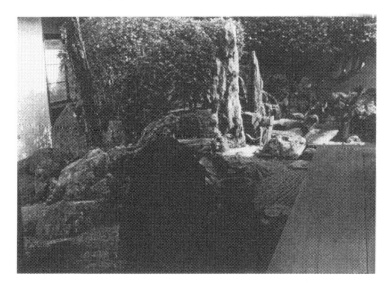

Fig. 4.5 Garden at Daisenin, Kyoto, Japan. Photo by Lynn Perry Alstadt.

wide, at the back of which runs a long, white, plastered wall. The study it-self is decorated with sliding panels on which Seami painted a magnificent set of landscapes. The design of the garden is traditionally attributed to Seami, though it could also have been the work of the founder himself. When you are seated by the edge of the room, the garden flows from left to right (north to south). In the left-hand corner are some tall rocks and small trees, which despite their size fit perfectly into the scale of the area. The source of the motion is in these rocks; it is as if a great cascade plunges to a torrent below. The sand at the foot of the stones is raked into a swirling eddy of patterns.

The tall, upright forms are balanced by a single horizontal slab of rock that traverses the sand like a natural bridge over the rushing stream. As you follow the current, you see pointed rocks that border the sand like a deep mountain valley. The garden is divided by a wooden bridge, which spans the sand and forms a walled partition. In the middle of the partition is a cusped window, *Kato mado,* which frames a view of the tall rocks of the cascade. Beyond the bridge the sand opens out from a stream into the mouth of a great river. An extraordinary boat-shaped stone points in the direction of the current. At the far end of the garden, the patterns in the sand curve under the verandah itself and disappear from sight. The sand flows out into the sea.

Suggestions for Further Reading

Bertheir, François. *Reading Zen in the Rocks: The Japanese Dry Landscape Garden.* Translated by Graham Parkes. Chicago: University of Chicago Press, 2000.

Bibb, Elizabeth. *In the Japanese Garden.* Photographs by Michael S. Yamashita. Golden, Colorado: Fulcrum Publishing, 1996.

Holborn, Mark. *The Ocean in the Sand: Japan: From Landscape to Garden.* Boulder, CO: Shambhala, 1978.

Hume, Nancy G., ed. *Japanese Aesthetics and Culture: A Reader.* Albany: State University of New York Press, 1995.

Itoh, Teiji. *The Japanese Garden: An Approach to Nature.* New Haven: Yale University Press, 1972.

Nagatomo, Shigenori. *Attunement Through the Body.* Albany: State University of New York Press, 1992.

Keiji, Nishitani. *Religion and Nothingness.* Translated by Jan Van Bragt. Berkeley: University of California Press, 1982.

Nitschke, Günter. *The Architecture of the Japanese Garden.* Cologne: Taschen, 1991.

Little, Steven. *Taoism and the Arts of China.* Berkeley: University of California Press, 2000.

Pilgrim, Richard B. *Buddhism and the Arts of Japan.* 2nd ed. Chambersburg, Pennsylvania: Anima Books, 1993.

Rimer, J. Thomas and Yamazoki Masakazu, trans. *On the Art of the Noh Drama: The Major Treatises of Zeami.* Princeton: Princeton University Press, 1984.

Rolf, Robert and John Gillespie, eds. *Alternative Japanese Drama: Ten Plays.* Honolulu: University of Hawaii Press, 1992.

Stein, Rolf. *The World in Miniature: Container Gardens and Dwellings in Far Eastern Religious Thought.* Translated by Phyllis Brooks. Stanford, CA: Stanford University Press, 1990.

Varley, H. Paul. *Japanese Culture.* 4th ed. Honolulu: University of Hawaii Press, 2000.

Yasuda, Kenneth. *Masterworks of the Noh Theatre.* Bloomington: Indiana University Press, 1989.

Yuasa, Yasuo. *The Body, Self-Cultivation, and Ki-Energy.* Translated by Shigenori Nagatomo and Monte S. Hull. Albany: State University of New York Press, 1993.

 Section 5

Darshan

Seeing the Hindu Divine Image in the Age of Mechanical Reproduction

> *When Hindus go to a temple, they do not commonly say, "I am going to worship," but rather, "I am going for darshan." They go to "see" the image of the deity present in the sanctum of the temple. . . . The central act of Hindu worship, from the point of view of the lay person, is to stand in the presence of the deity and to behold the image with one's own eye, to see and be seen by the deity. . . . The prominence of the eyes of Hindu divine images also reminds us that it is not only the worshiper who sees the deity, but the deity sees the worshiper as well. The contact between devotee and deity is exchanged through the eyes.*
>
> · *Diana Eck, Darshan*

A Sufi Muslim contemplating a nearly illegible calligraphic script, a Zen Buddhist in a rock garden, and an Orthodox Christian gazing on an icon of Jesus Christ all realize (however unconsciously) that seeing is an active practice bound up with the visible *and* the invisible, the body *and* the mind. Through this process, the viewer is transformed into a participant by way of a visual interaction.

In a range of ways, the Hindu experience of visuality expands the interactive nature of religious seeing as it has been developed so far in this volume. In this section we move outward beyond the relationship between viewer and image to illuminate the role that the ritualized environment plays in perception. In this context we find that religious seeing takes place within particular ritual settings and does not begin and end with the individual

looker, the medium, or the message. Religious seeing is set within a series of
ritual rules that *frame* the experience for the viewer, providing boundaries for
what is seen and *how* objects are seen. Vasudha Naryanan sums up this ritu-
alized seeing:

> Hindus worship the supreme being in temples in the form of an "image," a
> word often used (together with "idol") to translate the Sanskrit *murti,* which,
> however, is more accurately rendered as "form," "embodiment," or "incarna-
> tion." Most Hindus think of a sacred image as an actual incarnation of the
> supreme being, a form taken by the godhead in order to receive worship.
> During a consecration ritual called *prana pratishta* ("establishment of
> life"), an image ceases to be gross matter and becomes an actual presence or
> incarnation of divinity on earth. The divine spirit is believed to remain in
> the icon for as long as devotees wish.[1]

The introduction to this volume gave a striking example of a similar
process, as the substance of cowdung is used to form an image of the
highly-revered Krishna [see fig. 0.1]. Incarnation, in other words, can occur
through a great variety of substances and media.

In the midst of such activity, one highly significant consequence will be
highlighted through this section: if vision is a material as well as an intel-
lectual process, than the "seer" will simultaneously "be seen." As the last
section noted, with reference to Zen Buddhism and the landscape gardens
of Japan, seeing is an *embodied* experience. And if it takes not only an eye
and a mind to see, but a whole body as well, then that body is itself a phys-
ical entity that is seen by others. A person looks, and is simultaneously
being looked at; devotees and objects of devotion are intertwined with
each other. In the Hindu setting, moreover, the worshippers are looked at
by the gods and goddesses who are being worshipped. Seeing moves in
more than one direction; it is a dynamic interchange between viewers,
with the deities themselves taking part in the activity of seeing. These si-
multaneous and multiple directions of seeing are part of what is implied in
the Hindi term *darshan* (Sanskrit: *darshana*), a term to which all of the ex-
cerpts in this section will refer.

MASS REPRODUCTION AND RELIGIOUS SEEING

Yet, what happens when this interactive seeing is brought into the "mod-
ern age"?[2] We can imagine such interactivity with beautiful hand-made
products like gold-plated Eastern European icons or exquisitely produced
calligraphic metalworks, but what if the images being looked at are made
of plastic in a factory and produced by the thousands? Do mass media and
a global economy ruin the possibilities of religious seeing? Do television

and film diminish the religious significance of images? Does a mass-reproduced image lose its "aura," as Walter Benjamin suggests? Is the medium really more important than the message?

Contrary to many views that imagine modern culture to be tainted by cheap reproductions and the mass media, one of the Hindu responses has been to take these new forms of media and incorporate them into devotional practices. Throughout contemporary India, one finds roadside shrines made from cardboard boxes and plastic deities, or mass-printed calendars fixed to walls in the midst of household shrines, or commercial labels taken off shipping boxes and framed in a household shrine, or television shows being watched with great devotion by extended families. David Morgan's excerpt in section two already began to hint at the impact of mechanical reproduction on religious seeing, and here we have the chance to extend these movements even further. Intriguingly, a poster from Madras visually shows the way in which this has happened in India as it takes Warner Sallman's *Head of Christ* and transposes it into an even further mass reproduced image [fig. 5.1]. This image itself perhaps speaks more on Hindu visuality than this introduction!

There are three interrelated elements of visuality that are of concern in this section: the *message* or subject matter of the image, the *medium* of the image, and the *performative setting* in which the image is seen. Their interrelation may be seen, for example, when one considers how the visual encounter with an image of a goddess will be different if the goddess is depicted in a film or as a sculpture. Oversimplifying greatly, the differences are at least evident if you consider that a viewer sits in a still position in the movie theater with the images moving and changing in front of the viewer. To the contrary, when seeing a sculpture the viewer moves around and gains new perspectives on the unmoving sculpture. This difference in ways of seeing would support media theorist Marshall McLuhan's famous claim that "the medium is the message." Whatever the "message" that is being communicated, it will change depending on the medium through which it is communicated.

Yet again, in Hindu traditions the goddess in film and the goddess in bronze would both be worshipped with equal devotion, and ritual offerings (*puja*) would be given to either image. Dennis Hudson considers, "Worship through puja is based upon the belief that deities have differing material forms invisible to us, but which may become visible through their representation by, or embodiment in, objects we can see, touch, and handle."[3] And Richard Davis's excerpt below particularly complicates McLuhan's maxim as he discusses the same object (i.e., same "message" and same "medium") in two different ritualized settings. We must therefore amend McLuhan's message and say that both medium and message

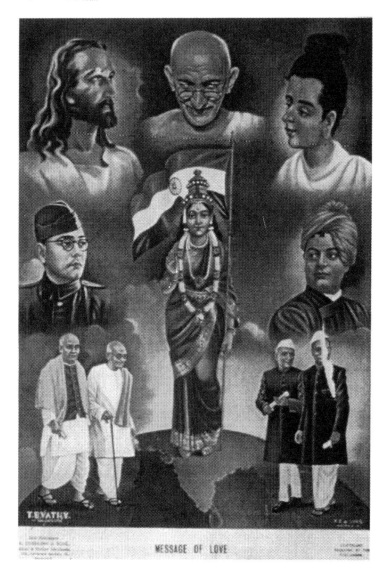

Fig. 5.1 "Message of Love." Poster from Vathy Studios. Mid-twentieth century. Madras, India.

are altered depending on the performance setting in which seeing (*darshan*) occurs.

Several recent publications have implicitly pointed out how an understanding of the performance tradition in South Asia offers a variety of fresh ways to see the relationship between message, media, and the performative milieu. Along the way they have suggested that one will not fully comprehend a "text," much less a tradition, if one merely reads printed words in a book, no matter how sacred that text may be. Tradition must be *transmitted*, Lawrence Babb argues, and the "most focused transmission occurs mainly in what have been called 'cultural performances': the rituals, discourses, tellings of myths, recitations of texts, and the like that we normally consider manifestations of 'religion.'" Even so, as Babb continues, "nothing is truly fixed; time inevitably deposits new layers over previously stored materials, and each generation finds its own new ways of construing the deposits of the past."[4] Within South Asia, one could argue, it has been the performance tradition that has enabled the continuation *and* the alteration of religious tradition, both at the same time. Just as we have seen contemporary Islamic artists find continuity and change in calligraphic scripts, Hindu religious practices maintain tradition through the very changes that performances allow.

Then again, it must quickly be pointed out that considerations of the performance of a text, rather than merely "what it says," does not entail total freedom to break with tradition and develop an individualistic interpretation. A performance, in its ritual sense, has certain sets of rules that provide a frame for the action. To elaborate by analogy, in filmmaking a cinematographer will zoom in or out, pan left or right, or tilt the camera up and down to make sure figures stay "in frame" (and other figures and objects stay out). The camera "frame" gives dramatic action a context within which play can take place. Thus, "rituals are not safe deposit vaults of accepted ideas," Richard Schechner considers, "but in many cases dynamic performative systems generating new materials and recombining traditional actions in new ways."[5] The ritual frame is provided by "traditional actions," even while "new materials" are generated within this context.

In this section, then, we will look at a number of instances in which the interactive, performative nature of *darshan* continues to occur in India even as the mass media of film, television, and print have replaced older modes and materials of creation. We will note both the traditions and the new materials, and how they interrelate in dynamic ways.

The Readings

The principal meanings of the term *darshan* for a study of Hindu visual culture are brought out in the excerpt from Diana Eck. This reading, from

her highly popular book, *Darshan,* details some of the experiences of Hindu religious devotion. India's is a highly visual culture, and she claims "India must be seen to be known." Seeing may be believing, but it is also *knowing,* a knowing that is understood and felt by the body and the mind. Eck's excerpt thus gives some glimpses into Indian Hindu life, and ends with a suggestion that film becomes an important way for students of Hinduism to understand the religious tradition in a fuller way. As she puts it, "Raising the eye from the printed page to the street or the temple, as conveyed by the film, provides a new range of questions, a new set of data."

As this last quote might hint, Eck's work is part of a much wider shift within religious studies away from verbal/linguistic and structural knowledge about other religions and cultures toward more experiential and, what we might call in the context of this volume, "aesthetic" knowledges. In other words, such knowledge is contextual and bodily. What this entails is that a fuller understanding of religions cannot stop with reading sacred texts, but must take into account the religious practices that evolve through a culture's history apart from what the *printed* texts say. Or again, religious studies must account for how the performative context alters both the medium and the message of the text. This shift in methodology should be evident throughout this volume with its emphasis on "religion and visual culture," but is restated here because it is perhaps more apparent in Hinduism than other religions and Eck's work stands as a key text for such a shift.

In light of this, it is interesting that many of Eck's initial points come from the work of Jan Gonda, whose study of the Vedas—some of the oldest religious texts in the world—emphasizes the power of seeing, both for creating as well as destroying. (Indeed, the term "veda" itself is an ancient forerunner to the terms "video" and "vision.") Because there is such an intrinsic power of the eye, the *mode* of seeing is crucial and must be bound by rituals and rules so as to maintain order in the world. One of those mentioned by Eck is the "eye opening ceremony" in which the eyes are the final part of an icon to be created and must open onto something pleasing and pure.

While Eck provides some general terms for understanding religious seeing in a Hindu context, the following three excerpts tell of specific instances of *darshan.* The next reading comes from Richard Davis, who extrapolates on the differences between the Western, detached "museum seeing"—where objects are meant to be looked at on display but not touched—and Hindu "temple seeing"—where objects are imbedded in a ritualized context in which intimate touch can occur between image and viewer. In other words again, the context in which seeing takes place changes the nature of the visual interaction.

Davis tells the story (the "biography") of a pair of sculptures and their contexts. In Davis's narrative, sculptures of the god Shiva and his consort, the goddess Parvati, travel through time and space and arrive in two drastically different settings. The sculptures originally came from the Thanjavur District of India in the eleventh century C.E., and their twentieth-century rediscovery and consequent display in modern, Western museums somewhat dislocated them from their "home." The difference in the two times and places in Davis's story is instructive for understanding how the ways we see, and the manner in which religious seeing occurs, is affected by one's cultural location. The Hindu seeing of images takes place amidst rituals of feeding, bathing, and touching the icons, while museum seeing animates images through a more detached, "visual and interpretive attentiveness," referred to by Svetlana Alpers as the "museum effect." Yet, rather than bemoan the detached viewing that takes place in modern museums, Davis is careful to argue that there is a different "sacred" space that is also set up within modern museums (as Lutgendorf similarly argues in the final excerpt with regard to television), even if it goes by the name of "secular."

Indeed, Carol Duncan perceptively suggests in her book *Civilizing Rituals,* that the installation (lighting, layout, placement of art objects) of the Western museum is uncannily similar to the structures of religious rituals. Following the anthropological writings of Victor Turner and others, Duncan suggests how museums work with rules similar to those of religious rituals in the sense that the museum experience is: (1) a *liminal* experience, that is, out of the ordinary, day-to-day life; (2) a *transformative* experience, the viewer is changed as result of the visual interaction; and (3) *performative,* visitors themselves enact the ritual of seeing. Two hundred years ago, the German poet Goethe similarly elaborated on the sacredness of the museum after a visit to the Dresden Gallery:

> That *salon* turning in on itself, magnificent and so well-kept, the freshly gilded frames, the well-waxed parquetry, the profound silence that reigned, created a solemn and unique impression, akin to the emotion experienced upon entering a House of God, and it deepened as one looked at the ornaments on exhibition which, as much as the temple that housed them, were objects of adoration in that place consecrated to the holy ends of art.[6]

But Goethe later realized, as Duncan relates in a way that is important to keep in mind in any display of visual objects, "that the very capacity of the museum to frame objects as art and claim them for a new kind of ritual attention could entail the negation or obscuring of other, older meanings."[7] Thus, it is not simply the case that the medium changes the message, but that the performative setting for the medium changes the message

as well. This is precisely what happens to the bronze statues of Shiva and Parvati as they are removed from their "original" ritual context and put on display in a new ritual context.

The final two readings by John Stratton Hawley and Philip Lutgendorf each demonstrate some of the effects of translating content or subject matter from one medium into another. At the same time, it is the performative nature of *darshan* that allows continuity in the midst of these otherwise disruptive translations.

The reading by Hawley is taken from the introduction to a collection of essays on the goddess traditions in India. Paying attention to the diversity of manifestations of the goddess, Hawley tells of a 1975 popular Indian film that, for all practical purposes, "invented" a new goddess—or at least made a very obscure goddess into a prominent one. Drawing on the imagery of mass-produced posters and calendars that are visible throughout India, the movie took already-popular images and combined them with older goddess myths to produce a "new" story and a "new" image. India has a film culture that makes Hollywood and Paris look miniscule by comparison, with over eight hundred new films being produced every year (many of them in Mumbai). Through this vastly popular medium, the new goddess, Santoshi Ma, was rapidly taken as a deity worthy of devotion by many people throughout Northern and Central India. Here, the medium can be seen to alter the message, for without her existence in a film Santoshi Ma would most likely have remained little known.

Yet again, this was not simply a creation out of nothing, for as Hawley considers, "Her new devotees could immediately recognize many of her characteristic moods and attributes, and feel them deeply, because she shared them with other goddesses long since familiar to them." While older scholarship on Hinduism (as written by Westerners) often discussed the "trinity" of male Hindu gods—Brahma, Vishnu, and Shiva—recent scholarship tends to emphasize Vishnu, Shiva, and Devi (the generic name for the Goddess) since these are the three key figures in actual religious practice (Brahma is rarely worshipped today). More critical understandings of the importance of gender to the study of culture and religion have also helped to bring about this emphasis on the goddess. The goddess tradition is over two thousand years old in India, and represents a stunning diversity of manifestations, from Kali (the "fierce" goddess, often depicted in scenes of violent destruction), to Lakshmi (goddess of wealth and good fortune), to Saraswati (goddess of knowledge and music), to Durga (the warrior who slew the Buffalo demon in the text *Devi Mahatmya*), and literally thousands of others. All the goddesses are interrelated in various ways, but, depending on who you ask, each of them may be considered to be part of the *same* single goddess. Others believe they are separate and cannot be placed

in any hierarchical schema. Nonetheless, when the film *Jai Santoshi Ma* lifted components from several other goddesses, no one was really surprised. She is simply taken up into the tradition, into a new media, and her devotees will suggest that she has always existed.

There is a point, as has already been suggested, at which McLuhan's claim about the medium as the message is hyperbole, and does not necessarily hold true in the Hindu setting. Thus, the final excerpt by Lutgendorf indicates once again that the setting for seeing takes precedence over the medium. This is not in disagreement with the previous reading, but seen together the readings display the multiplicity of interrelations between the subject matter (the message), the form into which the subject is put (the medium), and the context in which seeing takes place (whether it is a sacred or secular ritual).

Lutgendorf examines the translation of the great Indian epic the *Ramayana* into the medium of television, noting the ways in which *puja* is enacted in front of the television set, indicating that the sacred is made manifest regardless of its channel, its medium. So, instead of marking a contrast between media images and religious icons, he describes ways of combining the two so that the religious viewer is not bound by a particular medium. This does not mean that all such translations from one medium to another are without their critics, and Lutgendorf carefully lays out many dissenting voices in the re-presentation of the *Ramayana,* many of them equating the pacifying effects of both the television *and* religion. He responds to those critics by suggesting that it is the interactive performance that makes religious seeing (or, *darshan*) possible. (Interestingly, the Indian national television network is called "Doordarshan," literally "far seeing" and a distant cousin to "tele vision.") There are sets of rules to be followed regarding purifying oneself, making offerings to the deities, and sanctifying a particular space so that the encounter may be an auspicious one. In this way, "The *Ramayan* serial was not simply a program to 'see,' it was something to do—an event to participate in—and this participation was nearly always a group (extended family, neighborhood, village) activity." One becomes a participant rather than a mere observer (a shift that has been noted in other sections) when one enters the parameters of the performed ritual, when one enters a space in which she or he is both a "seer" and the one "being seen." In the United States and Europe "interactive TV" is a technological dream, in the case of *darshan* in India it is a lived reality.

In Hinduism, many deities have multiple incarnations. To put it another way, the *message* of the deity may take on a variety of *media*. Perhaps this is

why, along with the importance of performance and all the variations this brings to a "single" text, great epics can be translated into video, and why new goddesses in new media can be created out of a pastiche of older goddesses in older media. Within the frame of rituals and tradition, new activities and forms may be generated perpetually, as long as the devotees are active participants in the rituals.

Notes

1. Vasudha Narayanan, "Hinduism," in *The Illustrated Guide to World Religions,* ed. Michael Coogan (New York: Oxford University Press, 1998), 134.
2. "Modern India" is certainly a contested term, and I do not pose any clear definition of it. For our purposes here, however, we will be concerned with rise of "mass media"—i.e., mass printing (lithography, posters, calendars), television, and film—roughly since the mid-nineteenth century. This time frame of course corresponds to the British colonial rule, and there are significant implications of this that are drawn out in many of the books listed at the end of this section.
3. Dennis Hudson, "The Ritual Worship of Devi," in *Devi: The Great Goddess* (Washington, D.C.: Arthur Sackler Gallery, 1999).
4. Lawrence Babb, introduction to *Media and the Transformation of Religion in South Asia,* ed. Lawrence Babb and Susan Wadley (Philadelphia: University of Pennsylvania Press, 1995), 2.
5. Richard Schechner, *The Future of Ritual* (New York: Routledge, 1993), 228.
6. From Goethe's *Dichtung and Wahrheit.* Quoted in Germain Bazin, *The Museum Age* (New York: Universe Books, 1967), 160.
7. Carol Duncan, *Civilizing Rituals* (London: Routledge, 1995), 16.

Diana L. Eck, from *Darshan*

A common sight in India is a crowd of people gathered in the courtyard of a temple or at the doorway of a streetside shrine for the *darshan* of the deity. *Darshan* means "seeing." In the Hindu ritual tradition it refers especially to religious seeing, or the visual perception of the sacred. When Hindus go to a temple, they do not commonly say, "I am going to worship," but rather, "I am going for *darshan*." They go to "see" the image of the deity—be it Krishna or Durga, Shiva or Vishnu—present in the sanctum of the temple, and they go especially at those times of day when the image is most beautifully adorned with fresh flowers and when the curtain is drawn back so that the image is fully visible. The central act of Hindu worship, from the point of view of the lay person, is to stand in the presence of the deity and to behold the image with one's own eyes, to see and be seen by the deity. *Darshan* is sometimes translated as the "auspicious sight" of the divine, and its importance in the Hindu ritual complex reminds us that for Hindus "worship" is not only a matter of prayers and offerings and the devotional disposition of the heart. Since, in the Hindu understanding, the deity is present in the image, the visual apprehension of the image is charged with religious meaning. Beholding the image is an act of worship, and through the eyes one gains the blessings of the divine.

[. . .]

In popular terminology, Hindus say that the deity or the *sadhu* [holy man] "gives *darshan*" (*darshan dena* is the Hindi expression), and the people "take *darshan*" (*darshan lena*). What does this mean? What is given and what is taken? The very expression is arresting, for "seeing" in this religious sense is not an act which is initiated by the worshiper. Rather, the deity presents itself to be seen in its image, or the *sadhu* gives himself to be seen by the villagers. And the people "receive" their *darshan*. One might say that this "sacred perception," which is the ability truly to see the divine image, is given to the devotee, just as Arjuna is given the eyes with which to see Krishna in the theophany described in the Bhagavad Gita.

The prominence of the eyes of Hindu divine images also reminds us that it is not only the worshiper who sees the deity, but the deity sees the worshiper as well. The contact between devotee and deity is exchanged through the eyes. It is said in India that one of the ways in which the gods can be recognized when they move among people on this earth is by their unblinking eyes. Their gaze and their watchfulness is uninterrupted. Jan Gonda, in his detailed monograph *Eye and Gaze in the Veda,* has enumerated the many ways in which the powerful gaze of the gods was imagined and expressed even in a time before actual images of the gods were crafted. The eyes of Surya or Agni or Varuna are powerful and all-seeing, and the gods were entreated to look upon men with a kindly eye.

In the later Hindu tradition, when divine images began to be made, the eyes were the final part of the anthropomorphic image to be carved or set in place. Even after the breath of life (*prana*) was established in the image, there was the ceremony in which the eyes were ritually opened with a golden needle or with the final stroke of a paintbrush. This is still common practice in the consecration of images, and today shiny oversized enamel eyes may be set in the eyesockets of the image during this rite. The gaze which falls from the newly-opened eyes of the deity is said to be so powerful that it must first fall upon some pleasing offering, such as sweets, or upon a mirror where it may see its own reflection. More than once has the tale been told of that powerful gaze falling upon some unwitting bystander, who died instantly of its force.

Hindu divine images are often striking for their large and conspicuous eyes. The famous image of Krishna Jagannath in Puri has enormous saucer-like eyes. Shiva and Ganesha are often depicted with a third vertical eye, set in the center of the forehead. Brahma, inheriting the name "Thousand-Eyes" from Indra, is sometimes depicted with eyes all over his body, like leopard spots. While it would take us too far afield to explore the many dimensions of eyepower in the Hindu tradition, it is important for this study of the divine image to recognize that just as the glance of the inauspicious is thought to be dangerous and is referred to as the "evil eye," so is the glance of the auspicious person or the deity held to be profitable. When Hindus stand on tiptoe and crane their necks to see, through the crowd, the image of Lord Krishna, they wish not only to "see," but to be seen. The gaze of the huge eyes of the image meets that of the worshiper, and that exchange of vision lies at the heart of Hindu worship.

In the Indian context, seeing is a kind of touching. The art historian Stella Kramrisch writes,

> Seeing, according to Indian notions, is a going forth of the sight towards the object. Sight touches it and acquires its form. Touch is the ultimate con-

nection by which the visible yields to being grasped. While the eye touches
the object, the vitality that pulsates in it is communicated. . . .

Examining the words used in the Vedic literature, Gonda reaches the same
conclusion: "That a look was consciously regarded as a form of contact ap-
pears from the combination of 'looking' and 'touching.' Casting one's eyes
upon a person and touching him were related activities."
 [. . .]
 Not only is seeing a form of "touching," it is a form of knowing. Ac-
cording to the Brahmanas, "the eye is the truth (*satyam*). If two persons
were to come disputing with each other, . . . we should believe him who
said 'I have seen it,' not him who has said 'I have heard it.'" Seeing is not
only an activity of the eye, however. In India, as in many cultures, words
for seeing have included within their semantic fields the notion of know-
ing. We speak of "seeing" the point of an argument, of "insight" into an
issue of complexity, of the "vision" of people of wisdom. In Vedic India the
"seers" were called *risis*. In their hymns, collected in the Rig Veda, "to see"
often means a "mystical, supranatural beholding" or "visionary experienc-
ing." Later on, the term *darshana* was used to describe the systems of phi-
losophy which developed in the Indian tradition. However, it is misleading
to think of these as "systems" or "schools" of philosophical thought.
Rather, they are "points of view" which represent the varied phases of the
truth viewed from different angles of vision.

THE VISIBLE INDIA

Hinduism is an imaginative, an "image-making," religious tradition in
which the sacred is seen as present in the visible world—the world we
see in multiple images and deities, in sacred places, and in people. The
notion of *darshan* calls our attention, as students of Hinduism, to the fact
that India is a visual and visionary culture, one in which the eyes have
a prominent role in the apprehension of the sacred. For most ordinary
Hindus, the notion of the divine as "invisible" would be foreign indeed.
God is eminently visible, although human beings have not always had
the refinement of sight to see. Furthermore, the divine is visible not
only in temple and shrine, but also in the whole continuum of life—in
nature, in people, in birth and growth and death. Although some Hin-
dus, both philosophers and radical reformers, have always used the terms
nirguna ("qualityless") and *nirakara* ("formless") to speak of the One
Brahman, this can most accurately be understood only from the per-
spective of a tradition that has simultaneously affirmed that Brahman is
also *saguna* ("with qualities"), and that the multitude of "names and

forms" of this world are the exuberant transformations of the One Brahman.

India presents to the visitor an overwhelmingly visual impression. It is beautiful, colorful, sensuous. It is captivating and intriguing, repugnant and puzzling. It combines the intimacy and familiarity of English four o'clock tea with the dazzling foreignness of carpisoned elephants or vast crowds bathing in the Ganga during an eclipse. India's display of multi-armed images, its processions and pilgrimages, its beggars and kings, its street life and markets, its diversity of peoples—all appear to the eye in a kaleidoscope of images. Much that is removed from public view in the modern West and taken into the privacy of rest homes, asylums, and institutions is open and visible in the life of an Indian city or village. The elderly, the infirm, the dead awaiting cremation—these sights, while they may have been expunged from the childhood palace of the Buddha, are not isolated from the public eye in India. Rather, they are present daily in the visible world in which Hindus, and those who visit India, move in the course of ordinary activities. In India, one sees everything. One sees people at work and at prayer; one sees plump, well-endowed merchants, simple renouncers, fraudulent "holy" men, frail widows, and emaciated lepers; one sees the festival procession, the marriage procession, and the funeral procession. Whatever Hindus affirm of the meaning of life, death, and suffering, they affirm with their eyes wide open.

So abundant are the data of the visual India, seen with the eye, that what one has learned from reading about "Hinduism" may seem pale and perhaps unrecognizable by comparison. As E. M. Forster wrote of the enterprise of studying Hinduism: "Study it for years with the best of teachers, and when you raise your head, nothing they have told you quite fits."

The medium of film is especially important for the student of Hinduism, for it provides a way of entering the visual world, the world of sense and image, which is so important for the Hindu tradition. Raising the eye from the printed page to the street or the temple, as conveyed by the film, provides a new range of questions, a new set of data. In India's own terms, seeing is knowing. And India must be seen to be known. While Hindu spirituality is often portrayed in the West as interior, mystical, and otherworldly, one need only raise the head from the book to the image to see how mistakenly one-sided such a characterization is. The day to day life and ritual of Hindus is based not upon abstract interior truths, but upon the charged, concrete, and particular appearances of the divine in the substance of the material world.

Many Westerners, for example, upon seeing Hindu ritual observances for the first time, are impressed with how sensuous Hindu worship is. It is sensuous in that it makes full use of the senses—seeing, touching, smelling,

tasting, and hearing. One "sees" the image of the deity (*darshan*). One "touches" it with one's hands (*sparta*), and one also "touches" the limbs of one's own body to establish the presence of various deities (*nyasa*). One "hears" the sacred sound of the mantras (*shravana*). The ringing of bells, the offering of oil lamps, the presentation of flowers, the pouring of water and milk, the sipping of sanctified liquid offerings, the eating of consecrated food—these are the basic constituents of Hindu worship, *puja*. For all of its famous otherworldliness, India is a culture that has also celebrated the life of this world and the realms of the senses.

Richard H. Davis, from *Lives of Indian Images*

In 1985 a medieval south Indian bronze sculpture of the Hindu god Shiva traveled from southern India to the United States, accompanied by another bronze sculpture of his wife Parvati, to appear in a major show of "The Sculpture of India, 3000 B.C.–1300 A.D." at the National Gallery of Art in Washington, D.C. [fig. 5.2]. The eleventh-century image depicts Shiva in his aspect as Vrishabhavahana, "the Lord whose mount is the bull Nandi." Shiva stands in a position of grace and ease, weight on his left foot while his right leg crosses over. His right arm extends to rest on the back of Nandi, who no longer accompanies his master. Shiva wears a short lower garment tied with an elaborate belt ornamented with lion and crocodile forms. His plaited hair has been coiled into a turban, with loose strands dangling onto his back. From a show of many outstanding examples of Indian plastic art, the curators chose this image to grace the front and back covers of the show catalog.

[. . .]

TWO WAYS OF ANIMATING IMAGES

An Indian religious image, however, does not appear to us in a museum the same as it does to Indian worshipers in a temple. The way it is displayed, the frame of surrounding objects, and the expectations the two audiences bring to their encounters with the object differ dramatically.

Those who visited Vrishabhavahana and Parvati at the "Sculpture of India" show at the National Gallery of Art saw the couple standing on pedestals by themselves, unadorned, carefully spotlighted by track lights, against a subdued background. Following normal installation practice, the National Gallery displayed this religious icon from another culture as a self-contained aesthetic object, meant to be appreciated for the beauty of its essential sculptural form. The atmosphere was hushed; no extraneous noise (except the unavoidable rustlings and whispers of other visitors) was allowed to detract from the visual experience of the museum goer. Nearby

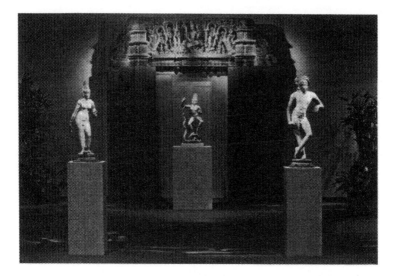

Fig. 5.2 Installation view from "The Sculpture of India, 3000 B.C.–1300 A.D." at the National Gallery of Art, Washington, D.C. Vrishabhavahana (Shiva) is on the far right, Parvati is on the far left. Photo courtesy of the National Gallery of Art, Washington, D.C.

was a label that provided some minimal identifying information: the place and date of the fabrication, its physical dimensions, and the iconographic form of the Hindu deity it represented.

Shiva stood in a large hall with many other such objects, all similarly displayed. These individual "masterpieces" had been assembled from thirty-nine museums in India as well as from museums abroad, private collections, and two temple collections, and brought to the United States as a collective representation of "India's artistic heritage." The purpose of the show, wrote curator Pramod Chandra, was "to give the viewer an impression of Indian sculpture as a whole, in all the rich diversity of idioms that flourished in the ancient regions of the country," and "to convey a sense of the contribution of Indian sculpture to the common artistic heritage of mankind." Chandra hoped thereby to counter long-standing attitudes in the West that denigrated Indian art. The arrangement of objects pointedly avoided any divisions into religious groupings. Images of the Buddha, Vishnu, Shiva, the Goddess, other deities, and saints all congregated together with secular and non-liturgical sculptures as equal representatives of "India's artistic heritage." The exhibition presented "Indian sculpture" as a historically produced

human artistic achievement unified as a national expression, with regional and temporal variations.

South Indians of the eleventh century who visited Vrishabhavahana in his original setting would have seen the bronze image very differently. In the Shvetaranyeshvara temple, he and Parvati would have presented themselves to viewers elevated on a pedestal (along with the now-missing image of Shiva's bull Nandi), much as in the National Gallery. However, priests and worshipers would have devoted their primary attention to another object, a smooth cylindrical shaft made of heavy stone emerging from an hourglass-shaped stone pedestal, the Shiva linga. Deemed uninteresting as a sculptural form, the linga is seldom seen in Western art museums. For Shaiva worshipers, by contrast, it stood at the physical and conceptual center of the temple. Medieval Shaiva texts refer to it as the very "root manifestation" (*mulamurti*) of divinity and the emanating source of all other anthropomorphic images in the temple.

Of course, those who attended the Shiva linga in a south Indian temple did not approach it as a visual object only to be savored aesthetically. Interactions between priests and their object of worship were much more physical than that. In rites of worship (*puja*), they would repeatedly smear it with unguents, shower it with flowers, and bathe it with liquids of many kinds. "Using bowls of various colors," recommends one priestly guidebook, "the priests bathe Shiva with diamonds and other jewels, with the five products of the cow, with nicely prepared powders, with black mustard seed and salt, with tepid water, sandal water, and herb water, with milk, curd, ghee, honey, and jaggery. . . . If money permits, he should also bathe Shiva with coconut milk or the juice of other succulent fruits, with flowers and the like, with gold water, with jewel water, and with sandal water" (*KA purva* 4.405–9) [cf. fig. 5.3]. They would dress it with fine garments and adorn it with all kinds of ornaments: gold diadems, medallions, moons and flowers of gold, pearl necklaces, belts, and much more. They would wave lamps before it, treat it to a sumptuous meal, and serenade it with mantras, devotional hymns, and instrumental music.

[. . .]

Differences in visual presentation and placement of the Tiruvengadu Vrishabhavahana in his two abodes correspond to very different ontological and moral premises that his two audiences held about what that bronze image in essence was and how one ought best to act toward it. In each case the encounter between the image and his community of response occurred within a complex framing set of cultural assumptions and ideas, what I call a dispensation, that guided that encounter.

For south Indian Shaivas of the eleventh century, as for traditional Hindus today, religious icons like the stone linga and the bronze image of

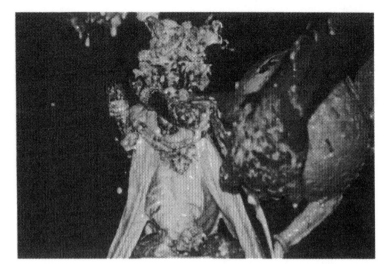

Fig. 5.3 Puja to the Lord Krishna on Janmashtami (Krishna's birthday), Vrindavan, India. Photo by Robyn Beeche, courtesy of Sri Caitanya Prema Samsthana, Vrindavan.

Shiva Vrishabhavahana at Tiruvengadu were most fundamentally living divine beings. The center of an icon's identity and value lay not in its physical materials nor its form, but in the divine presence that was invoked into it through ritual procedures and came to animate it. In medieval Shaiva theology, the animated icon or image was a localized, particularized "manifestation" or "incarnation" of the all-pervading, transcendent God Shiva, who at his highest level of being was considered to be beyond all form, but who simultaneously would inhabit a variety of immanent, physical "embodiments."

Shiva could inhabit all sorts of things. Not only would Shiva enter into beautiful bronze images and solid stone lingas, but also (according to the *Kamikagama*) into circular diagrams, cloth paintings, fires, water in consecrated pots, special books on their stands, and various other "supports." These supports need not be made by humans; Shiva also chose to manifest himself in "self-arising" lingas (*svayambhulinga*) and in the linga-shaped stones one might find in the beds of holy rivers (*KA purva* 4.270–72). Shiva's promiscuity when it came to embodying himself did not mean that Shiva, or his eleventh-century audience of devotees, was insensitive to physical beauty. Iconographic texts urged image makers to make their images as beautiful as they could, and devotional poets of the time repeatedly proclaimed the glorious beauty of their embodied gods. Aesthetic concerns

were, however, secondary to other criteria: iconographic correctness, completeness, ritual animation, and divine presence.

As a result of Shiva's theophany in physical icons, human worshipers considered it incumbent upon them to treat his physical embodiment as a divine person. The primary liturgical practices of medieval Shaiva temples, accordingly, involved the same kinds of respectful services a diligent host might offer an honored human guest or an attendant at court might offer his mortal lord, but presented in this case directly to God, personalized within an icon. So worshipers before Shiva received the deity graciously, offered him water to sip and rinse his feet, bathed and dressed him, adorned him with ornaments, fed him, gave him after-dinner condiments, entertained him with music and dance, bowed humbly before him, and petitioned him to grant them his all-powerful grace.

At the same time, the physical specificity of the god's presence in an icon or image might lead the devotee to glimpse beyond it Shiva's more all-encompassing nature. The icon was in this sense translucent. While it had a substantive presence in itself, it also allowed a viewer in the proper spirit of devotion and knowledge to glimpse with a devotional eye through it—imperfectly, since all human encounters with transcendence will be limited—to the transcendent reality of the deity as well.

[. . .]

Few of those who attended the Festival of India show at the National Gallery regarded Shiva as the transcendental Lord of the Cosmos, nor did they expect the images of Shiva they saw there to be alive with his presence. Culturally heirs of the Israelite prophets who had disdained the religious idols of neighboring tribes (and of their own past) as false, and Cartesian in their ontological outlook, Western museum goers understood these old images from the past of another culture as fundamentally inanimate objects. The Judaic or Christian God most of them recognize (if they do) certainly does not enter into matter in such a direct way.

However, those attending the National Gallery exhibition also understood the examples of great Indian sculpture assembled there to be, in the modern Western scheme of things, "art objects," and so they recognized that the images deserved careful treatment and were worthy of some special, quasi-religious regard. This attitude is what Svetlana Alpers has termed the "museum effect." As a culturally constructed setting in the modern West, the museum encourages its visitors to regard Indian works of religious imagery, as all other objects gathered there, with a close visual attention to their physical forms as both elegant and symbolically meaningful, and to attempt to understand these icons as the refined products of a sophisticated culture of the past. In the hushed atmosphere of the National Gallery, museum goers were implicitly urged

to animate the images of Shiva and Parvati from Tiruvengadu and their fellow icons not through rituals of installation and feeding, but through visual and interpretive attentiveness.

One reviewer told how the Tiruvengadu bronze had first arrested his attention during its previous 1982 visit to London. "Though my primary interest then was in studying the paintings," wrote Kenneth Robbins, "fully one-third of my time was spent gazing at each feature of this almost perfectly executed bronze." Robbins goes on to praise the impeccable taste of the show's curator for bringing this and several of its compatriots from Tiruvengadu to the United States. In the new exhibition "both novice and experienced viewers" will be able "to luxuriantly bask in the supple, sensuous, sinuous beauty of these idealized forms." The aesthetic lexicon and the promise of a rarefied experience Robbins evokes here reflect something of the hopes and expectations modern museum goers might bring with them to a display of ancient Indian art.

If the Indian sculptures appeared to viewers in the National Gallery at all translucent—if they led viewers beyond their physical selves to some other dimension of reality—it was to a human and historical reality, not a theological one. A viewer with the proper spirit of knowledge and empathy might use the Indian sculptures to envision the concerns, values, and religious beliefs of historical Indians that had led them to produce these human artifacts. The images stood collectively as metonymy for the human society and religious culture of ancient and medieval India. (The metonymic relation of collection and modern nation state was drawn even more closely in the other major show of Indian art in the 1985 Festival of India, focusing on objects from 1300 C.E. to the present, which was titled simply "India!") And in the historicist and cultural pluralism that late twentieth-century museum goers take for granted, viewers understood well that, merely by walking into another section of the National Gallery, they might explore the visual products of another human and historical world, that perhaps of colonial North Americans or medieval European Christians.

Medieval Shaiva temple and modern museum, then, can both be taken as consecrated spaces. Both set aside areas for highly valued cultural activities, where esteemed objects hold court (or in the Indian idiom, give *darshana*) for human viewers, and both engender certain ways of looking and responding on the part of their audiences. Both allow for certain types of experiences that transcend the parochial, though that transcendence leads in quite different directions.

John Stratton Hawley, from the prologue to *Devi: Goddesses of India*

ONE GODDESS AND MANY, NEW AND OLD

In 1975 the movie *Jai Santoshi Ma* emerged from the thriving network of studios that make Bombay one of the major capitals of the international film industry, and within months a new goddess was being worshiped throughout India. The name of the movie can be loosely translated as "Hail to the Mother of Satisfaction," and it heralded a divinity—"The Mother of Satisfaction," Santoshi Ma—who had hitherto remained entirely unknown to most Indians. In fact, although a temple to her existed in Jodhpur, Rajasthan, she had evidently not been known very long under that name or in that form even there. Before 1967 the temple now dedicated to her had belonged to a goddess called Lal Sagar ki Mata, "The Mother of the Red Lake," near whose banks it stands, and the characteristics of the earlier goddess diverged in important respects from those of Santoshi Ma. Most significantly, Lal Sagar ki Mata was a carnivore, to whom goats and other animals were periodically sacrificed, whereas Santoshi Ma is a vegetarian, with chickpeas and unrefined sugar at the center of her diet.

Most who saw the movie knew nothing of this previous history, or indeed of Santoshi Ma herself, before they walked into cinema halls throughout the subcontinent. Yet the goddess who appeared before them in celluloid form was in many ways familiar. The colors of her clothes and complexion were drawn from a palette standardized by the poster-art industry that dominates the iconographic imaginations of most modern-day Hindus. Her characteristic poses showed her standing or sitting on a lotus, as several other goddesses do. And she shared her most prominent implements, the sword and trident, with the great goddess often named Durga [fig. 5.4].

As her film brought her to life, however, Santoshi Ma quickly became one of the most important and widely worshiped goddesses in India, taking her

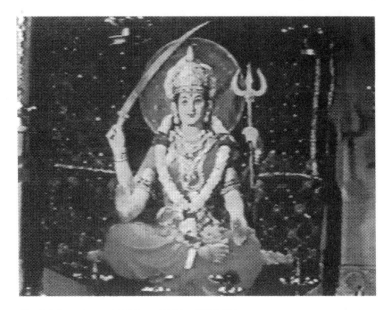

Fig. 5.4 From the movie Jai Santoshi Ma. *1975. Video capture.*

place in poster-art form in the altar rooms of millions of Hindu homes. People throughout India, especially women, kept (and still keep) a vow of fasting for sixteen consecutive Fridays. On those days they made special offerings to Santoshi Ma, hoping to be blessed with a wish fulfilled. Then, and at other times too, they read her story and sang her songs. The annual calendar of Hindu festivals also responded to her advent. In late summer there is a celebration of brother-sister solidarity, *rakhi* or *raksabandhana,* which the film identified as the moment of and reason for Santoshi Ma's birth. Not unexpectedly, then, her image began to appear on the bright paper medallions that decorate the threads (*rakhis*) sisters tie onto the wrists of their brothers and other male relatives and friends on that day. Everywhere, Santoshi Ma images and shrines were added to temples, and in some cases, as had already happened in Jodhpur, she took over the place of the presiding deity in temples that had previously been dedicated to other goddesses.

How was all this possible? Obviously the filmmakers had found the right story at the right time. Obviously, they were appealing to a religious culture in which visual access to the divine was understood to be both legitimate and crucial. Moreover, many said, it was devotion that had produced the film: the filmmaker's wife, after discovering Santoshi Ma on a

pilgrimage to Jodhpur, had been the one who persuaded her husband to spread the goddess's message by translating her into a new medium.

Yet it is hard to conceive that Santoshi Ma could have granted such instant satisfaction to so many people had she not been part of a larger and already well-integrated culture of the Goddess. Her new devotees could immediately recognize many of her characteristic moods and attributes, and feel them deeply, because she shared them with other goddesses long since familiar to them. Some of these divine women were somewhat playfully depicted in the film as struggling spitefully against the growth of the cult of the new goddess—and understandably, for she had stolen their fire. In some sense, she really *was* Brahmani and Parvati and Lakshmi, the goddesses who did their best to make life hard for Santoshi Ma's paradigmatic devotee. In some sense, too, she prevailed because of her youth and vigor. In India, as elsewhere, there is something fascinating about the new, and the film's own plot suggested it was natural that Santoshi Ma's youth should arouse the envy of older goddesses.

But there was another secret to her success: she was a unitive presence. At least in the context of this film, she was the Great Goddess in a way that Brahmani, Parvati, and Lakshmi, as wives to the classic triad of supreme Hindu gods (Brahma, Shiva, and Vishnu), were not. Although she was depicted as emerging from a divine lineage, she stood on her own. Not only did she incorporate and thus summarize a certain spectrum of preexisting female divinities, but she unified them as well, amalgamating their power for her devotees.

There is much more to be said about the appeal of this new film goddess, as Stanley Kurtz has attempted to do in his recent book, *All the Mothers Are One.* Yet in all of it one can scarcely miss the point that, as his title suggests, Hindu goddesses tend to be seen as close relatives of one another—even possessing a common substance—in a way that is somehow less true of the male side of the Hindu pantheon. The "high theology" of the Goddess enunciated in two classic Sanskrit texts, the *Devi Mahatmya* and the *Devi Bhagavata Purana,* provides a way of understanding why this should be so. For most Hindus, the gods, too, are ultimately understood as a unity: *bhagavan ek hi hai* ("God is one"), as the common Hindi phrase has it. Yet this unity is typically conceived to exist at a level distant from everyday life—at the "nonqualified" (*nirguna*) level. With goddesses, it is different. As described in the texts just named, the unity of the Great Goddess incorporates the world as we know it, as well as transcending it. In some sense, Goddess *is* our world, in a way that God is not. Hence the multiple forms she takes are connected in a way that strikes us as more intimate than those we typically project when we understand the divine as male.

This is not to deny the variousness of the Goddess. In one of her most prevalent expressions she spreads herself across the landscape of much of India—the southern part especially—such that she becomes specific to each place she touches. Each village has its tutelary divinity, its *gramadevata* ("village deity"), and the personality of each is distinct: no one place is the same as any other. Yet the fact that the divine *is* ubiquitous in this manner says something generic, and Hindus have overwhelmingly conceptualized that place-specific, divine reality as female. These village deities are almost always understood as goddesses, not gods. In most instances their commonality can be acknowledged by calling each of them "Mother," and in many places in South India one can be even more specific. There, village goddesses tend to collect under the common heading of Mariyamman: the Mariyamman of this locale or that, after the fashion of "Our Lady of——."

It is important to understand that for Hindus, real differentiations, such as those that obtain among local deities, do not necessarily imply un-bridgeable gaps between members of a given set of beings. As Diana Eck has commented about Indian ways of thinking, "If something is important, it is important enough to be repeated, duplicated, and seen from many angles." This is true for gods, and even truer for goddesses. Not so many years ago India's vast film industry produced a movie, entitled "Sarasvati, Lakshmi, Parvati," and on billboards the three goddesses were clumped together as a triad—three similar-looking heads emerging as if from a common frame. It is hard to imagine a film taking its title from the names of three gods who would be portrayed in the same fashion.

Of course, Hindu male deities do sometimes share emblems, attributes, and properties. Vishnu's characteristic disc can on occasion be found in the hand of Krishna, who is often conceptualized as his avatar, and Shiva's habit of wearing snakes as garlands is often replicated in his horrific manifestation as Bhairava ("The Fearsome One"). Yet this sharing of family traits is even more pronounced on the female side of the Hindu pantheon. To begin with, goddesses observe an important ground rule that does not apply to gods: when they appear in sculpted form, as images, they are almost invariably anthropomorphic. More than that, they share associations: with the auspicious, gentle lotus on the one hand, and with such powerful weapons as the sword and the trident on the other. Similar ties emerge at the level of theological analysis. For example, goddesses are characteristically described as bearing a close relation to power or energy per se (*shakti*). That energy is abundant in the physical universe we inhabit. Hence, goddesses tend to be strongly associated with the forces of nature (*prakrti*) and the earth—sometimes in its nurturing, maternal aspect, sometimes in its natural periodicity, sometimes in its uncontrollable, destructive power. The earth itself is typically figured as a goddess: *bhu,* the earth, is

Bhudevi. Often, too, the power of a goddess (or *the* Goddess) is experienced as brilliantly hot—a quality called *tejas*. Finally, perhaps especially in the eyes of men, this goddess power is felt to be somehow miraculous, to produce illusion (*maya*), to delude. And not surprisingly, all but one of the concepts we have just listed are grammatically feminine in Sanskrit and in other Indic languages that distinguish nouns by gender (*tejas,* the exception, is neuter).

To a certain degree, these family resemblances carry over into the ritual dimension as well. Both gods and goddesses are worshiped throughout India with a ritual vocabulary whose central elements remain more or less constant. To the accompaniment of music, offerings of praise (*puja*) are made to the divinity, who is typically present in the form of a clothed image (*murti*), and certain of the offerings are standard: incense, flowers, lighted candles or flames of burning camphor, and various sorts of food. These, once touched or tasted by the divinity, are returned to the worshipers as ritual leftovers, called *prasad.* The word means literally "grace" and signifies that the original giver in this transaction is actually the deity, who is the real author of the materials being offered—and, indeed, of the offerers. A similar thing holds true for the act of visual attention (*darshan,* "seeing" or "sight") that accompanies these acts of worship. On the one hand, the worshiper sees the divinity, in an imagistic expression. Yet on the other, the worshiper is seen by the deity, the image, for the image has been ritually enlivened and thus has eyes. As with *prasad,* there is the conviction that in this visual transaction the deity's act of seeing actually precedes the devotee's. Ontologically, it has a prior status.

Philip Lutgendorf, from "All in the [Raghu] Family: A Video Epic in Cultural Context"

> Rama incarnates in countless ways
> and there are tens of millions of *Ramayanas.*
> —Tulsidas

INTRODUCTION

On January 25, 1987, a new program premiered on Doordarshan, India's government-run television network. Broadcast on Sunday mornings at 9:30 A.M., it represented an experiment for the national network, for it was the first time that the medium of television was to be used to present a serialized adaptation of one of the great cultural and religious epics of India. The chosen work was the the *Ramayana*—the story first narrated in Sanskrit some two millennia ago by the poet Valmiki, and retold numerous times in succeeding centuries by poets in every major regional language, most notably, for North India and for Hindi, in the sixteenth-century epic *Ramcaritmanas* ("The Holy Lake of Rama's Acts") of Tulsidas. The television adaptation, produced and directed by Bombay filmmaker Ramanand Sagar, was itself an epic undertaking: featuring some three hundred actors, it was originally slated to run for fifty-two episodes of forty-five minutes each, but had to be extended three times because of popular demand, and eventually grew into a main story in seventy-eight episodes, followed after an interval of several months by a sequel incorporating the events detailed in the seventh book (the *Uttarakanda,* or epilogue) of the Sanskrit epic.

Long before the airing of the main story concluded on July 31, 1988, Sagar's *Ramayan* had become the most popular program ever shown on Indian television, and something more: a phenomenon of such proportions that intellectuals and policymakers struggled to come to terms with

its significance. Why and how, observers wondered, had this serial—almost universally dismissed by critics as a technically flawed melodrama—elicited such a staggering response? Did its success point once again to the enduring power of sacred narrative to galvanize the masses, or was it, rather, a cue to the advent of a new force in Indian culture: the mesmerizing power of television? Inevitably the airing of the serial provoked lively debate over such topics as the relationship of folk and elite traditions, the marketing of religion and art, the politics of communalism and of government-controlled mass media, and indeed over the message of the *Ramayana* story itself.

[. . .]

This response had tangible effects that were repeatedly noted in the press. The spread of "Ramayan Fever" (as *India Today* termed it) generated a flood of newspaper and magazine articles ranging from critical analyses of the serial's content to sensational accounts of its fans' behavior. Throughout most of the serial's run, *Ramayan*-related news appeared with almost daily regularity in local papers. Many reports described the avidity with which successive episodes were awaited and viewed, emphasizing that, for millions of Indians, nothing was allowed to interfere with *Ramayan*-watching. Visible manifestations of the serial's popularity included the cancellation of Sunday morning cinema shows for lack of audiences, the delaying of weddings and funerals to allow participants to view the series, and the eerily quiet look of many cities and towns during screenings—a reporter in Mirzapur observed, "Bazaars, streets, and wholesale markets become so deserted they appear to be under curfew." Other articles reported the decline of traffic on national highways during broadcasts, as truck and bus drivers steered their vehicles to teashops equipped with television sets, where driver and passengers piled out to watch the episode. On occasion, trains were delayed when passengers refused to leave platform sets until a broadcast was over.

Many articles described the devotional activities that developed around the weekly "auspicious sight" (*darshan*) of epic characters:

> In many homes the watching of *Ramayan* has become a religious ritual, and the television set . . . is garlanded, decorated with sandalwood paste and vermillion, and conch shells are blown. Grandparents admonish youngsters to bathe before the show and housewives put off serving meals so that the family is purified and fasting before *Ramayan*.

Local press reports detailed instances of mass devotion: a Banaras newspaper reported on a sweetshop where a borrowed television was set up each week on a makeshift altar sanctified with cow dung and Ganges water,

worshipped with flowers and incense, and watched by a crowd of several hundred neighborhood residents, who then shared in the distribution of 125 kilos of sanctified sweets (*prasad*) which had been placed before the screen during the broadcast. Such ritualized public viewings were not uncommon: throughout the country, crowds gathered in front of video shops to watch display sets, and some community groups undertook to place sets in public areas. During the final months of the serial, electronics shops reported a dramatic surge in television sales and all available rental sets were engaged for the crucial Sunday morning slot—sometimes by whole villages that pooled their resources to allow residents to see *Ramayan*. Sporadic incidents of violent protest resulted from power failures during the weekly screening, as when an angry mob in the Banaras suburb of Ramnagar (home of North India's most acclaimed *ramlila* pageant) stormed and set fire to an electrical substation.

[. . .]

VIDEO-LATRY

To both Indian and foreign reporters, one of the most striking features of the public response to *Ramayan* was its religious dimension: the ceremonies of worship that developed around the weekly broadcasts and the spontaneous expressions of reverence that greeted the public appearances of the stars. News stories described the purificatory *puja* of television sets, the burning of incense before the screen, and pious fans' prostrations before Arun Govil and Dipika Chikhlia (the actors who played Rama and Sita). More critical responses, especially in English-language publications, ranged from bemused condescension at the incongruity of "worshiping" an electronic gadget, to disgust at what was seen as an embarrassing cultural anachronism; wrote Arvind N. Das in *The Times of India*, "Through the electronic Ramayana . . . the Indian juggernaut is moving at a frenetic pace—backwards." In an interview in *The Illustrated Weekly*, one reporter pressed Dipika to evaluate the religious response of viewers.

> *Reporter:* In the mofussil [provincial] towns, and even in the cities people have a bath and do pooja [*puja*] of their television screens before watching the serial. Do you think this is right?
> *Dipika:* There's no right and wrong about it. It's a matter of their belief. We haven't asked them to do it, it's the way they feel.

Notable is the reporter's disdain for what she regards as rustic religious customs, now seeping back from provincial towns into "the cities." Such critics are often out of touch with the religious customs of their own urban

neighbors, and choose to overlook, for example, the purificatory *puja* of motor vehicles, printing presses, and other mechanical devices, which is common throughout the country. Equally prevalent is the custom of bracketing religious performances with auspicious rites. When a *kathava-cak* (storyteller) is preparing to expound the *Ramayana,* care is always given to the seat he is to occupy, which must be purified in order to be worthy of the divine sage, Veda Vyas, who will speak through the storyteller. Similarly the crowns, ornaments, and weapons of *ramlila* actors are worshipped before the start of the pageant. Since the *Ramayan* serial became a weekly in-house *katha* or *ramlila* for millions of families, the television screen became the new seat of the storyteller and ritual stage for the *lila,* and its perch in the family sitting room had to be sanctified.

Of course, a more reflective critic might also have noted that "backward" Indians are not the only people who "worship" television sets. Behind the modern secular smile of condescension lies a joke at our own expense, for the television set became the central altar of the American home some three decades ago—the main focus of the living room, displacing the hearth/fire altar as the nucleus around which family members gathered for communion and sustenance. It is only a highly compartmentalized notion of religion that blinds us to the ritual dimensions of such activities. Neil Postman's assertion that television is unsuited to religious experience because it is "so saturated with our memories of profane events, so deeply associated with the commercial and entertainment worlds that it is difficult to be recreated as a frame for sacred events" suggests the over-facility of the conventional sacred/profane dichotomy; in any case it is clearly inapplicable to the Indian situation. Millions of Hindus did indeed feel a need to sacralize their television screens each week in order to make them "a frame for sacred events" yet they apparently found no more difficulty in doing this than they do in sacralizing their town squares for *ramlila* plays each October, their kitchens for monthly *ekadasi* rites, or piles of cow dung for *govardhan puja.*

AND NOW, THE "COUCH PAKORA"?

Television, like religion, is frequently assailed by critics as an "opiate" that deadens and desensitizes its devotees; Robert MacNeil called it, "the soma of Aldous Huxley's *Brave New World.*" Many Indian intellectuals similarly despise the "idiot box" and feel particularly disturbed by the presentation of "fundamentalist" religious material through its hypnotic medium. A critic in *The Times of India* explained the appeal of *Ra-mayan*—even to those who should have known better—by invoking the tube's power to lull.

What about the Westernized elite which is not basically religious but nevertheless almost religiously viewed Ramayana in spite of making snide comments about its poor production? The answer . . . is to be found in a complex situation where mass culture, the search for roots, entertainment and education have all got mixed into an addictive and soporific compound which reinforces intellectual passivity. That this compound is available without much effort by the recipient adds to its ethereal charm as the medium itself becomes the message.

Such facile analysis, effortlessly (and without citation) incorporating the *mahavakya* or "great sentence" of the pre-eminent Western media pundit of the 1960s [McLuhan], typifies the knee-jerk reaction to the serial of many English-language critics. Yet how applicable is this warmed-over approach to the Indian situation? The technology of mass media may be much the same everywhere, but their utilization and impact depend on specific conditions—even specific "ways of seeing"—which vary in culture-dependent ways. In his perceptive study, *Amusing Ourselves to Death,* Neil Postman bases much of his critique of television on a historical analysis of the impact of literacy and publishing in the United States during the eighteenth and nineteenth centuries, arguing that Americans were the most print-oriented people in the world and that their cultural emphasis on the printed word influenced all forms of public discourse. His most damning case against television is that it leads to the trivialization of information and the reduction of all forms of discourse to "entertainment." Yet he is careful to point out that this effect derives in part from the specific circumstances of American television: the fact that it is available twenty-four hours a day on multiple channels and is presented mainly in tiny segments jarringly juxtaposed with commercial messages or (in news programs) contrasting bits of information. It is the constant bombardment of decontextualized information through a relentlessly amusing visual format that Postman views as promoting desensitization and passivity; rather than the act of "viewing" itself—for although they lack direct contact with performers, television viewers need not be more "passive" than audiences at other mass events.

For most Indian viewers, the *Ramayan* serial was not simply a program to "see," it was something to do—an event to participate in—and this participation was nearly always a group (extended family, neighborhood, village) activity. Audience participation included pre- and post-performance rituals, cheers of "*Raja Ramcandra ki jay!*" ("Victory to King Ramacandra!") and distribution of sanctified food. In addition, each episode became a prime subject of conversation throughout the week: was each character portrayed properly? Were the special effects up to standard? How did the

screenplay depart from the *Manas* or the Valmiki *Ramayana?* Such matters were endlessly debated, and everyone had an opinion. Moreover, some viewers made their opinions known through a dialogue with the storyteller that, in its own way, resembled the dialectic that goes on in *katha* sessions. Since Sagar's crew often worked on episodes until just before screening time, it was sometimes possible to incorporate audience feedback with little delay. The scene in which Rama and Lakshman are temporarily overpowered by a serpent weapon wielded by Ravan's son Indrajit, and lie helpless and wounded on the battlefield, was regarded by many viewers as a catastrophe comparable to an eclipse of the sun (some devotees took ritual baths, as during an eclipse, for protection during the Lord's period of helplessness). When Sagar chose to extend it for two broadcasts, he was deluged with letters and was forced to make an on-screen apology the following week for this undue extension of a painful and inauspicious scene. His sense of audience expectations was usually more on target, however. One feature article included an account of a day's shooting in which, as Rama completed a poignant speech on how sorely he missed Sita, Sagar, wiping his eyes with a handkerchief, rushed from behind the camera to embrace his actor, exclaiming, *"Vah, beta, vah!"* ("Superb, son, superb!"), while an onlooker chimed in, "The whole country will cry next Sunday."

Clearly, the impact on Indian culture of the proliferation of television needs to be carefully studied, particularly as programming schedules continue to expand, the bombardment of commercial messages increases, and VCRs provide bored viewers with a wider range of choices. Yet such research must be informed by cultural specifics: by the fact that Indian typographic technology is only a little more than a century old and has never produced the kind of print-saturated culture that developed in the United States; that "oral literacy" (in which people who cannot read and write are familiar with and sometimes creators of sophisticated bodies of literature) remains prevalent; that great religious significance attaches to the act of seeing (*darshan*) and hearing (*sruti*); and that a wide range of oral performance genres continue to flourish. All these factors contribute to creating an environment in which the advent of television may produce less jarring discontinuity and cultural alienation than it has in the United States.

Suggestions for Further Reading

Babb, Lawrence A. and Susan S. Wadley, eds. *Media and the Transformation of Religion in South Asia.* Philadelphia: University of Pennsylvania Press, 1995.

Davis, Richard. *Lives of Indian Images.* Princeton: Princeton University Press, 1997.

Duncan, Carol. *Civilizing Rituals: Inside Public Art Museums.* London: Routledge, 1995.

Eck, Diana. *Darshan: Seeing the Divine Image in India.* 3rd ed. New York: Columbia University Press, 1998.

Elgood, Heather. *Hinduism and the Religious Arts.* London: Cassell, 1999.

Hawley, John Stratton and Donna Marie Wulff. *Devi: Goddesses of India.* Berkeley: University of California Press, 1996.

Hoover, Stewart M., and Knut Lundby, eds. *Rethinking Media, Religion, and Culture.* Thousand Oaks, CA: Sage Publications, 1997.

Huyler, Stephen. *Meeting God: Elements of Hindu Devotion.* New Haven: Yale University Press, 1999.

Karp, Ivan and Steven D. Lavine, eds. *Exhibiting Cultures: The Poetics and Politics of Museum Display.* Washington, D.C.: Smithsonian Institution Press, 1991

Kersenboom, Saskia. *Word, Sound, Image: The Life of the Tamil Text.* Oxford: Berg Publishers, 1995.

Lutgendorf, Philip. *The Life of a Text: Performing the Ramcaritmanas of Tulsidas.* Berkeley: University of California Press, 1991.

Michell, George. *Hindu Art and Architecture.* London: Thames and Hudson, 2000.

Miller, Barbara Stoler, ed. *Exploring India's Sacred Art: Selected Writings of Stella Kramrisch.* Philadelphia: University of Pennsylvania Press, 1983.

Mitter, Partha. *Much Maligned Monsters: History of European Reactions to Indian Art.* 2nd ed. Chicago: University of Chicago Press, 1992.

Pinney, Chris. *Camera Indica: The Social Life of Indian Photographs.* Chicago: University of Chicago Press, 1997.

Polygraph 12: World Religions and Media Culture (2000) [online journal at http://www.duke.edu/~as1/pg/polygraph.html].

Raheja, Gloria Goodwin and Ann Grodzins Gold. *Listen to the Heron's Words: Reimagining Gender and Kinship in North India.* Berkeley: University of California Press, 1994.

Schechner, Richard. *The Future of Ritual: Writings on Culture and Performance.* New York: Routledge, 1993.

Vatsyayan, Kapila. *The Square and the Circle of the Indian Arts.* 2nd ed. New Delhi: Abhinav Publications, 1997.

Section 6

Zakhor

Modern Jewish Memory
Built into Architecture

"Take twelve stones from here out of the middle of the Jordan, from the place where the priests' feet stood, carry them over with you, and lay them down in the place where you camp tonight." . . . "When your children ask in time to come, 'What do those stones mean to you?' then you shall tell them that the waters of the Jordan were cut off in front of the ark of the covenant of the Lord. When it crossed over the Jordan, the waters of the Jordan were cut off. So these stones shall be to the Israelites a memorial forever."

- -Joshua 4.3, 6- 7

Albert Einstein became famous in the twentieth century for his theories about the interconnectedness of space and time. While earlier science believed space and time to be isolated categories that did not impinge on each other, Einstein's great work was to prove that each interpenetrates the other. To exist in space is also to exist in time, and vice versa. Einstein's mathematical formulae and theoretical particle physics were quite revolutionary in the early twentieth century, yet there is a medium of visual art that has long worked within such a space-time continuum: the architecture of the memorial. In loose Einsteinian terms, a memorial "bends" time into a configuration of space. Its intention is to remember a past person or event in a present spatial design. This may be as simple as placing a pile of stones on the edge of a river or, as we shall see, designing a titanium-clad, postmodern museum. Correlatively, the memorial cannot achieve this memory by itself, but always relies on its observers;

the memories produced are shaped by the ongoing life of the memorial within the visual, material history of a culture. Through the participation of observers within the space created by the memorial, past times and spaces are reactivated in the present.

The reactivation of past time in present space is deeply rooted in the Jewish religious tradition. Indeed, the imperative command *zakhor,* "remember," is of central importance in the Torah and throughout the Hebrew Bible. This memory does not arise from a simple curiosity about the past, nor from the need to keep good records. Rather, it is a communal way of embodying the present. As Jewish historian Yosef Hayim Yerushalmi makes clear, *zakhor* is bound up with "practices, rituals, and recitals." Memory is not an activity of the mind only, but of the body and of the minds and bodies of others. Like seeing, remembering is a dynamic, interactive process.

Yet, as Yerushalmi makes equally clear, memory is also "always problematic, usually deceptive, sometimes treacherous."[1] The problem here is the relational nature of memory: the linkage between one point in time and another. There is no simple structure or method to ensure that what has happened in the past will be understood in the present, nor is there a way to ascertain that what is happening in the present might be remembered in the future. This problem, like several others encountered in the pages of this volume, can be usefully understood as the problem of *representation*. Memory takes form in the distance between two points in time, and its ability to function depends upon how well the past is able to travel into the present to be re-presented. We write, we record, we build, we draw, based on what is present, yet nothing can guarantee a re-presentation at a later point in history. Nonetheless, communities of people have continually returned to architecture as a medium through which memory has some significant chance of survival. In this section we will look at several examples of architecture and its function within the Jewish visual culture of modern Europe.

BUILDING MEMORY

Contrary to popular opinion that suggests Judaism to be an iconoclastic tradition, a number of recent scholars have begun to demonstrate the presence of a wide variety of Jewish visual arts through history. There are at least two reasons for this common misconception about Judaism. First is a general ignorance, even among many scholars, of Jewish cultural history. As historian Erwin Goodenough argued in his massive examination of Jewish symbols in the ancient world, "those who had assured me that Jewish art had never existed had simply not known the facts . . . I discovered that

Jewish art of another kind had flourished everywhere in the ancient world."[2] Part of the problem is that people were, and still are for that matter, looking for the wrong thing. Trained to understand "art" only within the category of "fine art," scholars have long overlooked the "merely decorative" arts, the charms, amulets, tombstones, mosaics, and illuminated manuscripts that Goodenough "rediscovered" and inserted as a vital component to understanding ancient Jewish life. Though "visual culture" is a term put into practice long after Goodenough's death, his work is an important example for understanding the differences between "art" and "visual culture."

The second misunderstanding stems from a lack of historical consciousness in the modern period. Kalman Bland's recent meticulous study, *The Artless Jew,* argues that the radical aniconism so often attributed to Judaism is actually a modern European invention. Carefully reviewing the writings of medieval Jewish thinkers, Bland finds evidence for a vital aesthetic dimension in Jewish thought, suggesting that arguments against images correspond instead to the external and internal forces leading to the development of modern Jewish identity. If anything, aniconism indicates "the pressure of modern culture and politics on Jewish life,"[3] and has not necessarily been part of all Jewish history.

Nonetheless, the idea of "Jewish art" remains problematic (as does the idea of "Hindu art" or "Islamic art") and raises several questions: Does one define Jewish art by a certain style? genre? the fact that is was created by a Jew? for a Jew? or contains an image of a Jew, whether Abraham, Moses, or a nineteenth century Jewish businessman? or must it be religious in its subject matter? Joseph Gutmann explores many such suggestions for definitions of Jewish art, and, realizing there is no single way to define this elusive category, he considers,

> The history of Jewish art has been a manifestation of the historical processes that Jews have undergone. Because Jewish history, unlike that of other continuous entities, developed and evolved primarily within multiple societies, cultures, and civilizations, it bears the imprimatur of this long and diverse multicultural experience. A critical inquiry into all known artistic remains reveals no isolated, unique thread but, on the contrary, a many-colored thread interwoven into the fabric of Jewish involvement in the larger non-Jewish society.[4]

Here again are the inevitable cultural crossings that must be taken into account in any examination of religious visual culture. And while it will be impossible to formulate a precise definition of "Jewish art," this section might best be oriented following Richard Cohen's pragmatic definition:

"that which reflects the Jewish experience."[5] One useful way to come to terms with Jewish art, then, is to approach it through the Jewish idea of memory and its relation to architecture.

The origins of architecture have long been debated. While some claim architecture to have been born out of the physical necessity for shelter—and thus the first building was a "house"—others have envisioned a past in which architecture arose from the need to visualize the invisible, suggesting that the first architectural sites were either tombs or shrines. Architecture's origins are thus bound to the desire to memorialize, to spatialize something from past time. The past is absent to the present, but visual objects existing in space provide a link to that past. The pile of stones the Israelites left as they crossed the River Jordan into the promised land became a memorial for future generations to remember, and some of the greatest architectural sites in the world—for example, the Taj Mahal in India and the Pyramids in Eygpt—are essentially tombs. There seems to be an implicit belief in the power of architecture as a site, and sight, for memory.

For Judaism, an architectural structure has long stood at the heart of the tradition: the Temple in the city of Jerusalem. Originally built by King Solomon, the ancient Israelites used the Temple as the central point for worship, the site for sacrifice, prayer, and rituals. When Nebuchadnezzar destroyed the original temple in 586 B.C.E. and the Jews were exiled to Babylon, the first synagogues were created in the absence of the centralizing space of the Temple. Jews needed a physical place to gather for prayer and study (though sacrifice was only allowed in the Temple), and the synagogue became a conveniently transferable architectural idea for a people in exile. With the destruction of the Second Temple in 70 C.E. Jewish life outside the promised land, in *diaspora* ("dispersion"), became the norm. At the same time, the synagogue took on greater and greater importance. "If the Torah was the Jews' portable homeland in their long sojourn in exile," says Yom Tov Assis, "the synagogue as a house of worship and study was indeed their miniature temple, and their most vital institution."[6]

As synagogues provided space for prayers to be recited and rituals to be performed, they also became spaces in which memory could be acted out. Jewish rituals and liturgies throughout the Middle Ages, and on into the modern period, were structured so as to allow the past to reemerge in the present. The Ark that housed the Torah scrolls was eventually located on the synagogue wall oriented toward Jerusalem, and as the faithful recited prayers facing the same direction, the memory of the other place and time came to be imbedded within the ritual practices of synagogue architecture. On the one hand, synagogues served as a place where prayers and rituals were performed—the rituals took precedence over the space itself—but on the other hand the real goal was to be transported in time to another

place. Synagogues, to be sure, are not memorials, yet they can be understood to serve a memorial function, for even in Babylon one can remember Zion.

The readings in this section focus on Jewish life in modern Europe from the nineteenth through the twenty-first century. Because of the timeframe it is essential to take into account the catastrophic event of the Holocaust. So, while the imperative of post-Holocaust life is to "never forget" the horrors that took place during World War II, one immediate query might be to ask precisely *how* not to forget. That is, what is the *medium* of "not forgetting"? Judaism has inclinations toward verbal language (beginning with the words of the Torah, and the simultaneous condemnation of the idol of the golden calf; cf. Exodus 32), yet what about contemporary audio-visual media such as film? How do motion pictures such as *Schindler's List* and *Shoah* reenact the memory of the Holocaust? One cannot deny the power of Elie Wiesel's words in *Night,* yet neither can one forget the images of Resnais's *Night and Fog.*

In light of the previous sections in this book, we might also ask about the role of words, images, bodies, and rituals in this remembrance. For these reasons, the multimediated memory of the architectural memorial becomes an intriguing point of departure for an examination of religious visual culture in both its spatial and temporal aspects. The memorial, like the synagogue, links the past and present, just as it provides a window to future remembrances. Yet the memorial also links what we might call "internal memory" and "external memory." Many arguments have been made against memorials (an external manifestation of memory), stating that, once erected, we can cease remembering internally (in our minds). "The less memory is experienced from the inside," Pierre Nora warns, "the more it exists through its exterior scaffolding and outward signs."[7] Complaints against memorials often tend to fetishize the object itself, investing it with too much power—as all iconoclasm ultimately does. In contrast, the aim of "religious seeing" might be to understand that the power of the image resides in its ongoing life embedded within a set of cultural values. Memory is not somehow stored *in* a material object. Rather, the object works with personal and collective minds to *reenact* memory. Instead of thinking of memorials as "stand-ins" for memory (and thus *idols*), we might think of them as "triggers" for memories (and thus *icons*). The experience of/at the memorial then becomes an ever-new memorializing activity. Memory cannot be indelibly tied to objects; the link is always tenuous and ephemeral, open to spontaneity and innovation. Meanwhile, we must remember the "problematic," "deceptive," and "treacherous" nature of memory, as Yerushalmi has described.

And here the problem of representation comes back with particular force. As Wiesel succinctly puts it, "The Holocaust in its enormity defies language and art, and yet both must be used to tell the tale, the tale that must be told."[8] Precisely because memory is deceptive, full representation is not possible, yet we still must not forget. This problem has led many scholars in recent years to rethink and recast ideas about the nature of representation. On one hand, the goal of Jewish memory in some contexts is to "reactualize" the past, as Yerushalmi says of the Passover Seder: "Both the language and the gesture are geared to spur, not so much a leap of memory as a fusion of past and present. Memory here is no longer recollection, which still preserves a sense of distance, but reactualization."[9] On the other hand, too much *presence* runs the risk of idolatry, as Oren Stier argues, "because we think we have captured the whole, experienced the unmediated presence of the past." If we read *Night* and walk away thinking "Now I know," we have done a grave injustice to those who lived through and those who died in the concentration camps. The reading of a book or watching of a film can never make the experience "present" again. The Passover to which Yerushalmi refers, and the Holocaust to which Stier and Weisel refer, are not the same things, yet if the imperative in each is to remember, we are still stuck with the question, How do we remember?

The questions raised here relate to questions of the difference between myth and history. The blessing and curse of memory is that it is always a construction. There are times, in the name of justice, when it is absolutely vital to understand this difference, to know "what really happened," and each of the readings below takes up these problems of representation in modern Europe from a different perspective. Before moving on to those readings, however, one useful notion should be inserted here, and that is Ernst van Alphen's notion of what he terms "the Holocaust effect." This stands in contrast to "Holocaust representation," and may provide a middle term between "representation" and "reactualization":

> A representation is by definition mediated. It is an objectified account. The Holocaust is made present in the representation of it by means of *reference* to it. When I call something a Holocaust effect, I mean to say that we are not confronted with a representation of the Holocaust, but that we, as viewers or readers, experience directly a certain aspect of the Holocaust or of Nazism, of that which led to the Holocaust. In such moments the Holocaust is not re-presented, but rather presented or reenacted.[10]

We are close here to Yerushalmi's performative memory, and the dangers contained therein. But, as van Alphen continues, "We are there; history is present—but not quite."[11] It is this "not quite" that weaves its way through the selections.

THE READINGS

Richard Cohen's excerpt from *Jewish Icons* introduces us to the role of visual objects in the creation of modern Jewish identity in Europe, beginning around the turn of the nineteenth century. At a time when museums began to be built across Europe as repositories of history and culture, Jewish communities, recently emancipated from life in the ghettoes, gradually shifted some of their collections of Judaica from synagogues to museums. Cohen's excerpt tells the story of one of these instances: the formation of a Jewish museum in Prague. Objects such as Torah shields, circumcision benches, paintings, and other ceremonial objects, which had been kept in the private space of the synagogue, were moved into the public space of the museum. This shift from the private to the public was undertaken in order to establish Jewish identity as one identity among other identities of Europe. Here, identity is forged through visual, material culture, matched with institutionalized architecture. Museums, much like synagogues, function as sites of memory and the "museum effect" discussed in previous sections is here elevated to take on greater significance.

Through the selection by Cohen we see how the preservation of material objects is intimately connected with the establishment of identity and the concomitant preservation of history; memory is tied to objects in space. However, such identification can have dire consequences, for once one's identity and history are bound within a particular space and time, that very identity can be controlled and manipulated by other forces. Museums are not neutral receptacles, but are ideologically charged spaces susceptible to a variety of manipulations. So while Jews in the nineteenth century help to establish their identity through museum collections, the Nazis in the twentieth century are able to take that same collection of visual objects and twist it in their own way. As Cohen notes, "Transformation of meanings is an ever-present phenomenon in the history of museums and built into their very nature."

The second excerpt is from James Young, whose work has been vital to the ongoing concerns of memory and memorials in a post-Holocaust era. In a number of books on memory and the arts after the Holocaust, Young has raised questions that resonate with several concerns in the present volume. In *The Texture of Memory,* from which the excerpt below is taken, he suggests that memorials have no significance in and of themselves (again, there is no "art for art's sake"); they are "mere stones in the landscape." Memorials are instead created for, and in turn given meaning by, future generations, as this section's epigraph already hints. The function of public art in the promotion of memory, Young suggests, is "to create shared spaces that lend a common spatial frame to otherwise disparate experiences and

understanding. Rather than presuming a common set of ideals, the public monument attempts to create an architectonic ideal by which even competing memories may be figured." This is not a homogenizing unity, but rather leaves open the possibilities for the ongoing production of memory.

In this vein, the aesthetic evaluation of such architectural sites must necessarily be different than typical art historical evaluations, which would provide either a formal interpretation (Is the style provocative, or cutting-edge? Is the medium appropriate to the content?), or an historical interpretation (How historically "accurate" is the memorial?). The public art of the memorial is in the service of memory, and this fact resituates evaluation processes away from a "high art" or "low art" distinction toward art as a production of social processes, including collective memory. Throughout his work, Young is concerned with the ongoing, productive space of memory, where monuments do not disappear due to "oversight," but where memory, like seeing, is interactive and generated from personal and communal responses. This is nowhere more complex, and perhaps nowhere more important, than in Holocaust memorials, the key focus of Young's work.

Turning then to specific memorial sites, Oren Stier brings us briefly to two memorials: Israel's Holocaust memorial Yad Vashem and the U.S. Holocaust Memorial Museum in Washington D.C. The selection comes from Stier's larger investigation of the "media of memory" of the Holocaust. Looking at media such as videotestimonials, museums, and memorials, he examines the role of architecture, images, and language in the production of memory. In the excerpt here, the exhibition design is again essential to the overall memory and meaning being generated, as railway cars from the two different memorial spaces are compared and contrasted. Observers are invited to become participants within the architecture of the memorials, to "reactualize" history, but a key question is raised concerning the degree of that participation.

Like Young, Stier brings out the two-sided nature of memorials: they are there for memory, to remind us to "never forget," yet they constantly run the risk of becoming *idols.* Following the work of W. J. T. Mitchell and others, Stier warns that idolization occurs from both *too much* representation and from *not enough* representation: "too much representation, and the Holocaust is objectified, we are cut off from it . . . too little mediation and we are engulfed. We might say we are subjectified." In order to maintain a separation between idols and icons, Stier suggests, means we must not forget the mediation of memorials: "Icons thus call attention to the gap between then and now, there and here, to the necessary vicariousness of their (re)presentational strategies." Icons, to use van Alphen's notion of the "Holocaust effect," never forget the "not quite" of images.

In the final excerpt we return to the space of the museum, an architectural site that could very easily be rendered a memorial. For this we explore Daniel Libeskind's Jewish Museum in Berlin through my own writings on it. The museum, like the memorial, is a space that re-members and re-presents the past, and in the re-presentation the original thing or event is necessarily altered in the passage through space and time. Space is formed in a particular way that brings the past to bear on the future, but only as the museum goers transform into participants. Libeskind's museum is a stage where memory is reenacted. As the "museum effect" tells of the change in meanings of visual objects as they are displayed in museums, we see here how the "museum effect" meets the "Holocaust effect," so that the museum itself is altered by history, and history is altered by the museum. Libeskind's Museum is emphatically *not* a Holocaust museum, nonetheless due to its site in the midst of Berlin it is impossible to create a "Jewish museum" without reference to the Holocaust.

Ending with Libeskind's museum provides yet another perspective on how architectural design is linked to the past, but this building in particular also leads forward to the future, through what Libeskind calls a "hope-oriented" architecture. This is not a simple redemption of the Hollywood-type where everything turns out fine in the end, for as Libeskind's architecture ably displays, the past is an open wound, a jagged scar cutting across the city of Berlin. There is no future without a past, just as there is no hope without memory.

Notes

1. Yosef Hayim Yerushalmi, *Zakhor: Jewish History and Jewish Memory,* 3rd ed. (Seattle: University of Washington Press, 1996).
2. Erwin R. Goodenough, *Jewish Symbols in the Greco-Roman Period,* abridged version (Princeton: Princeton University Press, 1988), 33–34.
3. Kalman Bland, *The Artless Jew* (Princeton: Princeton University Press, 2000), 8.
4. Joseph Gutmann, "Is There a Jewish Art?" in *The Visual Dimension,* ed. Clare Moore (Boulder, CO: Westview Press, 1993), 14. Unfortunately, Gutmann, like many before him, concludes with a high art or low art distinction, complaining how contemporary "kitsch art, superficial, frequently mass-produced, is vacuous; it lacks any enduring power to move or to challenge." (Ibid., 15). Indeed, Sallman's *Head of Christ* and the television serializing of the *Ramayana,* as seen in previous sections, would seem to offer some very contrary views.
5. Richard Cohen, *Jewish Icons* (Berkeley: University of California Press, 1998), 7.
6. Yom Tov Assis, "The Synagogue Throughout the Ages," in *And I Shall Dwell Among Them: Historic Synagogues of the World* (New York: Aperture, 1995), 161.

7. Pierre Nora, "Between Memory and History: *Les Lieux de Memoire*," trans. Marc Rousebush, *Representations* 26 (1989): 13.

8. In Herbert Muschamp, "Shaping a Monument to Memory," *New York Times*, April 11, 1993, sec. 2, 1. Quoted in Liliane Weissberg, "In Plain Sight," in *Visual Culture and the Holocaust*, ed. Barbie Zelizer (New Brunswick: Rutgers University Press, 2001), 18.

9. Yosef Hayim Yerushalmi, *Zakhor*, 44.

10. Ernst van Alphen, *Caught by History* (Stanford: Stanford University Press, 1997), 10.

11. Ibid., 11.

Richard Cohen, from *Jewish Icons*

Jewish tradition from biblical times placed a major symbolic importance on the objects designed to serve God and service the Temple, but it is only at a later time and setting, in Jerusalem and Egypt of the eleventh and twelfth centuries, that evidence exists of ritual objects being stored in synagogues. Thus the collecting of Jewish ritual objects became a function of the synagogue, which housed them in its sacred space, the Torah ark (*heichal*). Record books (*pinkassim*) of certain communities (*kehillot*) attest to regulations instituted to determine how the objects should be kept and preserved, on what occasion they should be used, and who was allowed to remove them from the *heichal*. Accessibility was limited. Jewish religious objects of a communal nature were visible when they served a particular function, but they remained basically out of sight for most of the community most of the time, as was common with other ritual objects in other cultures and religions. The objects, collected over generations in a particular *kehillah*, not only served a specific religious function but were also charged with both a personal and a social meaning for the original patron and the *kehillah*.

Private homes also maintained some Jewish ceremonial objects—far fewer than became common in the modern period—to perform certain rituals, but apparently only in the middle of the eighteenth century did an individual, Alexander David (1687–1765), assemble religious artifacts not only to serve his private synagogue but to constitute a veritable Judaica collection. Prior to David, among Italian and Amsterdam Jews in the seventeenth and eighteenth centuries and among his contemporary Jews, Court Jews especially, collections of non-Jewish objects existed, while Jews in different countries actively established private libraries of printed books and manuscripts, yet it was not until the second half of the nineteenth century that a tendency to assemble Jewish ceremonial objects emerged. And only at the turn of that century were the first strides made toward the creation of Jewish museums in various European cities, where Judaica was to be exhibited publicly. Indeed, this phenomenon remained rather limited

prior to 1945, after which its scope extended considerably. In the interim Judaica had established itself as an area of interest and study that had previously been almost completely neglected by Jews and gentiles. The turning point then in the collection and exhibition of Judaica was that conjuncture in the history of European Jewry when the process of leaving the ghetto was fully matured and the bulk of Western and Central European Jewish society had achieved Emancipation. It is that nexus which offers an insight into a predisposition on the part of elements in Jewish society to openness, to an internal recognition that Jews need not fear exposing their religious and cultural tradition, and to the assumption that an exhibition or a museum may serve as a public meeting ground for Jews and gentiles alike in the spirit of culture and in appreciation of Jewish culture.

[. . .]

INSTITUTIONALIZATION OF JEWISH ART IN EUROPE

The dramatic European impulse during the second half of the nineteenth century to preserve and develop historic consciousness through museums and to exhibit objects of artistic, industrial, and mechanical nature at expansive international exhibitions found a clear resonance within Central European Jewry. Several factors combined with those already discussed to encourage this tendency in some Jewish communities. At the outset one must consider their setting—modern, urban centers in the midst of massive renewal that wrought the destruction of old, deteriorating quarters and the construction of new ones, employing innovative architectural designs together with modern technological advances in the construction trade. As this celebration of modern technology and renovation unfolded, local elites began to promote appropriate monuments for their city. Vienna, Prague, and Budapest—three cities with important Jewish concentrations—were undergoing the process of demolition and renewal, which engendered a craving for past glory. This dialectical tendency was buttressed by the contemporary interplay between ethnographic interest and historical memory, exemplified by the establishment of ethnographic museums or ethnographic departments in prominent museums, often specializing in native peoples. Such currents, along with particular efforts of individual collectors of Judaica, helped place the idea of creating Jewish museums on the agenda in various cities—Vienna (where the first Jewish museum was founded in 1895), Prague, Danzig, and Budapest, to name but a few. In each of these communities individuals began to explore the material culture of their region and to assemble Jewish art both as a means of promoting historical consciousness and of preserving local Jewish history.

Driven by a similar impulse as that which inspired Leopold Zunz and his
co-workers in Germany at the beginning of the century—a sense of re-
sponsibility for the image of the Jewish past and implicitly the Jewish pres-
ent—these figures were concerned with the rapid disappearance and decay
of Jewish ritual objects and dwindling interest in Jewish material culture.
[. . .]

Several of the Jewish museums, whose foundations were laid prior to
World War I, emphasized an attachment to their native city or country.
The Prague collection provides an instructive paradigm. Prague underwent
a major face-lift in the last decade of the nineteenth century and the first
decade of the twentieth century that included its historic Jewish ghetto
and several of its celebrated synagogues (the Zigeuner and Great Court
synagogues). Prague Jewry now confronted a dilemma similar to that en-
countered by Anglo-Jewry when the Bevis Marks synagogue faced de-
struction. How to preserve, if not the buildings themselves, at least the
synagogues' contents? Where could these objects be housed? From a dif-
ferent perspective, the community faced a common phenomenon in the
history of culture: as the result of the changing function of a traditional in-
stitution, private or ecclesiastical, due at times to destruction or to reloca-
tion, its treasures undergo a complete metamorphosis. They become part
of the public sphere. As a new home was needed in such situations to
house the dislocated objects, public museums were often created. Prague's
Jewish museum began under such circumstances.

Salomon Hugo Lieben (1881–1942) was the guiding force behind
Prague's new venture. Typical of the vast majority of Czech Jews, he re-
ceived a thorough German education yet viewed favorably the gradual
transformation of Bohemian Jews into "Czechs." Eventually to emerge as
a significant scholar of the history of the Jews in Bohemia and Moravia,
Lieben played an instrumental role in formulating the Czech-oriented
Verein zur Grundung und Erhaltung eines jüdisches Museums in Prag (Associa-
tion for the Establishment and Maintenance of a Jewish Museum in
Prague) during 1906, several months after the two Prague synagogues were
torn down. Undaunted by the severe criticism directed in those years at
the Czech-Jewish alliance from certain Jewish quarters, Lieben aligned
himself with individuals like August Stein, Markus Brückner, and Adolf
Hahn, who were forthrightly involved in promoting Czech-Jewish rela-
tions. The *Verein's* statutes reiterated this premise in stipulating as its ulti-
mate goal the collection and preservation of Jewish artifacts originating in
either Prague or Bohemia. Lieben actively pursued this nationalist orien-
tation, combing Prague and the local surroundings in search of objects that
would represent each Jewish holy day and ritual ceremony. His findings
were impressive and sometimes of a unique quality, like the circumcision

bench from Udlice, Bohemia, an authentic expression of the Jewish link to the Bohemian countryside. He took great pride in the imprint of the native land on the autochthonous and homogeneous nature of the collection. Clearly, Lieben saw the evolution of the museum as a link in the historical development of Czech Jewry, for which his generation was responsible. On several occasions Lieben reflected on that matrix, expressing the impact of the historic moment and the pull to commemorate the past. Describing the destruction of the Prague synagogues and the background to the museum Lieben remarked:

> a disquieting question was posed—what should be done with all the valuables and treasures that our fathers and forefathers through centuries, under great self-renunciation, offered as consecrated donations to the sanctuary? Should the history of the nineteenth century repeat itself, that each supposed urgent modernization of a synagogue and Jewish properties simply let valuable objects of great art historical, familial history and historical value disappear and cause irreplaceable damage forever? To avoid this I, with several supporters, founded then our Jewish museum in the community.

Lieben's enterprise was wholly identified with the community and it immediately attracted the support and following of dozens of Prague Jews. Within three years the *Verein* held its inaugural exhibition in a community building and in 1912 moved into a more permanent location in the recently reconstructed home of the historical Prague burial society. Adjacent to the old, eerie Jewish cemetery, the museum assumed a venerable place within the cultural nexus of the community—its exhibition evoked the spiritual and cultural world of the community and the diverse levels of Jewish involvement and association with Prague and Bohemian society. Within a decade Lieben had succeeded in juxtaposing religious and secular artifacts in a significant manner so that their display celebrated the community's confidence in the Czech-Jewish alliance and its commitment to the historical past and future.

Transformation of meanings is an ever-present phenomenon in the history of museums and built into their very nature. But the evolution of Prague's Jewish museum turned this truism into a unique direction. From its modest beginnings at the turn of the century, the museum became part of National Socialist designs during World War II. Driven to document "decadent" Jewish art and to confiscate Jewish possessions, Nazi officials in 1942 ordered a takeover of the museum and turned it into a large storehouse—the "Central Jewish Museum"—of Jewish religious and private objects from more than one hundred and fifty communities in Bohemia and Moravia. As Jews were deported from their hometowns, their objects

were assembled and sent to Prague, where they were carefully examined and classified. Prague's museum was transformed into a unique collection. Its holdings covered objects from all over the Czech lands, ranging from the finest Torah ark curtains to everyday objects created by unskilled craftspeople. Moreover, it paradoxically, and cynically, pursued the goals of its creators—both in its national character and in its desire to prevent the destruction of objects that had been preserved for generations in families and synagogues, about to be demolished. Members of the museum and additional staff from other Jewish museums in the former Czechoslovakia, who continued to fulfill their museological functions, could not know of the eventual goal of the Nazis—to create a permanent museum of Jewish art, from cradle to grave, that would be a constant reminder to the world of the decadent nature of Jewish civilization. This museum, so some National Socialist theorists claimed, would become even more essential following the destruction of European Jewry, for with their demise one needed to guarantee their ideological centrality to National Socialism. Objects were to vindicate and legitimate National Socialist policy on the "Jewish question." Thus emerged one of the most important repositories of Jewish art in the world today.

In the original local and national aspirations that the Prague *Verein* placed high on its agenda, the dialectic of Jewish museums comes to the forefront. It was not alone. Other Jewish museums of the period and at later stages were similarly motivated. The museum was at times meant to be a showcase, bearing witness to the deep-seated connection of Jews to their particular place of settlement and their historic presence in the respective country. It raised the banners of nationhood and religion in a unique form, communicating on a more visceral level how Jews maintained this symbiosis.

[. . .]

With the emergence of a Jewish national perspective in the east and west, a further significant dimension was added to the ways in which elements of the Jewish minority tried to acculturate to Europe and maintain a hold on its past. Though ideologically at odds with many aspects of bourgeois Jewish society, the Jewish national idea complemented and solidified a new vista of Jewish involvement that emerged from the embourgeoisement of Central European Jewry and penetration of bourgeois values in the fin-de-siècle. As the cultural orientation of a "return to the ghetto" manifested, Jews wrestled throughout the nineteenth and even into the twentieth century with the vacuum created by leaving the ghetto and with the challenges of modernity. Previously, Judaism had been an all-encompassing phenomenon for the bulk of Jews, but as its hold weakened and the distance from the ghetto experience widened, individuals turned to a

myriad of different occupations and callings. Within this process of integration, there emerged diverse attempts to reclaim parts of that past experience, in some cases through denying modernity and in others through merging modernity with aspects of that past. In the post-Emancipation era different elements of Jewish society found contrasting ways to reappropriate the past without succumbing completely to its previous tenets. The collecting and exhibiting of "Jewish art" was part of that process. Jews of opposing ideologies from across Europe and abroad were engaged by this cultural domain and found in it a viable expression for their association with Jewish life. For various reasons—apologetics, nostalgia, patriotism, historical consciousness, and nationalism—they turned to the display of Jewish art as a way to promote their particular self-image. They had come to appreciate the ability of art to convey traditions and evoke memories of the past, while asserting a particular view of the Jewish present and future. That tendency would take on an added meaning in the post–World War II setting and serve as a determining factor in the remarkable efflorescence of Jewish museums since the 1950s. In that development, in which the Holocaust and its consequences figured prominently, Jews and non-Jews were engaged in sorting out the meaning of the cataclysm and the ways in which the destroyed Jewish past could again become meaningful for contemporary society—even in places (for example, Germany, Poland, and the Czech republic) where Jews had become almost an anomaly. For many visitors attending these museums the encounter with the objects stimulates a form of engagement with the historic process that saw the elimination of Jewish culture from most of Europe.

James E. Young, from *The Texture of Memory: Holocaust Memorials and Meaning*

THE CONSEQUENCES OF MEMORY: AN ALTERNATIVE CRITIQUE

Public art in general, and Holocaust memorials in particular, tend to beg traditional art historical inquiry. Most discussions of Holocaust memorial spaces ignore the essentially public dimension of their performance, remaining either formally aestheticist or almost piously historical. So while it is true that a sculptor like Nathan Rapoport will never be regarded by art historians as highly as his contemporaries Jacques Lipchitz and Henry Moore, neither can his work be dismissed solely on the basis of its popular appeal. Unabashedly figurative, heroic, and referential, his work seems to be doomed critically by precisely those qualities—public accessibility and historical referentiality—that make it monumental. But in fact, it may be just this public appeal that finally constitutes the monument's aesthetic performance—and that leads such memorials to demand public and historical disclosure, even as they condemn themselves to critical obscurity. Instead of stopping at formal questions, or at issues of historical referentiality, we must go on to ask how memorial representations of history may finally weave themselves into the course of ongoing events.

While questions of high and low art may well continue to inform the discussion surrounding Holocaust monuments, they must not dictate the critical discussion any longer. Instead, we might keep in mind the reductive—occasionally vulgar—excesses in popular memorial representations, even as we qualify our definitions of kitsch and challenge its usefulness as a critical category for the discussion of public monuments. Rather than patronizing mass tastes, we must recognize that public taste carries weight and that certain conventional forms in avowedly public art may eventually have consequences for public memory—whether or not we think they should. This is to acknowledge the unfashionable, often archaic aspects of

so many Holocaust memorials, even as we look beyond them. It is also to recognize that public art like this demands additional critical criteria if the lives and meanings of such works are to be sustained—and not oppressed—by art historical discourse.

For there is a difference between avowedly public art—exemplified by public monuments like these—and art produced almost exclusively for the art world, its critics, other artists, and galleries, which has yet to be properly recognized. People do not come to Holocaust memorials because they are new, cutting-edge, or fashionable; as the critics are quick to note, most of these memorials are none of these. Where contemporary art is produced as self- or medium-reflexive, public Holocaust monuments are produced specifically to be historically referential, to lead viewers beyond themselves to an understanding or evocation of events. As *public* monuments, these memorials generally avoid referring hermetically to the processes that brought them into being. Where contemporary art invites viewers and critics to contemplate its own materiality, or its relationship to other works before and after itself, the aim of memorials is not to call attention to their own presence so much as to past events *because* they are no longer present. In this sense, Holocaust memorials attempt to point immediately beyond themselves.

In their fusion of public art and popular culture, historical memory and political consequences, therefore, these monuments demand an alternative critique that goes beyond questions of high and low art, tastefulness and vulgarity. Rather than merely identifying the movements and forms on which public memory is borne, or asking whether or not these monuments reflect past history accurately or fashionably, we turn to the many ways this art suggests itself as a basis for political and social action. That is, we might ask not only how the monument maker's era and training shaped memory at the time, and how the monument reflects past history, but, most important, what role the monument plays in current history.

We might now concern ourselves less with whether this is good or bad art, and more with what the consequences of public memorial art are for the people. This is to propose that, like any public art space, Holocaust memorials are neither benign nor irrelevant, but suggest themselves as the basis for political and communal action. With apologies to Peter Bürger, I would like to propose a reworking of what he has called the "functional analysis of art," adapted to examine the social effects of public memorial spaces. My aim is to explore not just the relations between people and their monuments, but the consequences of these relations in historical time.

Whereas some art historians have traditionally dismissed such approaches to art as anthropological, social, or psychological, others have opened their inquiry to include larger issues of the sociology of art: public memorials in this case are exemplary of an artwork's social life, its life

in society's mind. As Marianne Doezema has suggested, there is much more to the monument's performance than its mere style or school of design. "The public monument," she writes, "has a responsibility apart from its qualities as a work of art. It is not only the private expression of an individual artist; it is also a work of art created for the public, and therefore can and should be evaluated in terms of its capacity to generate human reactions." To my mind, such reaction refers not just to an emotional affect, but to the actual consequences for people in their monuments. The question is not, How are people moved by these memorials? but rather, To what end have they been moved, to what historical conclusions, to what understanding and actions in their own lives? This is to suggest that we cannot separate the monument from its public life, that the social function of such art *is* its aesthetic performance.

"There is nothing in this world as invisible as a monument," Robert Musil once wrote. "They are no doubt erected to be seen—indeed, to attract attention. But at the same time they are impregnated with something that repels attention." This "something" is the essential stiffness monuments share with all other images: as a likeness necessarily vitrifies its otherwise dynamic referent, a monument turns pliant memory to stone. And it is this "finish" that repels our attention, that makes a monument invisible. It is as if a monument's life in the communal mind grows as hard and polished as its exterior form, its significance as fixed as its place in the landscape. For monuments at rest like this—in stasis—seem to present themselves as eternal parts of the landscape, as naturally arranged as nearby trees or rock formations.

As an inert piece of stone, the monument keeps its own past a tightly held secret, gesturing away from its own history to the events and meanings we bring to it in our visits. Precisely because monuments seem to remember everything but their own past, their own creation, my critical aim will be to reinvest the monument with our memory of its coming into being. None of this is intended to fix the monument's meaning in time, which would effectively embalm it. Instead, I hope to reinvigorate this monument with the memory of its acquired past, to vivify memory of events by writing into it our memory of the monument's origins.

By returning to the memorial some memory of its own genesis, we remind ourselves of the memorial's essential fragility, its dependence on others for its life; that it was made by human hands in human times and places, that it is no more a natural piece of the landscape than we are. For, unlike words on a page, memorial icons seem literally to embody ideas, to invite viewers to mistake material presence and weight for immutable permanence. If, in its glazed exteriority, we never really see the monument, I shall attempt to crack its eidetic veneer, to loosen meaning, to make visible the

activity of memory in monuments. It is my hope that such a critique may save our *icons* of remembrance from hardening into *idols* of remembrance.

For too often a community's monuments assume the polished, finished veneer of a death mask, unreflective of current memory, unresponsive to contemporary issues. Instead of enshrining an already enshrined memory, the present study might provide a uniquely instructive glimpse of the monument's inner life—the tempestuous social, political, and aesthetic forces— normally hidden by a monument's taciturn exterior. By drawing back into view the memorial-making process, we invigorate the very idea of the monument, thereby reminding all such cultural artifacts of their coming into being, their essential constructedness.

To this end, I enlarge the life and texture of Holocaust memorials to include: the times and places in which they were conceived, their literal construction amid historical and political realities, their finished forms in public spaces, their places in the constellation of national memory, and their ever-evolving lives in the minds of their communities and of the Jewish people over time. With these dimensions in mind, we look not only at the ways individual monuments create and reinforce particular memory of the Holocaust period, but also at the ways events re-enter political life shaped by monuments. Taken together, these stages comprise a genuine activity of memory, by which artifacts of ages past are invigorated by the present moment, even as they condition our understanding of the world around us.

On a more general level, we might ask of all memorials what meanings are generated when the temporal realm is converted to material form, when time collapses into space, a trope by which it is then measured and grasped. How do memorials emplot time and memory? How do they impose borders on time, a facade on memory? What is the relationship of time to place, place to memory, memory to time? Finally, two fundamentally interrelated questions: How does a particular place shape our memory of a particular time? And how does this memory of a past time shape our understanding of the present moment?

Through this attention to the activity of memorialization, we might also remind ourselves that public memory is constructed, that understanding of events depends on memory's construction, and that there are worldly consequences in the kinds of historical understanding generated by monuments. Instead of allowing the past to rigidify in its monumental forms, we would vivify memory through the memory-work itself— whereby events, their recollection, and the role monuments play in our lives remain animate, never completed. In this light, we find that the performance of Holocaust memorials depends not on some measured distance between history and its monumental representations, but on the

conflation of private and public memory, in the memorial activity by which minds reflecting on the past inevitably precipitate in the present historical moment. It is not enough to ask whether or not our memorials remember the Holocaust, or even how they remember it. We should also ask to what ends we have remembered. That is, how do we respond to the current moment in light of our remembered past? This is to recognize that the shape of memory cannot be divorced from the actions taken in its behalf, and that memory without consequences contains the seeds of its own destruction. For were we passively to remark only the contours of these memorials, were we to leave unexplored their genesis and remain unchanged by the recollective act, it could be said that we have not remembered at all.

Oren Baruch Stier,
"Holocaust Icons, Holocaust Idols"

There is something in the way the Holocaust comes up in contemporary discourse that is structurally similar to the way the holy—the sacred, the *kadosh* (in Hebrew)—is dealt with, in its classic sense. That is, the ways people speak of, react to, and create in response to the Holocaust—with reverence, with awe, with humility—is as if they are confronted with a sacred mystery. This is especially operative in the memorial context, because issues of remembrance only serve to heighten the sensitivity to sacrality. It is increasingly engaging and intriguing when words like "iconographic," "fetish," and "sanctity" become part of the discourse of and about Holocaust memory.

Thus, I have a fascination not only with representations of the Shoah, but specifically with the symbolic language used in memorializing it. This is simultaneously energizing and vexing. How do we understand the process of symbolization as it is set in motion here? What is the nature of the "sanctity" evoked in its development, if I may even call it that (and there are many that would bristle at the term)? How do we as scholars respond? We have all come across this position, this expression of propriety (or charge of impropriety), this concern for protecting the sacred core of the Holocaust from abuse. Elie Wiesel is chief among this view's proponents. The Holocaust, in this setting, is a sacred mystery, held "over there" behind a carefully circumscribed fence that, presumably, protects it from abuse at the hands of all who would violate its memory, its symbols. But the fact is that those symbols are not so easily controlled. They have a life of their own.

I am interested therefore in how the Holocaust is symbolized, condensed or distilled, as it were, to its most compact and potent formulations. I am interested in how such symbols are used, instrumentalized, appropriated. I want to know what happens to the memory of the Holocaust when these symbols are adopted and put in the service of contemporaneous con-

cerns. Put another way, I want to ask how we resist—if we even want to—making the Holocaust and its representative artifacts, its icons, into idols, fetishes, the symbolic repositories (the final resting place?) for our own desires and fantasies concerning World War II and its memory.

[. . .]

Consider, for example, Israeli architect Moshe Safdie's 1995 *Memorial to the Deportees* at Yad Vashem, Israel's "Holocaust Martyrs' and Heroes' Remembrance Authority." Safdie (b. 1938) is perhaps best known for his "Habitat" housing complex made of stacked modular prefabricated "boxes" and built for the Montreal exposition in 1967. Safdie has also designed the late Yitzhak Rabin's tomb and Yad Vashem's children's memorial (itself a model of iconic presentation and reflection in its seemingly infinite visual repetition of a single candle flame), and he is currently working on the renovations for Yad Vashem's historical museum. Situated on a hillside overlooking one of the many pine-filled valleys that ring Israel's memorial mountain, the *Memorial to the Deportees* features an authentic, original *Deutsche Reichsbahn* railway car perched precariously on an iron rail line jutting out from the steep slope [fig. 6.1]. The car and track mark out an impossible journey, frozen and suspended in time and space over the steep hill. This line ends, as it did for so many deportees, abruptly and violently, a moment symbolized by the brutal twisting and shearing of the rails, meant to symbolize a bridge after an explosion.

This is not the only memorial presentation of an authentic railway car. The U. S. Holocaust Memorial Museum (USHMM) in Washington, D.C., whose permanent exhibit features an impressive array of genuine artifacts, and whose underlying narrative depends on those artifacts, includes another one of these grim specimens [fig. 6.2]. Unlike the Safdie memorial, whose railcar—set off from its surroundings, an "art piece" we should and may not touch—is tantalizingly just out of the reach of the over-curious visitor, the Washington museum's version is thrust in the direct path of the museum-goer. In Washington, the visitor must go through the boxcar to get to the next section of the exhibit: there is an escape for those who would choose not to pass through the car, but it is not obvious.

How can we read these different instrumentalizations of the Holocaust-era railcar? Again, the context of presentation is important. The Safdie memorial presents the railcar on a track extending from a viewing platform marked by the famous short poem by Dan Pagis, "Written in Pencil in the Sealed Railway-Car" [fig. 6.3]: "here in this carload / i am eve / with abel my son / if you see my elder son / cain son of man / tell him that i" (from *Points of Departure*). One of the most widely anthologized poems of the Holocaust, this brief but searing distillation of biblical myth and primal fratricide/genocide offers itself as an artifact of the Shoah, as if

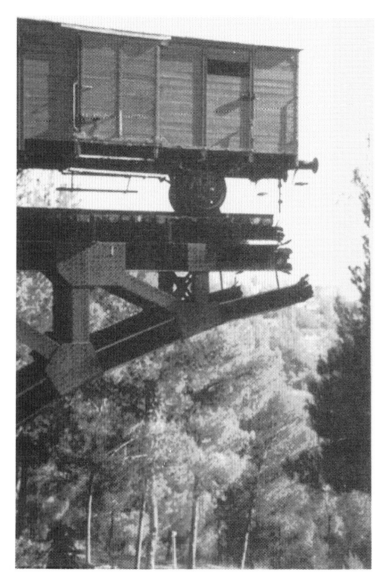

Fig. 6.1 Railcar at Memorial to the Deportees, Yad Vashem, Israel. Designed by Moshe Safdie, 1995. Photo by Oren Baruch Stier.

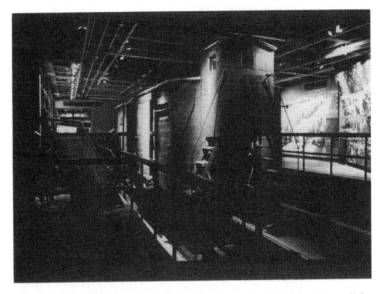

Fig. 6.2 Railcar on display as part of the permanent exhibition of the United States Holocaust Memorial Museum, Washington, D.C. Photo by Arnold Kramer. Courtesy of USHMM Photo archives © USHMM.

it were actually written (and abruptly cut off, perhaps by the opening of the car doors and the fearful cry of "*Raus, Juden*") inside one of those infamous railway cars. By itself the poem is a literary icon, invoking the presence of its speaker through its form and mythic resonances. It symbolically enlarges the narrative of Nazi deportations through the re-telling of the "family drama" of Western religious-mythic origins (recall that when Cain killed Abel he murdered one-fourth of the current human population), even as it compresses the scope of genocidal history into a scant six lines. As a fictional artifact, the poem is an example of Holocaust *presentation*, suggesting itself as a direct and un-mediated link to the past. In breaking off so abruptly and evocatively, the poem becomes an urgent and direct message to us as readers to complete the transmission—finish the sentence, deliver the message, carry on the story. We are thus implicated in Pagis's (re)writing of myth and history: we participate in it, we are drawn into the memorialization process. But in the context of the *Memorial to the Deportees*, the presentation is intensified: the railcar becomes the physical marker of the poem's possible embodiment, so that the visitor imagines it is *this* car that produced or contained this written message. Together, poem and

Fig. 6.3 Railcar with poem by Dan Pagis at Memorial to the Deportees, *Yad Vashem, Israel. Designed by Moshe Safdie, 1995. Photo by Oren Baruch Stier.*

artifact etch into the Israeli landscape an iconic presentation of memory with a voice that speaks directly to the visitor. In juxtaposing verbal and graphic imagery in this way, Safdie reenacts the scene of deportation by cattle-car, bringing it out of the distant past into the eternal present of memory.

The voicing of that scene is, however, suspended at Safdie's memorial; the experience of the presence of the Holocaust in its artifact and icon is physically inaccessible at Yad Vashem. Not so at the USHMM, where the visitor becomes part of the unfolding narrative of deportation and, indeed, must supplement through imagination any verbal icon—any text—of the sort that Pagis has (unwittingly) provided for the Israeli memorial. The work of reenactment through artistic presentation and juxtaposition performed by Safdie is done in Washington by way of emplacement and emplotment. If in Jerusalem I would need to use Pagis' poem as a vehicle for imagining the space of deportation, in Washington I can stand in that space.

Is there a risk of idolatry here? Yes, in both cases. For the *Memorial to the Deportees,* the stability of the icon as a non-idolatrous symbol is threatened by its inaccessibility and inflexible narrative voice. But, as long as the visitor understands these icons merely as possibilities of reenactment and presentation, as long as we do not believe that it was *this* car that yielded this poem, as long as this memorial remains a vehicle for reminding visitors of the history that lies behind it, then the icon remains open in its memorial possibilities. The same holds true for the railcar in the Washington museum. But the danger is more pronounced when the memorial is put in the service of a different historical-memorial narrative, when the overall image the icon presents is given closure in pointing toward a redemptive narrative. This is expressed in Yad Vashem's website describing the monument: "Although symbolizing the journey towards annihilation and oblivion, facing as it does the hills of Jerusalem the memorial also conveys the hope and the gift of life of the State of Israel and Jerusalem, eternal capital of the Jewish people" (http://www.yad-vashem.org.il/visiting/sites/deportees.html). This alternative narrative voice calls our attention to the way in which this memorial is positioned ideologically and symbolically, for it is a staple of contemporary Holocaust memorialization that the birth of the State of Israel be configured as coming out of the ashes of Jewish Europe. Even in the standard structure of commemoration "Holocaust" is coupled with heroism, destruction with rebirth in the Promised Land, understood as the symbol of national redemption. In the memorial strategy of dis- and re-placement, Safdie's railcar has been transplanted from its original environment, brought "home" to perch precariously over a Judean valley. The icon has been made into an idol of the state.

[. . .]

The term for idolatry in rabbinic tradition, *avodah zarah,* literally means "strange worship." This can be read in two ways: as the improper form of worship or in reference to the improper god being worshiped—"the strangeness of the ritual or the strangeness of the object of the ritual" (Halbertal and Margalit, *Idolatry*). The latter is surely unacceptable in a Jewish context, while the former is more ambiguous. And it is the former mode, I think, that allows for acceptable and effective iconization. An icon, in its traditional Jewish memorial mode, acts as a reminder—of G-d, of catastrophe, of past redemptions and their long-awaited but ever-deferred future recurrence. Icons thus call attention to the gap between then and now, there and here, to the necessary vicariousness of their (re)presentational strategies. Idols will forget that distinction, offer too much closure. When the icon's memorial trajectory is turned in a different direction—inward, or toward some contemporary, immediate form of redemption—idolatry rears its ugly head. Icons are dynamic; idols static. A religious icon is a medium for worship; an idol is the object of worship itself.

Holocaust icons operate according to the same structure. As long as the image, whatever its form, points beyond itself to tell something of the memory it invokes and yes, even the mystery it conceals or guards, the difference it points to, then it is an effective icon. Icons become idols only when a mistake of interpretation is made: when the voyeur mistakes the part for the whole, the artifact for the events that produced it or the ideologies that have put it on display. In this way the icon becomes instrumentalized, idolized, made into a false god. Idol-making shows a misplaced (or displaced) impatience for redemption. We know by now that easy redemption, especially in the case of the Holocaust, is an impossible desire, an ever-deferred wish. Nonetheless, the danger is real, because in this time of increasing memorialization and iconic proliferation, with the events of World War II and their authentic bearers of memory passing into history, virtually all we have to work with are the symbols we have inherited from the past. In this hypermediated age, it isn't simply that the medium is the message (and messenger as well) but that it is the totality of our experience of the Holocaust past. How could it not become an idol? Only through the careful manipulation of those media of representation and transmission, only through attention to effects and contexts and, especially, open signification, can those icons and the people who memorialize with and through them resist the seductive pull of idolatry. "You shall have no other gods before me" reads the biblical text. Perhaps this is also the cry out of the whirlwind of Holocaust memory we must increasingly find ways of hearing and seeing. We must nonetheless hear and see with the help of a volatile symbolic vocabulary of memorial presentation, one that will influ-

ence thinking about the Holocaust and its representation for many years to come.

Note

* This selection is excerpted from an early version of a chapter from Stier's forthcoming book, *Memory Matters: Contemporary Holocaust Memorial Culture.*

S. Brent Plate, "Building *Zakhor:* The Place of Memory in Daniel Libeskind's Jewish Museum, Berlin"

This is not a Holocaust museum [fig. 6.4].

Originally designated the "Extension of the Berlin Museum with the Jewish Museum Department," it evolved as its own autonomous structure and became simply the "Jewish Museum, Berlin." In the city of Berlin a "Jewish Museum" comes quite close to a "Jewish Memorial," and the difference between the two is where the building's architect, Daniel Libeskind, situates his design.

The building was completed by the end of 1998, though it took an immensely long time to officially open as a "museum." And it is the design

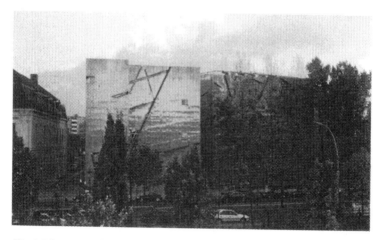

Fig. 6.4 Front view of the Jewish Museum, Berlin. Daniel Libeskind, architect. The "Berlin Museum" can be seen in the far left of the picture. Photo by S. Brent Plate.

of the building, before any artifacts of Jewish life are installed, that is the focus of my attention. I am interested here in the architectural materiality of memory, the possibility of organizing space in such a way that a particular history may be made visible, and through that, a collective sharing of memory might be enacted.

The following is intended to bring the reader into and through the space of Libeskind's Jewish Museum, Berlin. To do so, this writing is arranged in six sections or, more properly, six "stations of the star," following Libeskind's own structuring of the building and taking after suggestions given long ago by a former Berlin resident, Walter Benjamin. The museum, with its jagged shape, its earthly lightning bolt design, is made up of crossed lines which become intertwining triangles, and thus hint at fragmented, distorted, six-pointed stars.

Station 1: Crossed Lines: Disorientation

The restored Baroque building that has housed the "Berlin Museum" has now been supplemented with the Jewish Museum. The Jewish Museum itself is visibly detached from the Berlin Museum yet is connected underground. The entrance to the Jewish Museum is only accessible through the Berlin Museum, rising like a gaping abyss into the old museum space, interrupting the stored history of the city. Libeskind states:

> Absence therefore serves as a way of binding in depth, and in a totally different manner, the shared hopes of people. This is a conception which does not reduce the museum or architecture to a detached memorial or memorable detachment.

This is no memorial, isolated from its surroundings, straining to recall history. Here is history interwoven with memorial: museum as mausoleum, museum as muse.

Descending into the abyss from the Berlin Museum, we reach the passageway to the Jewish Museum. But at the initial depth, confusion sets in, for there are several passageways: three intersecting axes and no clear directions are given as to where we should go. This is no ordinary museum building, no ordinary space that disappears as the viewer orients themself to the stored artifacts on the walls or in display cases. In the conventional modern museum, one is given a somewhat simple trajectory to follow and when one comes out the other end, one has the confidence that she or he has "experienced" history. In Libeskind's Jewish Museum, however, we are disoriented even before we get there.

The disorientation that comes from facing the multiple axes is heightened as we take notice of a strange arrangement of lines [fig. 6.5]. Someone's

Fig. 6.5 One of the underground axes leading from the Berlin Museum to the Jewish Museum. Photo by S. Brent Plate.

planning seems to have gone wrong, someone's protractor and square were not quite so square: the lines of the walls, we see, are slanted, not perpendicular; the lights overhead are not centered but cross the overhead plane at non-parallel angles; and the floor moves uphill as it pushes us closer to the ceiling. Perspective is thrown off.

STATION 2: WANDERING LINE: EXILE

Taking a decision, we move toward the right, a decision somewhat prescribed for us based on psychological studies which conclude that when humans are set in disorienting spaces, they move toward the right, but also based on the fact that this axis has the most light at the "end of the tunnel." Walking uphill, toward the light, we come upon a door that leads to the outside, and into the E. T. A. Hoffmann Garden [fig. 6.6]. The garden is made up of 49 cement pillars perfectly parallel in relation to each other, yet set off-kilter from "true" verticality. As in the disorienting underground axes, the Hoffman Garden, also known as the "Garden of Exile," is set on a slope. In fact, there are several intersecting planes in the garden, none of which corresponds to a perfect verticality or perfect horizontality. In other words, no right angles. Looking at the pillars and the walls surrounding the

Fig. 6.6 The E.T.A. Hoffman Garden (or, the "Garden of Exile") outside the Jewish Museum, Berlin. Photo by S. Brent Plate.

pillars, the eyes detect straight lines. Thanks to a Western obsession with right angles and perpendicularity, the mind is inclined to perceive a "normal" space in which one might walk without a second thought. But once the first step is taken, the body tells us otherwise, for one walks on slanted ground. Something is not quite right. Walking slightly uphill while observing the straight lines of the pillars set at a different angle, and in the distance the straight lines of the buildings around, equilibrium is distorted. We stumble and almost fall. Disorientation stays with us in exile.

The "garden" conjures many visions. And in its designation as a "garden of exile," more memories come to mind. It is perhaps connected to the originary exile from the garden of Eden after that first mistake. And here one might note that children have no problem walking around in the space of this garden, it is only older people who stumble; disorientation, like orientation, has to be learned. The garden of exile is also connected to the many exiles that Jews have perpetually faced—exiles after slavery, exiles after the destruction of temples, exiles from various countries that no longer desired their presence. Jewish life in Berlin is itself the direct result of exile, when Emperor Leopold banished Jews from Vienna in the seventeenth century; at that time, fifty selected Jewish families were allowed to settle in Berlin. And the garden of exile also bears a relation to

the eventual exile *away* from Berlin that was the result of the rise of the National Socialists. Finally, in its city setting, Berlin itself has been, as Libeskind states, a city "in exile from itself"—the walls of the Jewish Museum today stand nearby the location of the former Berlin Wall.

The high pillars in the garden are filled with soil and planted with olive trees, so that one walks underneath a spreading garden of greenery overhead, just out of reach. We remain underground, inside the garden, though we have come out of the building. All we can touch is hard cement. We are not exiled from the garden, we are exiled *within* the garden.

STATION 3: BROKEN LINE: ABSENCE

Before we are up and inside the main museum building (though it is not clear when we are actually inside), we pass down one other of the underground axes and through a door that leads into a cold, dark, empty space, a dead end. This is the "Holocaust Tower," a building that is separate from the other buildings, yet again, connected underground. It is unheated and the only light comes through a small slit at the top of the tower, about five stories up.

The Holocaust Tower "outside" the museum is similar to the "void spaces" that exist throughout the space of the museum and that must be crossed in the exhibition space [fig. 6.7]. In both versions of this void space, the question of inside and outside resurfaces, for Libeskind insists that the space of the void "is a quality. It is a space you enter in the museum which organizes the museum, and yet it is not part of the museum. . . . [I]t refers to that which can never be exhibited when it comes to the Jewish Berlin history. Humanity reduced to ashes." Even that which will be exhibited in the museum space—expressionist paintings, stylized brass menorahs, silver torah shields, a pocket watch of Moses Mendelssohn, photos of the important and not-so-important—attests to a once-vibrant Jewish life in Berlin that is absent today.

Apart from the Holocaust Tower and the first and last void spaces, we are disallowed access to the interior of the voids. The voids are crossed through "void bridges" on each level. At various points we are allowed to see into the empty space through small slits in walls. Standing inside the museum we may think we are looking to the world outside, yet we are instead looking in to an even more interior space, to a center that remains elusive and absent. As Raoul Bunschoten puts it, "The void intersects the surface of time and creates a place of passage, of commemoration, of ritual in our daily life."

Through their sensual liturgy of sight, sound, and feeling, these void spaces mimic a sacred space, doubling it perhaps, leaving us in the very material presence of an absence. In the beginning was the void . . .

Fig. 6.7 Void space in the Jewish Museum, Berlin. While these spaces are "inside" the museum, they are inaccessible to the museum visitor. One sees into them through the slits in the walls. Photo by S. Brent Plate.

STATION 4: STRAIGHT LINE: HISTORY

When we finally emerge from the underground matrix of axes, we walk up the main staircase and enter the main exhibition space. We realize then that we are again faced with decisions, for the entrance has not let us enter at any beginning, but right in the middle of the zigzagging museum, and we can go either left or right. We enter the site of history, *in media res.*

The facts: From the first fifty families in the seventeenth century, Jewish life grew plentifully in Berlin and by the early twentieth century there were around two hundred thousand Jews living in the city. Though given little opportunity and taxed heavily through their history there, Jewish life flourished, due in part to Moses Mendelsohn's influence and reform in the eighteenth century. The first "Jewish Museum" of Berlin was opened next door to the synagogue on Oranienburger Strasse in 1933, a few weeks before the Nazis came to power.

More facts: A Polish-Jew born a year after World War Two ended, Daniel Libeskind lost many of his relatives in the Shoah. His family moved to the States when he was young and he studied in Israel, the United States, and England, training first as a musician and then as an architect. In the late 1980s he won the competition held by the city of Berlin to build a Jewish museum, a building that has been absent since 1938, when the then five-year-old Jewish Museum on Oranienburger Strasse was destroyed on Kristallnacht.

In this museum, Libeskind unearths a history of Berlin through Jewish life. He excavates old structures and finds crossings taking place. He builds into the museum the work of Berliners like Paul Celan, Arnold Schoenberg, Walter Benjamin, Rahel Varnhagen. He says that

> In the structure of the building, I sought to embody the matrix of connections which might seem irrational today but are, nevertheless, visible and rationalized by relationships between people. I attempted to represent the names and numbers associated with the Jewish Berliners, with the 200,000 Jews who are no longer here to constitute the fabric of Berlin which was so successful in business and the arts, intellectual, professional, and cultural fields.

In this matrix of architectural space, history is made visible, even before the artifacts are installed in their exhibition space. Instead, it is the physical structuring of the building that serves as a reminder, that serves to remind.

STATION 5: BRAIDED LINES: MEMORY

Libeskind is clear: "the museum is not a memorial, despite the fact that there are dimensions of memory built into it. The Museum is a museum—it is a space for the encounter of history: a building and not a memorial." Yet this *history* lends itself to *memory*: the museum building takes the straight line of factual information about the past and weaves it into the lives of those of us who walk through the space. By walking through the disorienting axes underground, the exile of the garden, the void spaces, as

well as the exhibition space, we reenact history in a new kind of ritual, and begin to make history meaningful by turning it into memory.

Because it brings both history and memory, the mind and the body, together, Libeskind's Jewish Museum, Berlin provides a space for the Hebrew *zakhor* to be acted out. Memory is an active, participatory process. History is there, but it must be made meaningful, and that is the action of memory, specifically collective memory. Through Jewish history, Yosef Hayim Yerushalmi contends, commemorative rituals and liturgies were not a matter of intellection, but of "evocation and identification." He says: "what was suddenly drawn up from the past was not a series of facts to be contemplated at a distance, but a series of situations into which one could somehow be existentially drawn." Memory must become visible, made material, and put into action through ritual and recital. It is not enough to write a history; memory must be enacted.

History, we may say, is learned through the head, memory through the feet. And it is architecture that provides a space to bring both together [fig. 6.8]. Architecture provides a singular and unique medium for such memory; architecture, as Libeskind notes, "is public memory." And the architecture of the museum space may be even more so, especially in a secular age. Museums today form a space for public discourse, and in this discourse the museum opens a space for collective memory to be forged out of the history presented. Because it is tied to the head and the feet, collective memory in the museum space is also tied to the body and the minds of others around us; it is linked to the past from which people have come, as well as to the future.

Station 6: Unending Line: Hope

Libeskind builds on the past, but leads out toward the future. He says with the planning of the museum he tried

> to reconnect the trace of the history of Berlin to Berlin and Berlin to its own eradicated memory which should not be camouflaged, disowned or forgotten. I sought to reopen the meaning which seems to be only implicit, and to make it visible. In terms of the city the idea is to give a new value to the existing context, the historical context, by transforming the urban field into an open and hope-oriented matrix.

Berlin itself today stands at a crucial point. As capitalist commercialism erects its own walls throughout the city, history is on the verge of going into hiding. However, the question of lines, of walls, of demarcation, remains and cannot be buried. Again, Libeskind:

Fig. 6.8 View inside the installation space of the Jewish Museum, Berlin. Photo by S. Brent Plate

I believe this [museum] scheme joins architecture to questions which are now relevant to all humanity. What I've tried to say is that the Jewish history of Berlin is not separable from the history of Modernity, from the destiny of this incineration of history; they are bound together. But not bound by means of any obvious forms, rather through faith; through an absence of meaning and an absence of artefacts. Absence therefore serves as a way of binding in depth, and in a totally different manner, the shared hopes of people. This is a conception which does not reduce the museum or architecture to a detached memorial or a memorable detachment. It is, instead, a conception which re-integrates Jewish/Berlin history through the unhealable wound of faith, which in the words of Hebrews 11.2 is the "substance of things hoped-for; proof of things invisible."

The void space that cuts through the jagged, historical "exhibition" space in the museum points to the past, but also to the future. Like lightning striking the earth, the Jewish Museum leaves a reminder in the midst of the city of Berlin. Illuminating as it burns, lightning brings to light a new history through flashes in the city. What is left is a hard concrete space, dimly lit, that is not filled, not reconciled, simply left as scorched earth.

Suggestions for Further Reading

Alphen, Ernst van. *Caught by History: Holocaust Effects in Contemporary Art, Literature, and Theory.* Stanford: Stanford University Press, 1997.

Bland, Kalman. *The Artless Jew: Medieval and Modern Affirmations and Denials of the Visual.* Princeton: Princeton University Press, 2000.

Cohen, Richard I. *Jewish Icons: Art and Society in Modern Europe.* Berkeley: University of California Press, 1998.

Friedlander, Saul, ed. *Probing the Limits of Representation: Nazism and the "Final Solution."* Cambridge: Harvard University Press, 1992.

Goodenough, Erwin R. *Jewish Symbols in the Greco-Roman Period.* Edited and abridged by Jacob Neusner. Princeton: Princeton University Press, 1988.

Halbertal, Moshe and Avishai Margalit. *Idolatry.* Translated by Naomi Goldblum. Cambridge: Harvard University Press, 1992.

Hervieu-Leger, Daniele. *Religion as a Chain of Memory.* Translated by Simon Lee. New Brunswick, NJ: Rutgers University Press, 2000.

Hooper-Greenhill, Eilean. *Museums and the Interpretation of Visual Culture.* New York: Routledge, 2000.

Kochan, Lionel. *Beyond the Graven Image: A Jewish View.* New York: New York University Press, 1997.

Levine, Lee. *The Ancient Synagogue: The First Thousand Years.* New Haven: Yale University Press, 2000.

Libeskind, Daniel. *radix-matrix: Architecture and Writings.* Munich and New York: Prestel, 1997.

———. *Daniel Libeskind: The Space of Encounter.* New York: Universe, 2000.

Meek, H. A. *The Synagogue.* London: Phaidon, 1995.

Mendelsohn, Ezra, ed. *Art and Its uses: The Visual Image and Modern Jewish Society.* Vol. 6 of Studies in Contemporary Jewry. New York: Oxford University Press, 1990.

Moore, Clare, ed. *The Visual Dimension: Aspects of Jewish Art.* Boulder: Westview Press, 1993.

Pagis, Dan. *Points of Departure.* Translated by Stephen Mitchell. Philadelphia: Jewish Publication Society, 1981.

Stier, Oren Baruch. *Memory Matters: Contemporary Holocaust Memorial Culture.* Forthcoming.

Yerushalmi, Yosef Hayim. *Zakhor: Jewish History and Jewish Memory.* Seattle: University of Washington Press, 1996.

Young, James. *The Texture of Memory: Holocaust Memorials and Meaning.* New Haven: Yale University Press, 1993.

―――. *At Memory's Edge: After-Images of the Holocaust in Contemporary Art and Architecture.* New Haven: Yale University Press, 2000.

Zelizer, Barbie. *Remembering to Forget: Holocaust Memory Through the Camera's Eye.* Chicago: University of Chicago Press, 1998.

―――. *Visual Culture and the Holocaust.* New Brunswick, NJ: Rutgers University Press, 2000.

Index

Made in the USA
San Bernardino, CA
24 August 2013